Sketchbooks
of the
Romantics

Sketchbooks
of the
Romantics

ROBERT UPSTONE

TIGER BOOKS INTERNATIONAL
LONDON

A QUARTO BOOK
This edition published in 1993 by
Tiger Books International plc, London

Copyright © 1991 Quarto Publishing plc

ISBN 1-85501-358-4

This book was designed and produced by
Quarto Publishing plc
The Old Brewery, 6 Blundell Street,
London N7 9BH

Art Editor: Philip Gilderdale
Designer: Graham Davis
Picture Researcher: Deidre O'Day
Senior Editor: Sally MacEachern
Editors: Christine Shuttleworth, John Morton
Index: Christine Shuttleworth
Art Director: Moira Clinch
Publishing Director: Janet Slingsby

Typeset by Bookworm Typesetting, Manchester
Manufactured in Hong Kong by Excel Graphic Art Company
Printed in Singapore by Star Standard Industries Pte. Ltd

Contents

Foreword

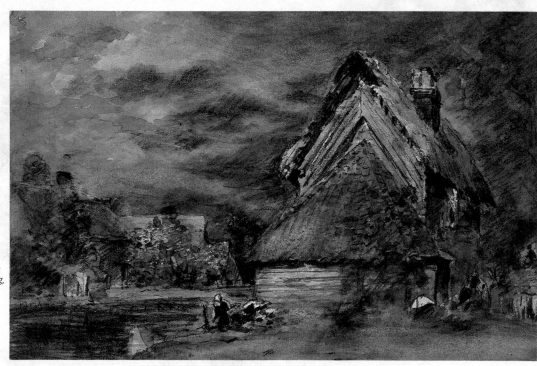

JOHN CONSTABLE
*Cottage by a Pond:
Storm approaching*,
1821
pencil and
watercolour,
6⅝ × 10⅛ in
(16.8 × 25.7 cm)
British Museum,
London

"I will begin a new sketchbook and, I hope, try to work with a child's simple feeling and with the industry of humility." So wrote the young Samuel Palmer in 1824, when he stood on the verge of discovering that intensity of vision and imagination for which he ranks among the greatest of British Romantic artists. Like so many artists before and after him, Palmer found it natural to turn to a sketchbook in order to try to trace the marks of a new and personal vision. No aspect of an artist's work is more revealing than his sketchbook. Within its pages – small or large, stiffly or loosely bound – lies a private, even secret domain in which he can record his impressions and explore his ideas. Here are to be found his most intimate statements, immediate responses to the world around him, his experience or imagination, first ideas for other works, or concepts in evolution through sequences of studies. Whether slight or spontaneous jottings or quite finished drawings, whether the record of empirical observation before the motif or more mature recollection in the studio, the contents of a sketchbook provide unrivalled insights into an artist's mind and methods.

Alas, sketchbooks are among the most vulnerable of all artists' remains. Few have survived intact, for the temptation to dismember them, to separate particularly beautiful or covetable sheets, has often proved irresistible. Commerce has often, but not always, been to blame. The period covered by this book offers examples of vandalism worse possibly than that perpetrated by market forces. Samuel Palmer's son destroyed what were evidently some of the artist's most remarkable and characteristic sketchbooks – more personal still than the one described in the following pages – on the grounds that the contents were neither sufficiently masculine nor sufficiently reticent. Likewise, Ruskin exercised his own editorial zeal – aesthetic and sometimes moral – upon the sketchbooks in the Turner Bequest. Clearly, the very frankness and clarity with which the Romantics confronted their own mental landscape – as honest and direct as their investigation of the natural world and of people and places – posed problems for the Victorians. For us today, it makes their remaining sketchbooks a subject of compelling interest.

The heritage is still a rich one. There is little of fundamental concern to Turner that cannot be found in his sketchbooks, whether the tiny thumbnail sketches he caught on the wing as he travelled, or the more developed studies in watercolour that he made in his studio, in inns and hotels and friends' houses. Constable's search for a new and natural landscape style, and the inception of some important pictures, can likewise be found between bound pages; so too can the sinister meditations of Goya, and the pictorial ideas of Delacroix and Géricault. Some of Friedrich's landscape drawings, on the other hand, have been separated. These at least are relatively easy to reassemble, at least in the imagination or in the pages of a book like this; other sketchbooks are not so easily reconstructed.

The literature of "master drawings" of all periods has usually been written in terms of individual sheets, partly because it is not always possible to recognize or reconstruct the larger sequence to which these originally belonged, partly because criticism inevitably confers a particular integrity upon a unique and outstanding work. This book attempts to strike a balance, paying proper respect for the quality of individual drawings – which are indeed sometimes the solitary survival of a bound sequence – while providing a wider sense of the original context. It is to be hoped that it opens some remarkable pages, from a period when that liberation of the imagination and intensity of observation that we associate with Romanticism sent artists to their sketchbooks with a passion and energy, or sometimes a humble inquiry, scarcely matched in the history of art.

David Blayney Brown
The Clore Gallery,
London

Chronology of the Romantic Era 1740-1853

HISTORY: POLITICAL AND SOCIAL

VISUAL ARTS

LITERATURE, MUSIC AND PHILOSOPHY

	1740	1741	1742	1743	1744	1745	1746
History	Famine in France	Sweden declares war on Russia; Prussia defeats Austria	Austro/Prussian peace; Centigrade thermometer invented	Russo/Swedish peace; Voltaire visits Frederick II; Thomas Jefferson born; J.P. Marat born	France declares war on England and Austria	Jacobite rebellion	Charles Stuart defeated at Culloden
Visual Arts	Canaletto: *The Square of St Mark's*; *The Quay of the Piazzetta*; Boucher: *The Triumph of Galatea*; J.T. SERGEL born; Hogarth: *Captain Coram*	Pietro Longhi: *The Apothecary's Shop*; HENRY FUSELI born	Boucher: *Diana Resting*; Hogarth: *The Graham Children*; Oudry: *The Gardens of Arcueil*; THOMAS JONES born	Hogarth: *Marriage à la Mode*		Perronneau: *Girl with a Kitten*; Hogarth: *Self Portrait*; Oudry: *Still Life with Peasants*; Tiepolo: *Antony and Cleopatra*	Boucher: *Mme Bergeret*; Reynolds: *The Eliot Family*; FRANCISCO GOYA born
Literature	Handel: *Water Music*; Stukeley: *Stonehenge*	Handel: *Samson*; *Deidamia*; Voltaire: *Mahomet*; Hume: *Essays, Moral and Political*	Handel: *The Messiah*; Fielding: *Joseph Andrews*	Voltaire: *Merope*	Alexander Pope dies; Gluck: *Iphigenia in Aulis*; G. Berkeley: *A Chain of Philosophical Reflexions and Inquiries*	Jonathan Swift dies; Samuel Johnson: *Observations on the Tragedy of Macbeth*	Diderot: *Penseés philosophiques*; Handel: *Judas Maccabaeus*

	1757	1758	1759	1760	1761	1762	1763
History	Russia joins Franco-Austrian alliance against Britain and Prussia	James Monroe born; Robespierre born; Horatio Nelson born	British defeat French at Quebec; Georges Danton born; Portugal expels Jesuits	British take Montreal; Berlin attacked by Russians; First deaf & mute school in Britain	Pitt the Elder resigns as Prime Minister; Spain invades Portugal	Catherine the Great becomes ruler of Russia; Britain declares war on Spain	J.P. Bernadotte born; Peace of Paris ends Seven Years' War
Visual Arts	WILLIAM BLAKE born; Tiepolo: *Cleopatra's Banquet*	Boucher: *Madame de Pompadour*; Hogarth: *Parliamentary Elections*	Hogarth: *Sigismonda*	Reynolds: *Georgiana*; Gainsborough: *Mrs Philip Thicknesse*; Society of Artists holds first exhibition in London; Wedgwood pottery works started	First exhibition of Gainsborough	Stubbs: *Mares and Foals*	Guardi: *Election of the Doge of Venice*; La Madeleine, Paris, completed
Literature	Handel: *The Triumph of Time*	Diderot: *Le Père de famille* (play)	Voltaire: *Candide*; Handel dies; Goldsmith: *An Enquiry into the present State of Polite Learning in Europe*	Sterne: *Tristram Shandy*; Goldsmith: *Citizen of the World*; Saint-Simon and Cherubini born; Haydn: Symphonies 2–5	Gluck: *Don Juan*; Gray: *The Descent of Odin*	Rousseau: *The Social Contract*; *Emile*	Mozart, aged six, tours Europe; Boswell meets Johnson; Voltaire: *Treatise on Tolerance*; Walpole: *The Castle of Otranto*

1747	1748	1749	1750	1751	1752	1753	1754	1755	1756
John Paul Jones born Revolution in Holland Russo/British treaty	War of Austrian Succession ended First wool-carding machines	Reorganization of British navy	Spain and Portugal divide South America East India Company's Chinese ventures curtailed	Adolphus Frederick becomes king of Sweden James Madison born	Benjamin Franklin invents lightning conductor	Louis XV expels Parlement of Paris France declares national bankruptcy British Museum founded	Talleyrand born Future Louis XVI born Anglo-French war in North America	Braddock defeated by French Marie Antoinette born	Britain declares war on France Seven Years' War begins Louis XV suppresses two chambers of Parlement
Hogarth: *Industry and Idleness*	Gainsborough: *View of the Charterhouse* J.L. DAVID born Hogarth: *Calais Gate*	Tiepolo: *Giovanni Querini*	Boucher: *The Sleeping Shepherdess* JOHN BROWN born	Boucher: *Toilet of Venus* Hogarth: *Four Stages of Cruelty* Cabinetmaker Sheraton born	J.R. COZENS born Architect J. Nash born	Reynolds: *Commodore Keppel* Hogarth: *The Analysis of Beauty*	Boucher: *Judgment of Paris* Chippendale: *The Gentleman and Cabinet Maker's Directory* Hogarth: *The Election*	Gainsborough: *Milkmaid and Woodcutter*	Sèvres porcelain factory founded
Handel: *Joshua* Voltaire: *Zadig* Benjamin Franklin: *Plain Truth* Johnson: *Plan of a Dictionary of the English Language*	Hume: *Philosophical Essays Concerning Human Understanding* Richardson: *Clarissa Harlowe* Montesquieu: *L'Esprit des Lois*	Fielding: *Tom Jones* Handel: *Firework Music* Goethe born Bach: *The Art of the Fugue*	Gray: *Elegy Written in a Country Churchyard*	Richard Brinsley Sheridan born Hume: *Enquiry Concerning the Principles of Morals*	Hume: *Political Discourses* Poet Chatterton born		Rousseau: *Discours sur l'origine de l'inégalité parmi les hommes* Hume: *History of Great Britain, Vol. 1*	Johnson: *Dictionary of the English Language* (1773)	Burke: *Origin of our Ideas of the Sublime and Beautiful* Mozart born

1764	1765	1766	1767	1768	1769	1770	1771	1772	1773
Russo-Prussian alliance Spinning Jenny invented Mme de Pompadour dies	Stamp Act affects American colonies Francis I, husband of Empress Maria Theresa, dies	Stamp Act repealed (but only in Britain) Mason-Dixon line drawn	Andrew Jackson born J.Q. Adams born New York refuses to quarter British troops	France given Corsica Turkey declares war on Russia Boston refuses to quarter troops	Duty on tea kept in American colonies Napoleon born in Corsica	Boston "Massacre" Marriage of Dauphin and Marie Antoinette	Russo-Prussian partition of Poland	James Bruce traces the Blue Nile	Boston "Tea Party"
Hogarth dies	Boucher becomes French court painter Fragonard: *Corésus et Callirhoé* Gainsborough: *Sunset*	Fragonard: *The Swing*	Allan Ramsay British court painter	Born: JOSHUA CRISTALL Royal Academy founded; Reynolds is the first President	Fragonard: *The Study* Thomas Lawrence born	Deaths of Boucher and Tiepolo Gainsborough: *Blue Boy*	Fragonard: *A Game of Hot Cockles*	Gainsborough: *Ralph Schomberg*	Reynolds: *The Graces Decorating Hymen*
Voltaire: *Philosophical Dictionary* Winckelmann: *History of Ancient Art* Mozart's first symphony	Haydn: Symphonies in D Minor, C and D (*Christmas, Hallelujah*, and *with Horn Signals*)	Goldsmith: *Vicar of Wakefield*	Gluck: *Alceste* Rousseau: *Dictionary of Music*	Mozart's first opera, *Bastien and Bastienne*, produced	Goethe's earliest poems published Burke: *Observations on the Present State of the Nation*	Wordsworth, Hegel and Beethoven born Chatterton dies Burke: *Thoughts on the Cause of the Present Discontents*	Thomas Gray dies Walter Scott born	Coleridge born First barrel organs made	Goldsmith: *She Stoops to Conquer*

1774	1775	1776	1777	1778	1779	1780	1781	1782	1783
Continental Congress meets at Philadelphia Louis XV dies Austrian peasant revolt	American Revolution Britain replaces Portugal in opium trade James Watt perfects steam engine	American declaration of Independence Russo-Danish treaty	Jacques Necker made French finance minister	Franco-American alliance	Royal serfs freed in France US Congress acts against Indians Crompton invents the "mule" spinning machine	Empress Maria Theresa dies Gordon riots, England Pitt the Younger in Parliament	Cornwallis surrenders at Yorktown	Anglo-American peace talks begin Watt and Boulton steam engine	Britain recognizes US independence Russia annexes Crimea Montgolfier brothers make first balloon ascent
C.D. FRIEDRICH born Gainsborough: *Lord Kilmorey*	J.M.W. TURNER born Reynolds: *Miss Bowles*	JOHN CONSTABLE born Fragonard: *The Washerwoman*	Gainsborough: *The Watering Place* Guardi: *Santa Maria della Salute*	JOHN VARLEY born Piranesi dies	Canova: *Daedalus and Icarus* Gillray's cartoons first appear REYNOLDS begins his Discourses at the Royal Academy	Canaletto dies Reynolds: *Mary Robinson as Perdita* J.A. Ingres born GOYA: *The Doctor*	DAVID: *Belisarius* ROMNEY: *Miss Willoughby* FUSELI: *The Nightmare*	ROMNEY: *Lady and Child* Guardi: *Fetes for the Grand Duke Paul of Russia*	Reynolds: *Captain Bligh* DAVID: *Grief of Andromache*
Goethe: *The Sorrows of Young Werther* Goldsmith dies	Sheridan: *The Rivals* Charles Lamb and Jane Austen born Burke: *Speech on Conciliation with America*	Smith: *An Inquiry into the Nature and Causes of the Wealth of Nations* Gibbon: *Decline and Fall of the Roman Empire*	Gluck: *Armide* Haydn: Symphony No. 63 in C Major Sheridan: *School for Scandal*	Beethoven presented as a prodigy Voltaire and Rousseau die	S. Johnson: *Lives of the Poets* Sheridan: *The Critic*	Haydn: Symphony in C (*Toy*)	Rousseau: *Confessions* Mozart: *Idomeneo* Kant: *Critique of Pure Reason*	Mozart: *The Abduction from the Seraglio* Nicolò Paganini born	BLAKE: *Poetical Sketches* Mozart: *Linz Symphony in C*

1794	1795	1796	1797	1798	1799	1800	1801	1802	1803
Danton executed and Robespierre arrested (Terror ends) British capture Corsica	Napoleon made commander in chief, Italy; bread riots in Paris; peace with Austria	France regains Corsica Anglo-Spanish war Catherine the Great dies Jenner introduces smallpox vaccination Napoleon marries Joséphine de Beauharnais	Poland removed from map France at war on many fronts British navy mutinies at Spithead	French capture Rome; set out for Egypt; take Malta and Naples, Battle of the Nile Rebellion in Ireland	Napoleon made First Consul French find Rosetta stone George Washington dies	Volta invents first electric battery Herschel discovers infra-red rays Reform group in England	French treaties with Austria, Spain, Naples and Portugal Alexander I becomes Tsar of Russia Battle of Copenhagen Jefferson elected president of USA	Napoleon becomes president of Italian republic and First Consul for life	US makes Louisiana Purchase Anglo-French war Treithick invents steam locomotive
Goya: *Procession of the Flagellants* BLAKE: *The Ancient of Days*	GOYA: *The Duchess of Alba* WRIGHT: *Rydal Waterfall*	J.B.C. COROT born GOYA: *Los Caprichos* Thomas Jefferson designs Monticello TURNER: *Fishermen at Sea*	Deaths of J.R. COZENS, WRIGHT OF DERBY BLAKE: 537 watercolours to illustrate *Night Thoughts* (by Young) TURNER: *Millbank, Moon Light* GOYA: *The Duchess of Alba*	E. DELACROIX born GOYA: *The Bewitched*	CONSTABLE at Royal Academy schools GOYA: *Portrait of a Woman* DAVID: *Rape of the Sabine Women*	DAVID: *Mme Récamier* GOYA: *Portrait of a Woman* TURNER: *Dolbadern Castle*	GOYA: *Naked Maja; Clothed Maja* DAVID: *Napoléon au Grand Saint-Bernard*	ROMNEY dies Canova: *Napoleon Bonaparte* Gérard: *Mme Recamier*	T. JONES dies TURNER: *Calais Pier*
BLAKE: *Songs of Experience; America; Visions of the Daughters of Albion; Songs of Innocence and Experience, First Book of Urizon* and *Europe* Antoine Lavoisier executed	Keats and Carlyle born Deaths of Boswell and Gibbon Beethoven: three piano trios, Opus 1	Wordsworth: *The Borderers* Haydn: Holy Mass in B Flat Austen: begins *Pride and Prejudice* Burns dies	Coleridge: *The Ancient Mariner; Kubla Khan* Schubert born Haydn: Emperor quartet Cherubini: *Medée* Austen: begins *Sense and Sensibility*	Wordsworth and Coleridge: *The Lyrical Ballads* Austen: *Northanger Abbey* Malthus: *Essay on Population* Bentham: *Political Economy*	Balzac born Beethoven: Symphony No. 1 in C and Sonata in C Minor	Schiller: *Maria Stuart* Cherubini: *The Water Carrier*	Haydn: *The Creation; The Seasons* Beethoven: *Moonlight Sonata*	Victor Hugo born Bentham: *Civil and Penal Legislation*	Hector Berlioz born Beethoven: Sonata for violin and piano (*Kreutzer*)

1784	1785	1786	1787	1788	1789	1790	1791	1792	1793
Joseph II suppresses feudal rights in Hungary John Wesley's Methodist charter	"Affair of the Diamond Necklace" in France Swedish scandal over lavish royal spending Cartwright invents power loom	Frederick the Great dies	France again declares national bankruptcy	First evidence of George III's illness First US Federal Congress; Constitution comes into effect Bread riots in France	The French Revolution begins George Washington made US president	Benjamin Franklin dies Washington DC founded Lavoisier publishes Table of 31 Chemical Elements	French royal family captured at Varennes US Bill of Rights ratified	France declared a Republic; mobs invade the Tuileries; Louvre opened as museum Tom Paine charged with sedition and sentenced to death; *Rights of Man* banned	Franco-British war Reign of Terror; Louis XVI and Marie Antoinette executed; Marat assassinated
P. DE WINT born GOYA: *Don Manuel de Zuniga* ROMNEY: *Mrs Davenport* DAVID: *Oath of the Horatii*	Gainsborough: *Mrs Siddons*	GOYA: *The Seasons*	JOHN BROWN dies Reynolds: *Heads of Angels*	J.C. DAHL born DAVID: *Love of Paris and Helen* Gainsborough dies	DAVID: *Lictors Bringing Brutus the Body of His Son*	J.A. RAMBOUX born Guardi: *Gondola on the Lagoon*	THÉODORE GÉRICAULT born	Reynolds dies	DAVID: *Death of Marat* Guardi dies Canova: *Cupid and Psyche* Louvre made national art gallery
Samuel Johnson dies Kant: *Notion of a Universal History in a Cosmopolitan Sense*	Boswell: *Journal of a Tour in the Hebrides* Haydn: seven adagios for Cadiz Cathedral	Mozart: *The Marriage of Figaro* Carl Maria von Weber born Beckford: *Vathek*	Mozart: *Don Giovanni; Eine Kleine Nachtmusik* Goethe: *Iphigenia at Tauris*	Byron born Kant: *Critique of Pure Reason* Goethe: *Egmont* Mozart: *Jupiter, E Flat and G Minor* symphonies	BLAKE: *Songs of Innocence* Bentham: *Introduction to Principles of Morals and Legislation* White: *The Natural History of Selbourne*	Wordsworth tours France BLAKE: *The Marriage of Heaven and Hell* Burke: *Reflections on the Revolution in France* Mary Wollstonecraft: *Vindication of the Rights of Woman*	Boswell: *Life of Johnson* Paine: *Rights of Man (I)* BLAKE: *The French Revolution* Mozart: *The Magic Flute*; dies	Percy Bysshe Shelley born Beethoven studies with Haydn	Godwin: *The Inquiry Concerning Political Justice* Kant: *Religion within the Limits of Mere Reason* Wordsworth: *An Evening Walk; Descriptive Sketches*

1804	1805	1806	1807	1808	1809	1810	1811	1812	1813
Napoleon created emperor Spain declares war on Britain	Napoleon crowned king of Italy Battle of Trafalgar; battle of Austerlitz	Joseph Bonaparte made king of Naples; Louis Bonaparte, king of Holland	Garibaldi born Napoleon secures dictatorship; Jerome Bonaparte king of Westphalia	Joseph Bonaparte, king of Spain; Peninsula War begins	Franco-Austrian peace Abraham Lincoln born Pope excommunicates Napoleon, who captures the Pope Bernadotte made Swedish Crown Prince Napoleon divorces Joséphine	Napoleon marries Marie Louise of Austria	George III insane; Prince of Wales becomes Prince Regent Luddite riots in Nottingham Napoleon's heir born	Anglo-American war Napoleon invades Russia; Moscow burned	France at war with much of Europe (incl. Sweden)
Watercolour Society founded	SAMUEL PALMER born GOYA: *Doña Isabel Cobos de Procal* TURNER: *The Shipwreck*	Fragonard dies CONSTABLE: *Langdale Pikes; Helvellyn* Cotman: *On the Greta* TURNER: *Mer de Glace*	Cotman: *Road to Capel Curig* DAVID *Sacre de Joséphine* Ingres: *La Source*	FRIEDRICH: *The Cross in the Mountains* GOYA: *Execution of the Citizens of Madrid* Ingres: *La Grande Baigneuse*	TURNER: *Valley of Chamonix* CONSTABLE: *Malvern Hill* FRIEDRICH: *Monk by the Sea* and *Abbey in Oakwood*	GOYA: *Majas on Balcony; Los Desastres de la Guerra* J.F Overbeck founds the Nazarenes	Ingres: *Cordier; Jupiter and Thetis*	TURNER: *Hannibal crossing the Alps* GOYA: *Portrait of the Duke of Wellington* CONSTABLE: *Landscape with Double Rainbow* GÉRICAULT: *Charging Chasseur*	BLAKE: *The Day of Judgment*
Births of George Sand (Amandine Dupin-Dudevant), Johann Strauss, Nathaniel Hawthorne Schiller: *Wilhelm Tell* Beethoven: *Eroica* symphony	Beethoven: *Fidelio* Virtuoso Paganini tours Europe Schiller dies	Births of Elizabeth Barrett Browning and J.S. Mill Rossini: *Demetrio a Polibio* Beethoven: Symphony No 4	Byron: *Hours of Idleness* Wordsworth: *Ode on Intimations of Immortality* Beethoven: *Leonora Overture* The Lambs: *Tales from Shakespeare*	Beethoven: Symphonies Nos. 5 and 6 Goethe: *Faust*	Poe, Mendelssohn, Darwin, Tennyson born Deaths of Haydn and Paine Byron: *English Bards and Scotch Reviewers* Beethoven: *Emperor Concerto (No. 5)*	Births of de Musset, Chopin, Schumann Scott: *The Lady of the Lake* Beethoven: music for Goethe's *Egmont*	Births of Liszt and Thackeray	Byron: *Childe Harold's Pilgrimage* Austen: completes *Mansfield Park*	Austen: *Pride and Prejudice* Shelley: *Queen Mab* Wagner born

1814	1815	1816	1817	1818	1819	1820	1821	1822	1823
Napoleon defeated; exile to Elba Start of Congress of Vienna British burn Washington DC; US-British peace	Napoleon returns to France; defeat at Waterloo; final exile Bismarck born	British economic crisis Invented: stethoscope (Laënnec); kaleidoscope (Brewster)	Charlotte, heiress to British throne, dies Serfdom abolished in Estonia	Bernadotte becomes King of Sweden Karl Marx born	Spain sells Florida to US Future Queen Victoria born (also Prince Albert)	Prince Regent becomes George IV Revolution in Spain F. Nightingale born	Napoleon dies Revolution in Greece Champollion deciphers the Rosetta Stone Faraday constructs first electric motor	Turks massacre Greeks on island of Chios	US Monroe Doctrine Britain recognizes Greek revolution
SERGEL dies GOYA: *The Third of May 1808* Ingres: *L'Odalisque* Millet born CONSTABLE: *The Vale of Dedham*	GOYA: *Self-Portrait* CONSTABLE: *Boat Building* Canova: *The Three Graces* TURNER: *Crossing the Brook*	F. TOWNE dies GOYA: *The Duke of Osuna*	CONSTABLE: *Flatford Mill* GÉRICAULT: *Horse Held by Slaves*	Landseer: *Fighting Dogs* Prado founded in Madrid	GÉRICAULT: *The Raft of the Medusa* TURNER: *Childe Harold's Pilgrimage* BLAKE begins *Visionary Heads* series	BLAKE: *Book of Job* (illustrations) CONSTABLE: *Harwich Lighthouse; Dedham Mill* Venus de Milo discovered	CONSTABLE: *The Haywain* GÉRICAULT: *Derby Day*	CONSTABLE: *The Lock* and *Trees at Hampstead* DELACROIX: *Dante and Virgil Crossing the Styx*	Cotman: *Dieppe Harbour* T. Lawrence: *The Calmady Children*
Beethoven: *Fidelio* (final) Wordsworth: *The Excursion* Scott: *Waverley* Byron: *The Corsair; Lara*	Scott: *Guy Mannering* Trollope born	Rossini: *The Barber of Seville* Austen: *Emma* Charlotte Brontë born	Byron: *Manfred* Keats: *Poems*	Austen: *Persuasion* Byron: begins *Don Juan* Mary Shelley: *Frankenstein* Emily Brontë born Keats: *Endymion*	Byron: *Mazeppa* Births of George Eliot (Mary Ann Evans), J.W. Howe, Whitman, J.R. Lowell, J. Ruskin	Scott: *Ivanhoe* Shelley: *Prometheus Unbound* Keats: *Lamia, Isabella, The Eve of St Agnes and Other Poems*	Keats dies Births of Dostoevsky and Flaubert De Quincey: *Confessions of an Opium Eater* Shelley: *Adonais* (on Keats)	Shelley dies	Byron sails for Greece Lamb: *Essays of Elia* Schubert: *Rosamunde*

1834	1835	1836	1837	1838	1839	1840	1841	1842	1843
Abolition of slavery throughout British Empire	Texas secedes from Mexico	Siege at the Alamo; Texas independent	Queen Victoria ascends British throne Electric telegraph patented	Talleyrand dies Steamship passengers cross Atlantic	Chinese Opium War First Trans-Atlantic steamer service	Queen Victoria marries Albert of Saxe-Coburg-Gotha Beau Brummell dies	Britain takes sovereignty over Hong Kong	Opium War ends British industrial unrest W. James born	Jefferson Davis enters politics
COROT: *View of Santa Maria della Salute* TURNER: *Venice, Dogana and San Giorgio Maggiore* DELACROIX: *Arabic Fantasy* Ingres: *Martyrdom of Saint Symphorian*	CONSTABLE: *The Valley Farm* COROT: *Hagar in the Desert*	CONSTABLE: *Stonehenge* TURNER: *Valley of Aosta* COROT: *Diana Surprised by Actaeon* Births of Fantin-Latour, Tissot and Winslow Homer	CONSTABLE dies	COROT: *Young Woman; View near Volterra*	TURNER: *The Fighting Téméraire*	FRIEDRICH dies DELACROIX: *Entry of the Crusaders into Constantinople* Births of Monet, Rodin and Renoir	COROT: *Quai des Paquis Geneva*	VARLEY dies TURNER: *Snow Storm: Steam Boat off a Harbour's Mouth* Ingres: *Odalisque with Slave*	COROT: *Tivoli* Turner: *Approach to Venice; San Benedetto Looking towards Fusina*
Berlioz: *Harold in Italy* Bulwer-Lytton: *Last Days of Pompeii* Coleridge dies Hugo: *The Hunchback of Notre Dame*	Donizetti: *Lucia di Lammermoor* H.C. Anderson publishes first fairy tales R. Browning: *Paracelsus*	Dickens serializes *The Pickwick Papers* Carlyle: *Sartor Resartus* Gogol: *The Inspector General* Emerson: *Nature*	Carlyle: *The French Revolution* Pushkin dies Swinburne born	Dickens: *Oliver Twist; Nicholas Nickleby* E.B. Browning: *The Seraphim and Other Poems*	Poe: *Fall of the House of Usher*	J.F. Cooper: *The Pathfinder* Births of Hardy and Zola Donizetti: *La Fille du Régiment* Paganini dies	Dickens: *The Old Curiosity Shop*	Wagner: *Rienzi* Gogol: *Dead Souls* Balzac begins publishing his *Human Comedy* Poe: *Murders in the Rue Morgue*	Wordsworth made Poet Laureate Wagner: *The Flying Dutchman* Dickens: *A Christmas Carol* Ruskin: *Modern Painters* (Vol 1)

1824	1825	1826	1827	1828	1829	1830	1831	1832	1833
Louis XVIII dies; Charles X French king	Nicholas I becomes ruler of Russia Britain declares neutrality in Greek war The first railway in the world opens in England	Russo-British agreement on Greece Russo-Turkish conflict over Serbia	Turkey rejects international plea to end war with Greece; Turks enter Athens Russia seizes Armenia	Russo-Turkish war Test Act repealed (Catholics et al. can hold office) Duke of Wellington becomes Prime Minister of Britain	Catholic Emancipation Act Turkey acknowledges Greece as independent	Charles X deposed; "July monarchy" in France	Darwin's first voyage Poles revolt against Russia Slave revolt in Virginia led by Nat Turner	Mazzini begins youth movement for Italian independence Reform bill passed in England	Abolition of slavery in British colonies US anti-slavery society founded
GÉRICAULT dies DELACROIX: *The Massacre of Chios*	Deaths of DAVID and FUSELI CONSTABLE: *Leaping Horse*	Bonington: *Piazza San Marco* DELACROIX: *Greece on the Ruins of Missolonghi*	BLAKE dies CONSTABLE: *The Glebe Farm* W. Holman Hunt born	GOYA dies DELACROIX: *Faust*	DELACROIX: *Sardanapalus* TURNER: *Ulysses Deriding Polyphemus* CONSTABLE: *Hadleigh Castle*	COROT: *Houses at Honfleur; Chartres Cathedral* DELACROIX: *The 28th July: Liberty Leading the People* Camille Pissarro born		CONSTABLE: *Waterloo Bridge from Whitehall Stairs* Births of Doré and Manet	TURNER first exhibits his Venetian paintings at the Royal Academy
Byron dies at Missolonghi	Pushkin: *Boris Godunov* Johann Strauss born Scott: *The Talisman*	De Vigny: *Cinq-Mars* Mendelssohn: overture to *A Midsummer Night's Dream*	Beethoven dies Hugo: *Cromwell* Schubert: *Die Winterreise*	Births of D.G. Rossetti, Tolstoy, G. Meredith, J. Verne Webster: *American Dictionary of the English Language* Coleridge: *Poetical Works* Schubert: Symphony No. 9; dies	Chopin makes Viennese debut Rossini: *William Tell*	Donizetti: *Anna Bolena* Births of Emily Dickinson and Christina Rossetti Stendhal: *The Red and the Black*	Poe: *Poems* Chopin in Paris Bellini: *La Sonnambula*	Goethe: *Faust* (*II*); dies G. Sand: *Indiana* (her first novel) Tennyson: *Lady of Shalott* Berlioz: *Symphonie Fantastique*	Johannes Brahms born Chopin: *Twelve Etudes* Donizetti: *Lucrezia Borgia*

1844	1845	1846	1847	1848	1849	1850	1851	1852	1853
Marx and Engels meet Revolt in Mexico	Great Potato Famine begins in Ireland	Corn Laws repealed Pius IX becomes Pope	US takes Mexico City Lincoln in Congress	Revolution in France; Louis Napoleon elected president Revolutions in Austria, Germany, Milan, Parma, Prague, Rome	Garibaldi proposes republic; flees Rome	Louis Philippe dies	Louis Napoleon (Napoleon III) rules France I. Singer: sewing machine Great Exhibition in London	French empire restored	Napoleon III marries Eugénie de Montijo
TURNER: *Rain, Steam, and Speed*	Ingres: *Contesse d'Haussonville*	Millet: *Oedipus Unbound*	Deaths of CRISTALL and LOCK DELACROIX: *St George and the Dragon*	Formation of the Pre-Raphaelite Brotherhood Gauguin born Millet: *The Winnower*	DE WINT dies	COROT: *Une Matinée* Courbet: *The Stone Breakers* Millet: *The Sower*	TURNER dies COROT: *La Danse des Nymphes*	Millais: *Ophelia*	Van Gogh born
G.M. Hopkins born E.B. Browning: *Poems*	Wagner: *Tannhäuser* Poe: *The Raven*	Berlioz: *The Damnation of Faust*	C. Brontë: *Jane Eyre* E. Brontë: *Wuthering Heights* Mendelssohn dies	Dumas: *La Dame aux Camélias* Deaths of Donizetti and E. Brontë J.S. Mill: *Political Economy* Marx & Engels: *The Communist Manifesto*	Chopin dies Liszt: *Tasso*	Deaths of Wordsworth and Balzac Tennyson Poet Laureate E.B. Browning: *Sonnets from the Portuguese* Hawthorne: *The Scarlet Letter* Dickens: *David Copperfield*	Verdi: *Rigoletto* Melville: *Moby Dick* Gounod: *Sappho*	Dickens: *Bleak House* H.B. Stowe: *Uncle Tom's Cabin*	Verdi: *Il Trovatore* Wagner completes *Ring* text

The Romantic Era

'We young people of the time were intoxicated with art, passion and poetry; our heads were all in a whirl, our hearts pounding with extravagant ambitions. The fate of Icarus had no fears for us. 'Give us wings, wings, wings!', rose the cry on every side, 'even though we plunge into the sea!'

Théophile Gautier,
Histoire du Romantisme, 1874.

PART ONE

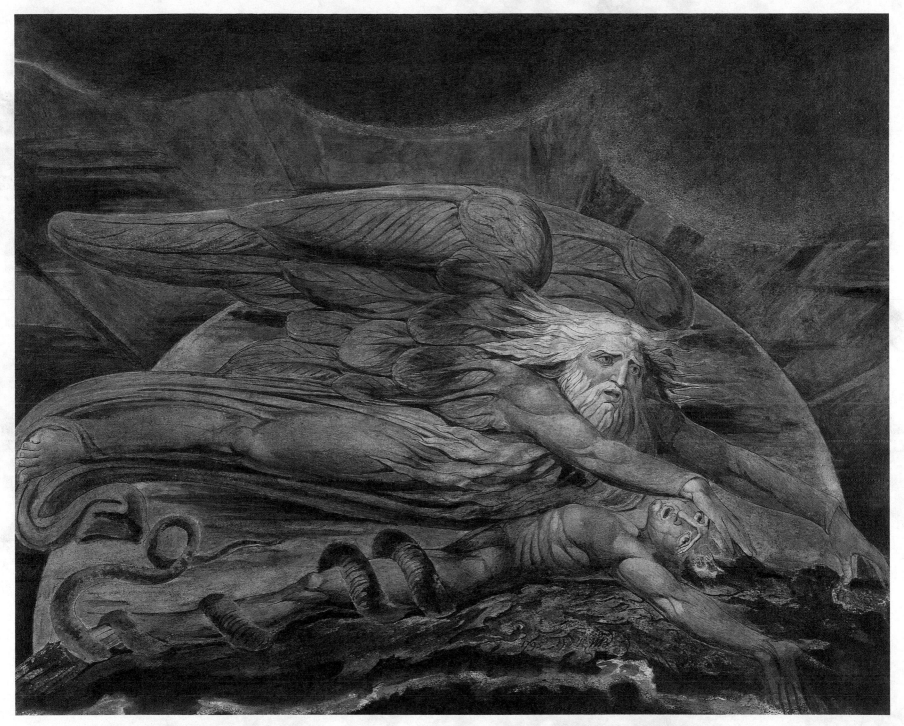

WILLIAM BLAKE
*Elohim creating
Adam* c. 1795
colour print
finished in pen and
ink and
watercolour
17 × 21⅛ in
(43.1 × 53.6 cm)
Tate Gallery,
London

15

Introduction

The work found in artists' sketchbooks can be far more revealing than their finished works, often in a different medium. While the latter are intended for public display and discussion, sketchbooks remain inherently private and personal and tell us much about an artist's character, working methods and reactions to the world. For this reason artists can often be extremely guarded about their drawings, not wishing anyone to see them. The choice of subject may be as enlightening as the manner of its execution. From sketchbooks one is able to glimpse the workings of an artist's mind, and study the approach to the subject and the techniques employed, which may differ radically from those displayed in more public, finished pictures.

Sketchbooks may contain notes as well as drawings; these are sometimes a record of the artist's thoughts on the work in hand, but frequently also ruminations on a wider variety of topics. When a large-scale picture is being planned, whether an oil, watercolour or sculpture, it is often in a sketchbook that the artist will make his initial drawings, the first plans of how to treat and compose a subject. From looking at these and subsequent drawings, the evolution of a picture may be traced from the original idea through to the finished work, which will often be very different from the first sketch. Drawings, and in particular sketchbook sheets, can prove to be among some of the artist's finest work, with an immediacy and verve absent from more formal exhibition pieces.

George Gordon, sixth Lord Byron (1788–1824), the author of *Childe Harold*, *Don Juan* and *Manfred*, was one of the most remarkable poets of the Romantic period. Poetry for him was "the lava of imagination whose eruption prevents an earthquake", and in his verses he gave vent to his desire for a world of passion and colour, and pilloried the weakness and hypocrisy he despised. Although an aristocrat, he was a committed libertarian, and it was his passionate involvement with the cause of Greek liberty that brought about his death at Missolonghi.

The Scottish artist David Wilkie (1785–1841) liked to draw on the backs of envelopes or on scraps of paper rather than in sketchbooks, and his sketches display a magnificent and imaginative spontaneity. Wilkie tended to destroy these sketches or simply gave them away, despite their being "beyond all praise", according to the French Romantic artist Delacroix, who had visited the artist in the 1820s. Delacroix sorrowfully wrote in a letter that "like all painters, in all ages and in all countries, he regularly spoils his best work".

Sketchbooks from the Romantic period contain beautiful drawings, for the most part little known, which are a rich and rewarding source, not only of aesthetic pleasure, but also of an understanding of the underlying concerns and attitudes of the artists of that time. The Romantics recorded their responses to the natural world around them, often travelling to exotic lands for inspiration. They also drew upon their minds and senses for imaginary or visionary subjects, these too faithfully depicted in their sketchbooks, the natural place to record their quest for new experiences and sensations.

THE ROMANTIC BACKGROUND

"By endowing the commonplace with a lofty magnificence, the ordinary with a mysterious aspect, the familiar with the merit of the unfamiliar, the finite with the appearance of infinity, I am Romanticising."
NOVALIS

The Romantic movement emerged as a dominant

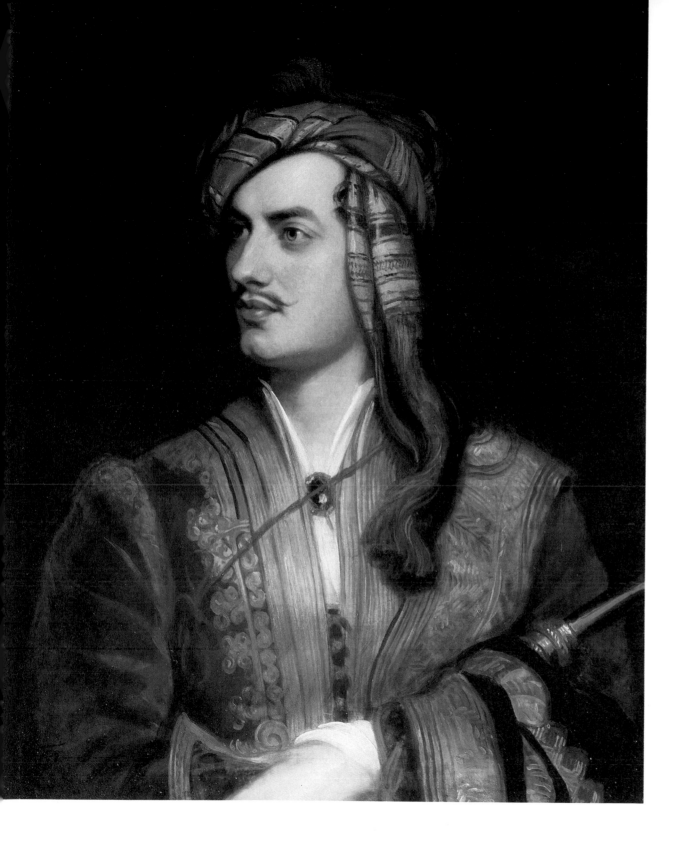

force in the development of Western art during the second half of the eighteenth century, and continued until roughly the mid-nineteenth. It was a literary and musical phenomenon as well as an artistic one, and manifested itself in the cultural life of almost every European country at one time or another, even spreading as far afield as the youthful Americas.

The universality and potency of Romanticism is remarkable. It was a product of the turbulent times during which it appeared, but as it developed it also began to affect history itself. Despite the waning of its influence in the mid-nineteenth century, artists have been inspired and affected by the achievements of their predecessors ever since. Its presence is even felt in the art of the twentieth century, in the work of painters as disparate as the Englishmen Stanley Spencer, John Nash, Graham Sutherland and John Piper, the German Expressionists or the American Abstract Expressionists, who at various times in their careers all consciously cast themselves as Neo-Romantics. Even the archetypal Modernist Matisse grudgingly recognized the influence of the archetypal Romantic, Delacroix, when he travelled to Morocco, painting scenes similar to those executed by his predecessor in the previous century.

Romanticism as a precise ideology is notoriously difficult to define in exact terms, to pin like a butterfly. Such an endeavour is made harder by the fact that the Romantics themselves were a far from homogeneous group. There were no formal groupings, as with later groups of artists, writers and composers, no published statement of belief, and no constitution. To complicate matters further, figures such as Byron and Delacroix, whom we may identify today as typical Romantics, actively denied in their own lifetimes that they were anything of the kind. Yet, even if Romanticism lacks a formal, common ideology, even if some of the Romantics, J. M. W. Turner and Caspar David Friedrich for instance, remained unaware of, and uninfluenced by, each other, it is nevertheless possible to draw together strands of belief and shared attitudes that unite

INTRODUCTION

disparate figures such as Goethe and Beethoven, Wordsworth and Novalis, Turner and Goya. Some of the Romantics were well aware of the work of their colleagues and took strength, encouragement and inspiration from it, as with Beethoven's setting of Schiller's *Ode to Joy* in the final movement of his Ninth Symphony, or the shared inspiration of the Lake poets in Britain. Others, like Palmer, unaware of their counterparts in other countries, drew from their very isolation that extraordinary individuality that now makes them so quintessentially Romantic.

Above all else, the Romantics believed passionately in the importance of the individual and the personal, and of the value of their own perceptions and experiences of the world. Indeed, the role of personal experience in the creative process was central to the Romantic consciousness; so too was the urge to heighten and enhance their perception of the world by seeking out new sensations. This desire led the English poet Coleridge and the French composer Hector Berlioz to experiment with opiates, the experiences of which were incorporated into their creative output. Supposedly it also led an elderly J. M. W. Turner to have himself lashed to the mast of a steamer for several hours during a violent storm at sea, an experience which he then documented in his famous oil painting of 1842 *Snowstorm: Steam Boat off a Harbour's Mouth* (Tate Gallery, London). Turner's claim to have been actually tied to the mast may in fact be untrue, but in the vortex-like composition of the painting, where seas and sky merge together in a terrifying, apocalyptic storm, he seeks to present the viewer with an image that is truthful to its subject. Following its exhibition at the Royal Academy, the painting was damned by critics who accused it of being unlifelike. "I wonder what they think the sea's like?" Turner is reputed to have said; "I wish they had been in it." Later he stressed: "I did not paint it to be understood, but I wished to show what such a scene was like."

The anecdotes associated with *Snowstorm* perfectly

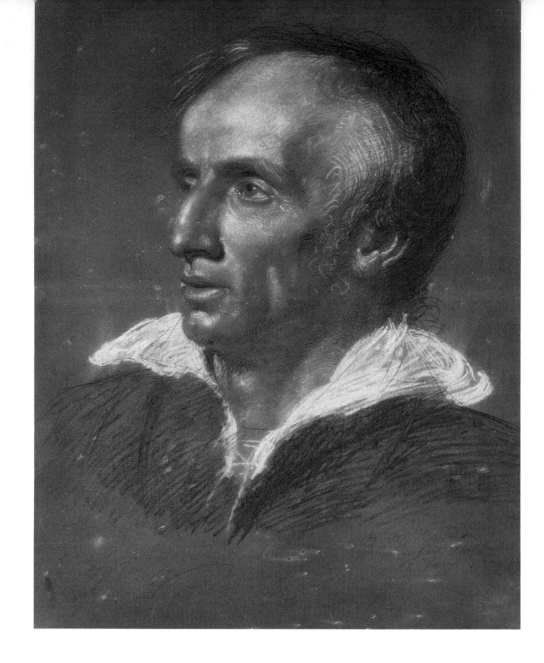

William Wordsworth (1770–1850) was to the fore of the Lake Poets. He spent much of his life at his Grasmere cottage: it was his vision of nature, particularly the Lakes' beauty that inspired much of his most successful poetic work.

sum up one side of a typical Romantic attitude — the quest to glorify sensation and to revel in the excitement and dangers that the world had to offer in order to make oneself and those who saw the resulting work more aware of being alive. Yet the Romantics enjoyed taking risks, even to the point of self-destruction. Hence perhaps the poet Shelley's reckless decision to sail his yacht under full sail in a violent storm, against

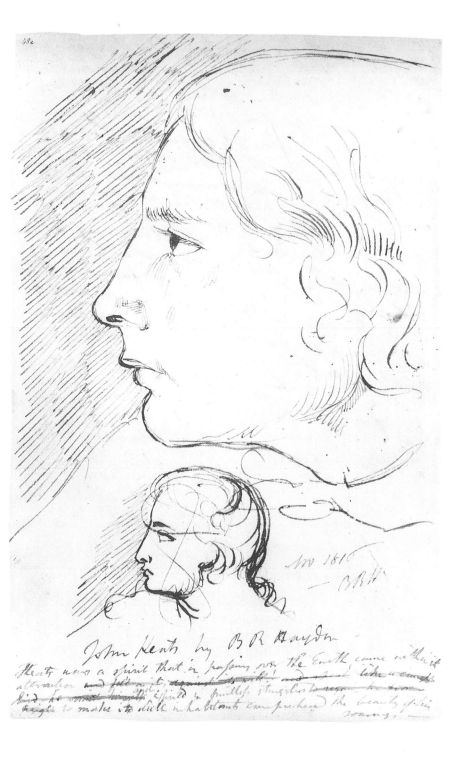

John Keats was the epitome of the ideal of the Romantic, the brilliant young poet who died tragically young from tuberculosis, who had called for "a life of sensations rather than thoughts" and written magnificent, sensuous verses. Benjamin Robert Haydon knew the poet well and considered him a rare genius. This sketch, made from life, was later inscribed by the artist: "Keats was a spirit that in passing over the earth came within its attraction, and expired in fruitless struggles to make its dull inhabitants comprehend the beauty of his soarings."

the advice of all around. The yacht was wrecked and Shelley drowned in what was quite possibly an act of suicide. No doubt a similar desire in part lay behind Byron's decision to go and fight alongside the Greeks in their War of Independence, an expedition from which he was not to return. Although he was the victim of a quack doctor rather than the battlefield, this has never prejudiced the Byronic mythology of heroic self-sacrifice.

The Romantics, then, tried to live life to the full, to experience it deeply and intensely, immediately, through the passions of the senses, and willingly risked self-destruction in the process. They despised whatever destroyed the mystery and excitement of the world, and this included many of the rational scientific explanations of life. In a letter to Benjamin Bailey in 1817 John Keats called for "a life of sensations rather than thoughts", while in Goethe's *Faust*, Mephisto condescendingly tells one of the students: "All theory, dear friend, is grey/But the golden tree of actual life springs ever green." They championed the supremacy of the experiences of the senses and the inner person, and in so doing generally rejected the clear-cut categorizations of the eighteenth-century Enlightenment, and along with it many of the theories which they believed were devised at the expense of destroying individuality and mystery. The German painter Carl Gustav Carus summed it up when he lamented: "The higher intelligence develops, the brighter the torch of science shines, the more the sphere of the miraculous and magical contracts"; his contemporary Heinrich von Kleist was more succinct — "Oh Reason, miserable Reason."

It was to escape the very reasonableness of science and the Enlightenment that many of the Romantics cultivated interests in anti-rational subjects such as mysticism, astrology or the occult. They felt these could often sum up or explain humanity's position within the universe as well as, if not better than, any rational scientific explanation. It is not a coincidence that this backlash occurred at the precise historical

moment at which European society was rapidly being transformed. Science had made great strides, explaining phenomena that had remained mysteries for centuries, and providing the knowledge that was needed to create new inventions. In England at least, these had fuelled an industrial revolution that had transformed a pastoral culture into an urban one in scarcely more than a generation. For many thinkers, what Blake described as the "dark Satanic mills" of industry functioned, like the science that had created them, as a system of repression, stifling the spiritual and mysterious for material gain.

Such a rejection of some aspects of the direction of modern society led the Romantics to cherish the imaginative and visionary potential of human beings, and fantasy often serves as the inspiration for their most perceptive work. This is especially true of artists such as William Blake, Samuel Palmer and Henry Fuseli in England, Francisco Goya in Spain and the Nazarenes in Germany. The Romantics were fascinated by psychology, often subjecting themselves to rigorous self-analysis, as well as by madness: both Goya and Géricault executed series of paintings of the mentally ill and the insane. Immersion in the excesses of sensation and concentration upon the darker sides of the human psyche could take their toll, sometimes leading to sickness, madness or even death, but it was a risk that the Romantics gladly took in the belief these experiences could lead them to a greater truth and more universal vision than any scientific explanation of the world. The great German poet and critic Friedrich Schlegel explained: "Whereas reason can only comprise each object separately, feeling can perceive all in all at one and the same time."

The Romantics were also devoted to antiquity, being fascinated by past cultures and all that was ancient and hence mysterious. This impulse was particularly strong in Germany, where the Nazarenes looked back longingly to a mythical medieval past when society was in harmony. They dreamed of the dignity of religious devotion and heroic knights, and tried to cut

With this work, *The Phoenix or the Resurrection of Freedom*, which takes the form of an allegory, Barry boldly and dangerously stands against the political repression suffered in Britain during the second half of the 18th century. The figures on the right, Algernon Sydney, Milton, Andrew Marvel, Barry and John Locke, mourn the death of freedom in Britain, while Father Time scatters flowers over the remains of ancient civilizations where the tree of liberty once grew strong. However, the phoenix of liberty has risen again in America, which had begun its fight for independence from Britain at this time. Beneath the designs Barry bemoans at the departure of the spirit of liberty from "thy more favor'd England when they grew Currupt and Worthless, thou hast given them over to chains & despondency & taken thy flight to a new people of manners simple and untainted."

themselves off from the grimmer realities of their own modern society.

The cultures of ancient Greece and Rome were a universal source of inspiration and fascination. Like the Neo-Classicists, the Romantics respected the artistic heritage of the Classical world and indeed learned from it. However, they did not hold in high regard the rigidly Classical art of the eighteenth century inspired by these cultures, and some artists, such as Blake, despised it. While deeply interested in the artistic achievements of the ancients, they did not try to emulate them and evolved a thoroughly modern style of their own. Therefore, although the Romantics in general rejected some aspects of the world — scientific theory, for instance — for the most part they revelled in their experiences of it, loving new sensations and exoticism of all kinds and even, conversely, some new inventions. Some Romantics, in fact, were positively fascinated by the realm of science. The English artist Joseph Wright of Derby, for example, took scientific experiments and new industrial processes as the subject-matter for many of his most successful and compelling paintings.

THE HISTORICAL BACKGROUND

The Romantics were witnesses to some to the most dramatic and remarkable moments of modern history, which naturally acted as a stimulus to their creativity. During their lifetimes the direction of contemporary Europe was being decided. The most influential event of the whole period was the French Revolution, which began in 1789.

For several decades there had been calls for a more egalitarian society from the populations of many European countries, spurred on further by the publication of the work of Jean-Jacques Rousseau, and in March 1791 of the highly influential book by the English writer Tom Paine, *The Rights of Man*. Paine developed Rousseau's arguments into a demand for radical political reform, leading to the abolition of the monarchy and the establishment of a Republican

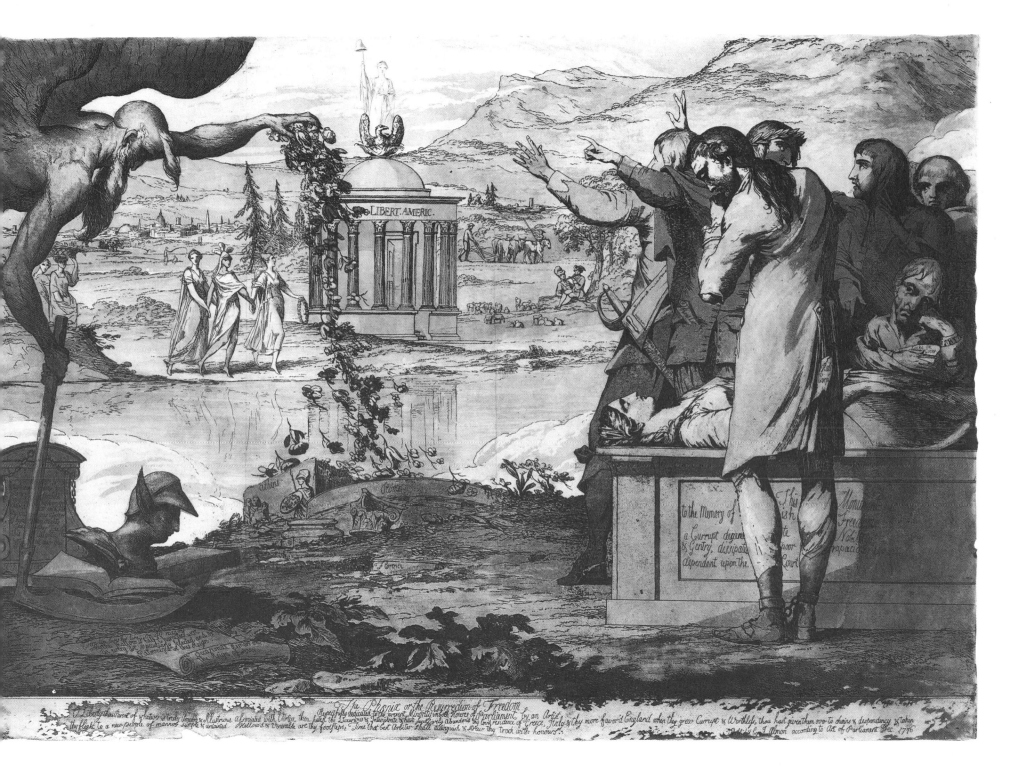

The Phœnix or the Resurrection of Freedom

state. Throughout Continental Europe, in the second half of the eighteenth century, ordinary people had no rights at all. Ruled by absolute monarchs, they had no framework for political representation or power and could be subjected to abuses of what today we would call fundamental human rights, with little or no recourse for complaint. The state structures of the *anciens régimes* of Europe were also as clumsy as they were corrupt, and were losing the ability to control their countries effectively. This led to economic crises, during which the poor were overburdened by taxation and were frequently the victims of food shortages.

The success of the American War of Independence in 1776, in which the colonists had defeated the might of the British and drawn up what was, for this period, a radically egalitarian constitution, acted as an encouragement and an example to all. It helped to concentrate popular opinion and debate upon the natural rights of the individual within a society and upon what were now seen as the responsibilities of the ruler or rulers of a country to its citizens. This marked a fundamental development in human thought. The concentration of popular consciousness upon the issue of individual rights, of equality, was in itself considered by the ruling classes to be very dangerous at this time. In this atmosphere it is easy to see how the Romantics also came to champion the supremacy of the individual and of personal experience.

Against this background, and following food shortages, economic collapse and a discontent that had festered through violent repression by successive monarchs, revolution broke out in France in 1789. The Revolution quickly took its course, with the army pledging support. The hated Bastille in Paris, the symbol of state oppression, where political prisoners were traditionally incarcerated, fell to the mob in July 1789. At first the nascent revolutionary state was governed by moderate factions, but it was eventually overtaken by extremists. This heralded the beginning of the "Terror", during which Louis XVI, in 1793, and many of the aristocracy were executed on the guillo-

Thomas Jones *The Bard*, 1774, was one of many paintings inspired by Gray's popular poem *The Bard* of 1757. The poem's subject had innate appeal to painters of the Romantic period and was also full of allusive parallels with contemporary political developments. Under Edward I the Welsh were finally subjugated to English rule, part of this repression supposedly involving the execution of the bards, the quasi-religious poets who evoked and embodied the spirit of Wales and its aspirant nationalism. Jones shows the moment at the end of Gray's poem when the last bard makes a defiant gesture and puts a curse on Edward and his armies before leaping to his death. The blood-red sunset against which Jones sets this action strengthens allusions to death and destruction and the extinction of an ancient people. The violent crushing of the bardic influence is shown in a critical light, as it is in other paintings, and it thus contains an implicit statement on the exercise of government. Radical thought in the second half of the eighteenth century considered that violent coercion and bloody repression were illegitimate uses of governmental power that were to be resisted.

tine along with many of the revolutionaries who had fallen from favour. Thousands died, and many of those abroad who had at first applauded the revolution, including many of the Romantics, now began to withdraw their support.

On the whole, the Romantics were encouraged at the outset by the ideals of the French *sans-culottes*. Wordsworth travelled to Paris shortly before the Terror began (in later years he recalled picking up a fragment of the demolished Bastille and putting it in his pocket as a souvenir). In his *Letter to the Bishop of Llandaff*, he even defended the execution of Louis XVI, writing: "The office of king is a trial to which human virtue is not equal. Pure and universal representation, by which alone liberty can be secured, cannot, I think, exist together with monarchy ... They must war with each other, till one of them is extinguished. It was so in France ..."

Mary Wollstonecraft, whose daughter, Mary Shelley, became the author of the Gothic novel *Frankenstein* and married Percy Bysshe Shelley, also stayed in Paris for a time. Eventually even she had to flee when she was threatened by dangerous political developments. In *A Vindication of the Rights of Woman*, published in 1792, she took as her premise "the simple principle, that if woman be not prepared by education to become the companion of man, she will stop the progress of knowledge, for truth must be common to all, or it will be inefficacious with respect of its influence in general practice".

Some, however, remained loyal to the revolution despite its excesses. Byron, with a certain degree of somewhat juvenile posturing, was rash enough to give vent to the opinion that he would welcome a similar terror in his own country, a genuinely dangerous view to express in the nervous, repressive atmosphere of 1790s Britain, whose ruling elite were terrified by the French Revolution, especially after France declared war in 1793.

Despite the country's nominal parliament, many of the population still called for a greater degree of

INTRODUCTION

democracy. Instead of incorporating any of these popular demands, the regime effectively panicked and tried to quell radical feeling through excessive repression. Tom Paine, his writings already banned, fled to America, and in his absence was found guilty of sedition. In December 1792 he was sentenced to death. It is thought that William Blake finally persuaded him to flee to safety.

By the turn of the century Napoleon had gained power in France, and at first he was the quintessential Romantic hero — the genius who had risen from nowhere by his championship of the ideals of the Revolution. Beethoven dedicated his *Eroica* symphony to him, but eventually tore Napoleon's name from the score after hearing that he had crowned himself Emperor. Wordsworth too was to repent bitterly his youthful admiration for the leader who had once seemed the embodiment of a new and better world. Looking back in later life, he wrote in his great autobiographical poem *The Prelude* of his initial enthusiasm:

'Twas a time when Europe was rejoiced,
France standing on top of golden hours,
And human nature seeming born again.

But Napoleon had proved himself no better than those he had swept aside. The Emperor conquered most of Europe during his reign, and was almost perpetually at war with Britain, Russia and the German states until 1815, when he was finally defeated at Waterloo and permanently exiled to the island of St Helena. It was from this time onwards, with the once great Emperor now dejected and defeated, his vision of a reformed Europe destroyed, and exiled from his homeland that Napoleon could safely become a figurehead for Romantic sympathy. An epic reversal of fate such as Napoleon's was the very stuff of Romanticism, and J.M.W. Turner used him, perhaps ironically, as the subject for his oil painting *The Exile and the Rock Limpet* (Tate Gallery, London), while the artist Benjamin Robert Haydon executed portrait after

Ludwig van Beethoven (1770–1827) came from a musical family who encouraged his talent from an early age, and his first compositions were firmly rooted in the Viennese Classical traditions of Mozart and Haydn, the latter being his tutor for a time. However, with the onset of deafness he evolved the mature style that was to make him the most dominant musical force of the 19th century, a combination of traditional forms with a style that was heavily imbued with emotion, a fusion of personal exploration and expression. Beethoven's deafness caused him great anguish, but it was also the stimulus to his achievement, a force to be overcome, as he wrote in a letter "I will seize Fate by the throat; it shall certainly not crush me completely – Oh it would be lovely to live a thousand lives". Beethoven developed the sonata to give it full emotional depth and did much to make the symphony one of the pre-eminent musical forms. Beethoven's music frequently probes the world of sensation and urges humanity on to greater triumphs and achievements.

portrait of his hero, firmly convinced that they shared the same frustrated genius.

In a post-Napoleonic Europe, terrified of any repetition of the Revolution and its bloody aftermath, the repression of democratic ideals became entrenched. In Britain Percy Bysshe Shelley's mother, Lady Shelley recorded in her diary that "the awakening of the labouring classes, after the first shocks of the French Revolution, made the upper classes tremble", while Sir Samuel Romilly recalled how he had tried to reform the criminal law during this period, but the revolution had produced "among the higher orders ... a horror of every kind of innovation".

After the end of the war in 1815 the British economy suffered badly, and after successive failed harvests the working classes began to starve. The radicals had directed their aims through the Chartist movement, which sought a revision of the rules governing the election of members of parliament. On 16 August, 1819, a peaceful Chartist rally in St Peter's Fields, Manchester, was repeatedly charged by mounted yeomanry. Men, woman and children were viciously cut down. One observer, Samuel Bamford, recorded how "In ten minutes from the commencement of the havoc, the field was an open and almost deserted space ... The yeomanry had dismounted, and some were wiping their sabres. Several mounds of human beings still remained where they had fallen, crushed down and smothered. Some of these still groaning, others with staring eyes were gasping for breath, and others would never draw breath more." This infamous incident was the subject for Shelley's verses *The Mask of Anarchy*, in which he invited the population to:

Rise like lions after slumber
In unvanquishable number,
Shake your chains to earth like dew
Which in sleep had fallen on you —
Ye are many — they are few.

Despite Shelley's clarion call, some of the Romantics — Wordsworth for instance — developed a somewhat

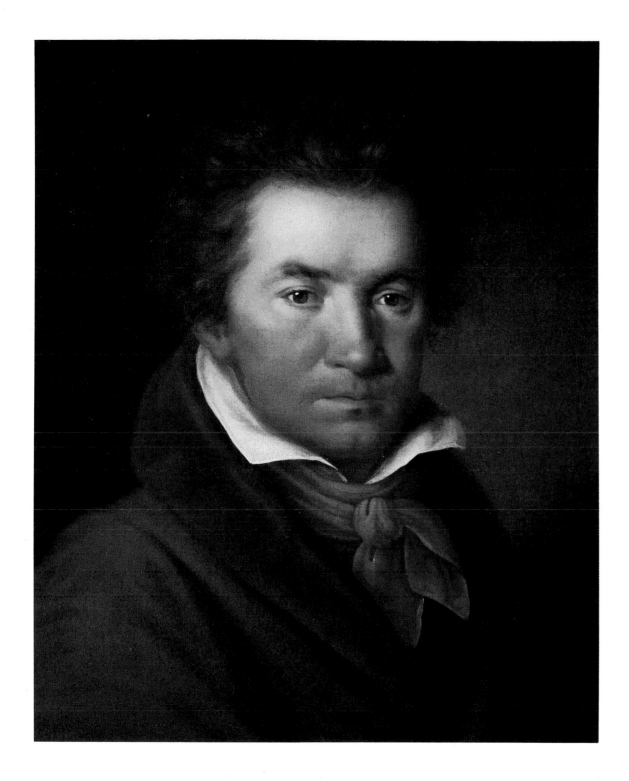

ambivalent attitude towards politics and political involvement. At first stimulated and inspired, they had seen their initial faith both in the French Revolution and in Napoleon eroded, the former because of its spiral downwards into excess and factional fighting, and the latter because, despite dethroning many of the despots of Europe, he became no better than them.

Nevertheless, in the repressive atmosphere following the defeat of Napoleon, all over Europe the ideal of freedom remained a potent one and was both encouraged and tempered by political events. The struggle against Napoleon in Germany, the so-called *Freiheitskrieg* or War of Liberation, gave birth to both strident nationalism and a liberal movement which centred upon the demand for democratic reform. In 1814 the painter Caspar David Friedrich wrote in a letter of his desire to construct a monument to Scharnhorst, a German general who had died of a wound received at Grossgörschen. "So long as we remain the menials of princes", he wrote, "nothing great of this kind will be seen. Where the people have no voice, the people will not be allowed to be conscious of and honour themselves." Here Friedrich is quite clearly linking the ideals of liberty with the freedom of artistic expression. The artist's vision was not to be accomplished, however, for after 1815 the liberal movement was repressed, although demands for democracy could not be entirely stifled.

In France many of the Romantics found themselves forced into opposition to the monarchy, despite having originally favoured its restoration. The regime of Charles X was particularly corrupt and repressive, and the libertarian ideals of the Revolution were completely cast aside. The freedom of the press was suppressed and the electorate was reduced to include only the landed classes. Romantic painters, especially Delacroix, found themselves in the position of carrying the torch of liberty in a state that treated them with deep suspicion. "As if anything was not political at present," August Jal wrote in his book on the state-sponsored Salon of 1827, "Romanticism in painting is political; it

is the echo of the cannon shot of 1789." Delacroix's overtly political painting *The 28th July: Liberty Leading the People* (Louvre, Paris) commemorates the 1830 revolution in Paris which brought Louis-Philippe to the throne of the "July Monarchy", a regime which finally put the upper-middle classes in the position of power they had sought since 1789. The initial aims of the revolution had been far more radical, seeking to put the working classes in a position of preeminence, but this was never to be so.

The Romantics were stimulated also by the struggles for democracy in Italy and Poland, but it was the Greek War of Independence, which had started in earnest in 1821, that drew their greatest support and which fired their belief in liberty the most. The heroic struggle of the population against overwhelming Turkish domination deeply inspired them. Ancient Greece had been the birthplace of democratic ideals which gave recognition to the political rights of the individual, and this made the modern struggle all the more compelling. It even, as we have seen, led Byron to join the fighting, commanding a large number of Greek troops. In the third canto of *Don Juan* he had written of his dream "that Greece might still be free", and it was an ideal for which he was to die.

Charity concerts and exhibitions were held in Paris, and Delacroix showed his *Greece on the Ruins of Missolonghi* (Musée des Beaux-Arts, Bordeaux) at the salon of 1826. The painting shows a Greek woman, the symbolic embodiment of her country, standing among ruins, her arms open wide in a gesture which appeals for help, symbolizing the triumph of the spirit of liberty over disaster.

In post-Napoleonic Europe, then, art had become overtly politicized. The Romantics found their desire for personal freedom of expression mirrored and encouraged by the political ideals of liberty and the struggles for democracy. Freedom of expression had itself become politicized, and politics and Romanticism became inextricably bound together. Indeed, the validity of Romanticism as an artistic movement was

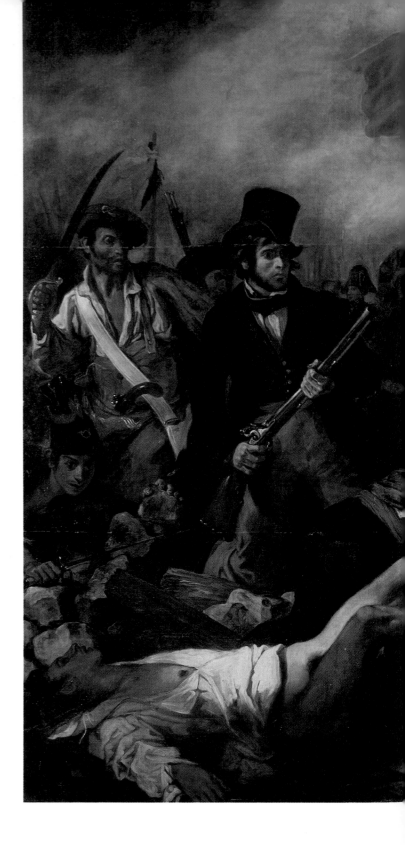

Delacroix's almost totemic representation of revolution, *The 28th July: Liberty leading the People*, 1830, commemorates the uprising in Paris which overthrew the last Bourbon monarch, Charles X, and placed his cousin Louis-Philippe, the "citizen king", on the throne of France. Under Louis-Philippe the French *haute bourgeoisie* attained political power, and business initially prospered, but at the expense of the working class. With an economic slump in the 1840s, republicans, liberals and socialists united against the corrupt regime and, despite promises of reform, in February 1848 the people of Paris rose again and a republic was proclaimed. Louis-Philippe was forced to abdicate, and fled to Britain under the pseudonym Mr Smith.

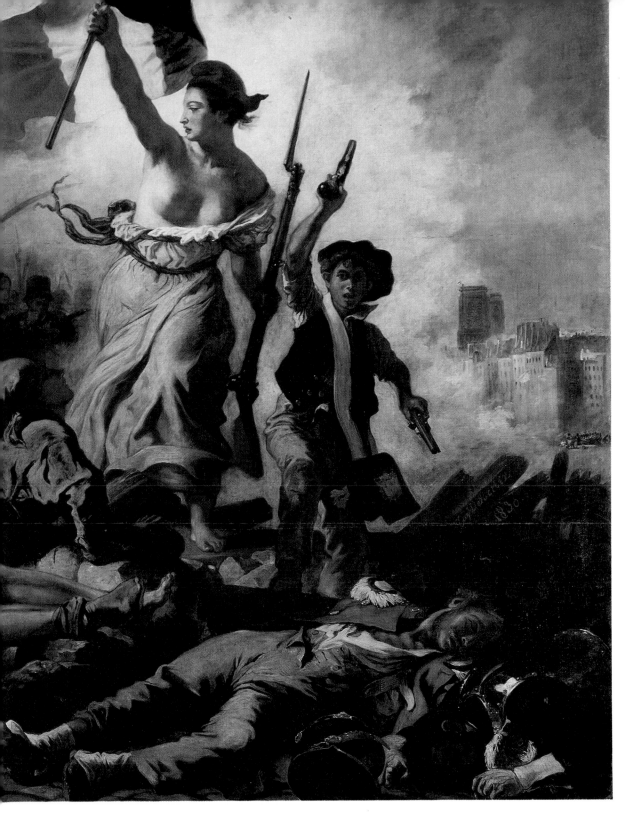

indissolubly linked to the political fate of the pan-European demand for liberty.

LITERATURE

The epic events of European history during the 100 years between 1750 and 1850 formed the backdrop to an equally remarkable period of innovation in all areas of cultural production, in literature, music and art. This period saw the development of some of the most original writers of modern times. In Germany this was the age of Johann Wolfgang von Goethe, the poet Novalis (the pseudonym of Baron Friedrich von Hardenberg), the critic Friedrich Schlegel, and E.T.A. Hoffmann, author of the influential stories on which Offenbach's opera *Tales of Hoffmann* is based. France saw the rise to preeminence of Baudelaire and of Victor Hugo, the poet also well-known for his novel *Notre Dame de Paris*.

In Britain the Romantic poets remain as some of the most important and enduring of all literary figures. The work of Byron, Shelley, Keats, Wordsworth and Coleridge was considered avant-garde in its time and elicited from society strong responses of both favour and disapproval, for they did not respect the conventions or traditional values of society. Lady Caroline Lamb's comment that Byron was "mad, bad and dangerous to know" was no doubt a somewhat one-sided exaggeration, but it is nevertheless a viewpoint with which many in Regency England would have eagerly concurred. They all led unconventional lives — Byron had shared his room at university with a bear, and immersed himself in sexual conquest; Shelley disowned his aristocratic background and encouraged his best friend into an affair with his wife to form a curious triangle; Wordsworth isolated himself in his cottage in his beloved Lake District with his sister, while Coleridge undertook a voyage of self-discovery through the agency of opium. The brilliance of John Keats had been extinguished by tuberculosis at a pitifully young age.

More outwardly conventional literary figures,

although their work was equally innovative, were the novelists Sir Walter Scott, who was nevertheless an opium addict himself, and Jane Austen. The Gothic was a sub-genre of Romantic literature, representing the fascination of the Romantic consciousness with all things strange, macabre and perverse. Classic Gothic novels include Mary Shelley's *Frankenstein*, M.G. Lewis' *The Monk*, Horace Walpole's *Castle of Otranto* and the eccentric and ostracized William Beckford's *Vathek*. Edgar Allan Poe carried on the conventions of these novels in his own work in the United States.

MUSIC

In music this was the age of Beethoven, described by Delacroix as "the man of our time ... romantic to the supreme degree", who compounded the direction of German music away from the stilted classicism of the eighteenth century. It was also the age of Robert Schumann and Carl Maria von Weber, and towards the end of the Romantic period Richard Wagner, who turned to ancient German mythology as the inspiration and subject for his music. The Romantic movement in music also embraced the work of Chopin and Felix Mendelssohn, while being scarcely able to contain the extravagances of Franz Liszt and Hector Berlioz.

ROMANTIC PAINTINGS

In art Romanticism was a truly pan-European phenomenon, for there were artists in each country who produced some of the key works of the movement, influencing an entire generation and remaining among the most powerful images from the nineteenth century.

The most important and innovative Romantic artists in Britain were J.M.W. Turner (1775–1851), John Constable (1776–1837) and William Blake (1757–1827). Blake devoted himself to depicting the internal world of vision and imagination and obscure allegorical works. His fellow artist Henry Fuseli (1741–1825) in his introduction to Robert Blair's poem *The Grave*,

Franz Schubert (1797–1828) is today recognized as a major composer of the Romantic epoch, but during his own lifetime he achieved only partial recognition and success. His music, especially his *Lieder*, is imbued with poetic and lyrical spontaneity, and poetry exercised a great inspiration for him; he admired the works of Goethe, whose poems he set to music many times. Schubert's output was prodigious and he composed in almost all forms, including operas, symphonies, sonatas and songs, the last of which number more than 500. The artist, Leopold Kupelwieser was a friend, and here he shows the composer seated at the piano during a game of charades when they were both house guests at Atzenbrugg.

illustrated by Blake, admirably described Blake as seeking "to connect the visible and invisible world, to lead the eye from the milder light of time to the radiance of eternity."

While Blake devoted himself to the visionary and spiritual, Turner's and Constable's entirely original work transformed nineteenth-century landscape painting, depicting the actual world as the artists interpreted it and producing enduring Romantic images. Their visions of the British landscape were, however, very different. This divergence of interpretation was highlighted when Constable, looking at one of Turner's paintings on display at the Royal Academy turned to the artist and told him "I do not see nature that way". "Ah," replied Turner, "do you not wish that you could?" Apart from giving us a good indication of Turner's often egotistical character, this anecdote also clearly points out the Romantics' cherished belief in the validity of personal vision and interpretation.

Turner's oil painting *The Shipwreck* of 1805 (Tate Gallery, London) depicts a moment of danger and high drama when, in perilous seas, small boats attempt to rescue the passengers and crew of a large sailing ship that has been wrecked during a storm reminiscent of the Biblical deluge. This painting is one of the clearest representations of the Romantics' awe of the destructive power of the elements, and humanity's struggle for survival within an often forbidding world. It was a theme to which Turner returned again and again, feeding his often pessimistic view of the world. *The Shipwreck*, along with other well known works by the artist such as *Snow Storm: Hannibal and his Army crossing the Alps* (Tate Gallery, London), showing the barbarian leader and his army distracted from rape and pillage by an apocalyptic storm in the Alps that momentarily blots out the sun; *Avalanche in the Grisons* (Tate Gallery, London) which takes as its subject the moment of imminent destruction of a small house in the Alps by an avalanche which completely dwarfs it with its immensity; and *Snow Storm: Steam Boat off a Harbour's Mouth*, depicting a

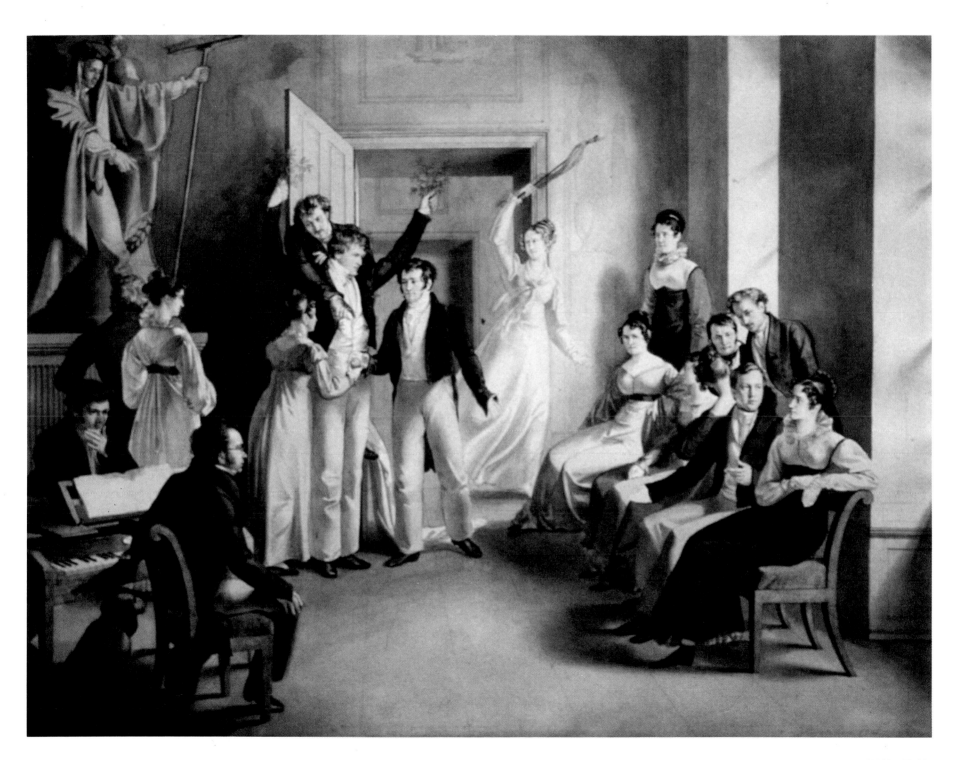

ship in difficulties in a swirling storm at sea, demonstrated the great potential of Romantic landscape painting.

Constable's equally distinctive approach to landscape was very different, but in its celebration of pastoral England and nature in all her forms often followed similar themes to Turner's work. Constable's *The Hay Wain* (National Gallery, London) was generally reviled when it was first exhibited at the Royal Academy in 1821. Although considered today to be a traditional depiction of rustic society painted in a conventional manner, in its own day it was viewed as intensely avant-garde both for its subject-matter and the manner of its execution. Constable was convinced of the value of working outdoors, both in watercolours and oil, in order to soak up the spirit of the place he was painting. He was also committed to presenting the landscape in a naturalistic form untainted by epic, ennobling distortions, or improvements. While reactions to *The Hay Wain* in England were on the whole unfavourable, it was greeted with approbation by the French Romantic artists when it was shown at the 1824 Paris Salon, where it won a gold medal. Delacroix was so impressed by it, particularly by the artist's use of broken areas of colour, that when he travelled to England in the following year he visited Constable in his studio to express his admiration.

Théodore Géricault (1791–1824) was also particularly impressed by *The Hay Wain*; he had first seen it in London in 1821 when, by a quirk of history, he was touring with his own magnificent painting *The Raft of the Medusa* (Louvre, Paris). This painting is another touchstone of Romantic art. Géricault had deliberately set out to paint a subject that would strike at the heart of the corruption and inadequacies of the society of the restored monarchy, and so he was disappointed when it was greeted neither with particular approval or disapproval by the French government, the major commissioner and purchaser of contemporary art, in what was probably a carefully considered reaction. Géricault had sought an extreme response, either

In a self-conscious attempt to fulfil his stated ambition as a painter "to shine, to illuminate, to astonish the world", Géricault chose as his subject for *The Raft of the Medusa*, 1819, a scandal that had struck at the heart of the corruption and cruelty of French society under the restoration. The *Medusa* had run aground off West Africa in July 1816 because of the incompetence of its captain. As there were not enough lifeboats, 149 people had to take to a makeshift raft, which was first towed by the lifeboats but then abandoned. With few provisions, the incumbents fought each other and turned to cannibalism. Fifteen days later, when the raft was found, only 15 people were left. When two of the survivors tried to sue for compensation they were dismissed from government service.

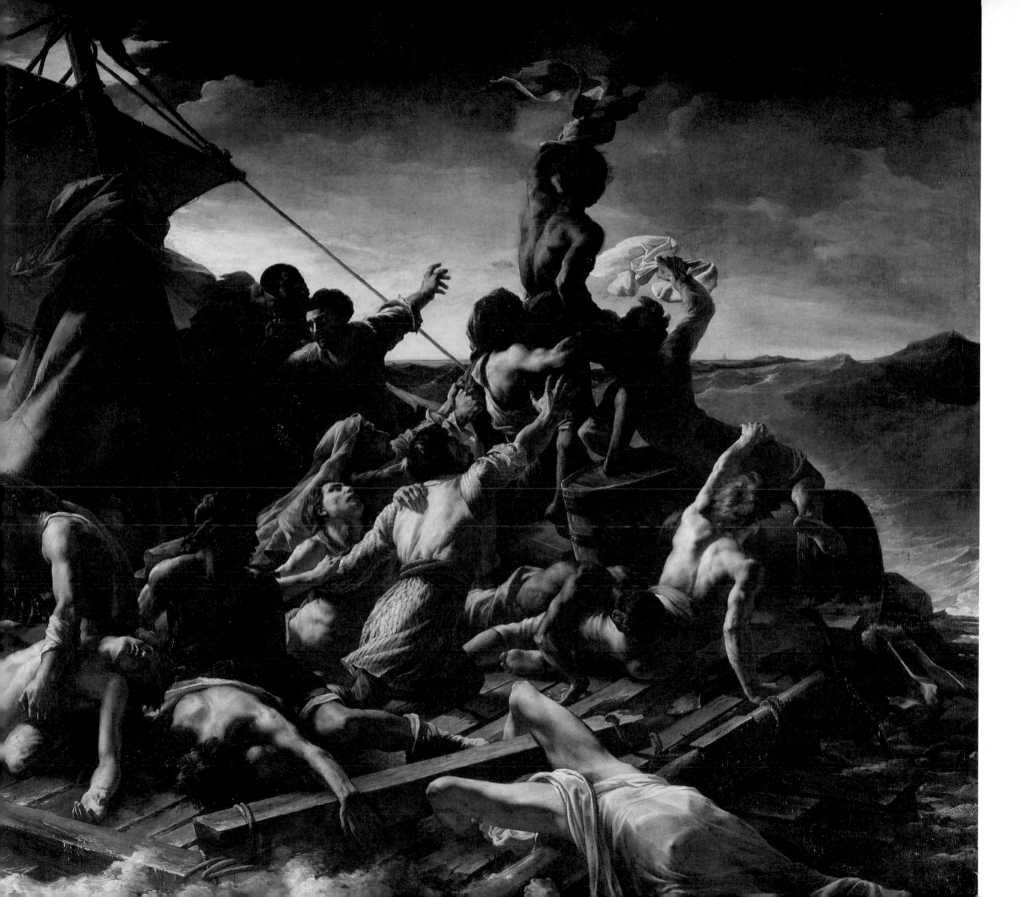

outright revulsion or passionate praise, not indifference. From this moment he sank into deep disillusionment, for his stated aim had always been "to shine, to illuminate, to astonish the world".

Géricault's chosen subject was a political scandal involving a transport ship that had been wrecked three years earlier, thanks to the incompetence of a captain who had obtained his officially sanctioned position through Royalist corruption and preferment. While taking settlers and soldiers to Senegal the *Medusa* had run aground and, as there were not enough lifeboats for all the passengers and crew, a raft was constructed for the remaining 150 people. After being towed for only two leagues by the lifeboats the raft was cruelly cut adrift, and those on it left to their fate. Fifteen days of horror followed, during which time the raft was buffeted by storms and, without provisions, those on it fought with each other and turned to cannibalism. When they were finally rescued, only 15 of the original complement had survived, and many of these died soon after. Géricault chose carefully the moment he was to depict from this ordeal, rejecting the more obvious scenes of mutiny, cannibalism or salvation in favour of the most bitter episode of all — that when those on the raft glimpsed on the horizon the *Argus*, one of the ships from the convoy that was searching for them. Although they signalled, the ship was too far away to see them, and the artist shows the moment when they realize that their hope of salvation is entirely false, and their feelings turn to despair.

Another great French Romantic artist, Eugène Delacroix (1798–1863), posed for Géricault as one of the figures on the raft, and when he saw the finished painting it had a profound effect upon him. "The impression it gave me was so strong," Delacroix recorded, "that as I left the studio I broke into a run, and kept running like a madman all the way back to the rue de la Planche where I then lived." Despite the capacity to elicit such extreme reactions from those who understood the significance of his work, Géricault regarded *The Raft of the Medusa* as a failure, and

In *Third of May*, 1814, Goya marks the vicious reprisals on Madrid's citizens when, after riots in which some French soldiers were killed, the occupying Bonapartist army summarily executed hundreds of civilians. While Goya is concerned with the specifics of recent history in this and other works relating to the occupation, he also investigates the futility of war and his cynicism towards successive regimes. Despite their reformist ideology the French were just as repressive as the Spanish monarchy.

never again undertook a major work or exhibited at the salon. He nevertheless continued to produce fine, incisive work, including a series of 10 realistic portraits of inmates of the Salpêtrière Asylum in Paris which were inspired by his friend Georget, an advocate of humane treatment of the insane. However, the popularly prevalent idea that underlay them, that certain types of physiognomy relate to particular kinds of madness, is now known to be incorrect. Quite possibly the portraits were intended to serve as illustrations for a treatise by Georget.

Through his paintings of death and destruction, of revolution and Eastern exoticism, Delacroix became the driving force behind French Romantic art, the natural heir to Géricault. Géricault had himself inherited the mantle of Baron Antoine Jean Gros (1771–1835), a pupil of David. As official painter to

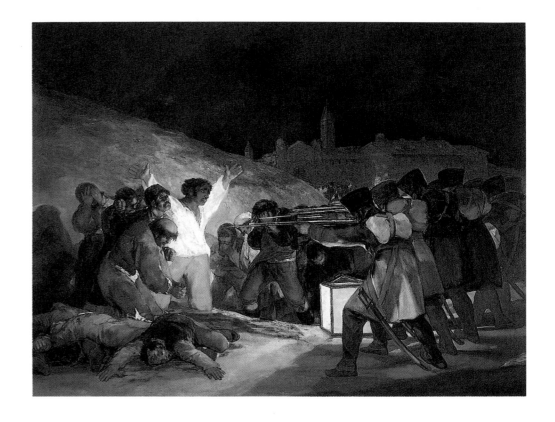

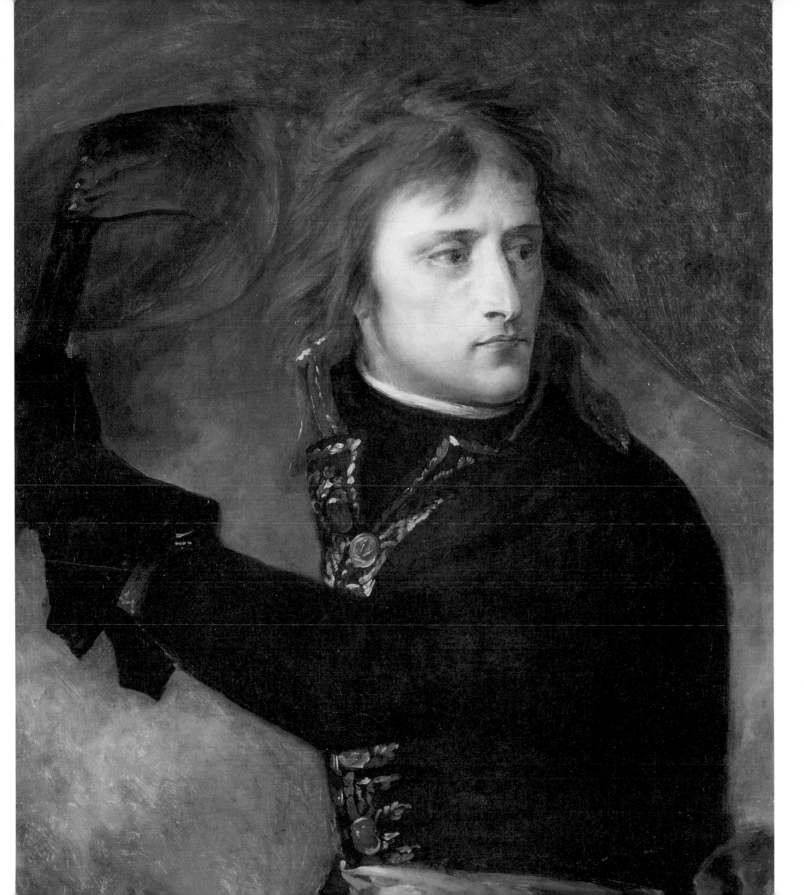

In this painting, *Napoleon at Arcole*, 1798, Gros commemorates Napoleon's victory over the Austrians at Arcole during his Italian campaign, while in the service of the Directory. Such audacious battlefield successes made him a national hero, and in the *coup d'état* of 1789 Napoleon became First Consul. By 1804 he was able to crown himself Emperor and had made France the greatest single power in Europe. Through his paintings Gros glorified Napoleon and his achievements, a process in which the artist's friend and tutor David was also involved.

INTRODUCTION

Napoleon, Gros executed battle-pieces full of movement and colour, alongside sympathetic portrayals of the Emperor such as *Napoleon visiting the Plague-stricken at Jaffa* (Louvre, Paris) and *Napoleon on the Battlefield at Erlau* (Palais de Versailles). All were composed on a massive, epic scale, the dead bodies in the foreground of *Erlau*, for example, being twice life-size.

Delacroix seems to have disliked being categorized as a Romantic, apparently replying angrily "I am a complete Classicist", to someone who suggested he was "the Victor Hugo of art". Yet despite his protestations, Delacroix painted some of the most archetypal Romantic images of French art, with their often broadly handled style and reliance upon colour. *The 28th of July: Liberty Leading the People* (Louvre, Paris), perhaps his best-known painting, is a celebration of the 1830 revolution and shows the mythical embodiment of the French revolutionary spirit, with a tricolour in one hand and a musket in the other, leading the middle and working classes into combat. "I have undertaken a modern subject, a barricade," Delacroix told his brother, who was a general, "and if I have not conquered for my country, at least I will paint for her." Despite being purchased by the French government the painting was considered to be too inflammatory for public display, and was not put on permanent view until 1861.

Delacroix had previously painted another overtly political work on the subject of Greek liberation. *The Massacre of Chios* (Louvre, Paris), of 1824, caused a furore when it was first exhibited, and depicts another contemporary event when, during the Greek War of Independence, the Turks massacred the Christian inhabitants of the island of Chios. Delacroix's desolate vision offers no relief; death is inevitable and there is no escape. Those victims who are not already being attacked are shown sitting with expressions of grim resignation upon their faces, calmly waiting for their fate to overcome them. *The Massacre of Chios* is an eternity away from the Neo-Classical image celebrat-

In *The Plum-pudding*, James Gillray caricatures the carving up of the globe by Britain and France. A print maker of great ability and vision, Gillray was supremely gifted in the design of caricatures that provided humour and savage political commentary. The French and the Whigs were his favourite victims, and although by no means always partisan, he received an annual pension from the Tory party. By the 1790s his career, now firmly established, was further strengthened by his partnership with the print publisher Mrs Humphrey. Caricature prints during this period were eagerly received by the population as an accepted and significant part of popular political debate.

ing the nobility of the human spirit, opting instead for a more realistic account of the evil of which humans are so easily capable. Baudelaire described it as a "terrifying hymn in honour of doom and irremediable suffering".

In Germany the leading Romantic artist of the period was undoubtedly the reclusive Caspar David Friedrich (1774–1840), who asserted that "every true work of art must express a distinct feeling". He produced highly individual masterpieces of great intensity of vision and inspired a number of disciples. His friend and fellow-artist Carl Gustav Carus described how Friedrich would stand before his bare canvas until what he was about to paint "stood lifelike before his soul"; Carus advised him to "close your bodily eye, so that you may see your picture first with your spiritual eye. Then bring to the light of day that which you have seen in the darkness so that it may react upon others from the outside inwards".

Friedrich's paintings, such as *Monk by the Sea* and *Abbey in the Oakwood* of 1809 (Schloss Charlottenberg, Berlin), which were exhibited as a pair, are often ruminations upon death and transformation and the transient nature of life on earth. *Monk by the Sea*, composed of a stark strip of seashore and sky with the solitary monk standing between them, exudes a remarkable power, suggesting an unremitting existential loneliness. Heinrich von Kleist wrote that "because of its monotony and boundlessness, with nothing but the frame as a foreground, one feels as if one's eyelids had been cut away". The pendant to this picture, *Abbey in the Oakwood*, shows the funeral of the same monk, now liberated forever from the barrenness of temporal life. Friedrich's outlook can frequently be a bleak one, dwelling upon the often troubled lives we lead, but it is ultimately optimistic, for the artist believes in and looks forward to a spiritual salvation. His landscapes, laden with personal symbolism are at the same time evocatively beautiful and mysterious, and are imbued with a feeling of yearning spirituality combined with an intense

The Plumb-pudding in danger — or — State Epicures taking un Petit Souper.
"the great Globe itself and all which it inherit" is too small to satisfy such insatiable appetites.
vide Mr. W—d—s eccentricities my Political Regis

melancholy that is immensely moving and powerful.

Another artist who was predominantly concerned with the human spirit was the Spaniard Francisco Goya (1746–1828). Goya led a troubled life, uneasy in his contradictory position as official court painter to the Spanish royal family and advocate of social and political reform. Royal portrait commissions coexist in his output beside more private nightmarish visions of hideous beasts and spirits, frequently threatening, in which the artist's imagination has been allowed to flow freely. Goya summed up these fantastical works as a need "to make observations for which commissioned works generally give no room, and in which fantasy and invention have no limit". He produced some of his most disturbing work as a result of the excesses his country suffered following the invasion by Napoleon's conquering armies, notably the series of etchings entitled *The Disasters of War*, which horrifyingly depict the atrocities committed by the French.

Another work which derived from this period was Goya's famous masterpiece of 1814 *The Third of May* (Prado, Madrid), intended, he wrote at the time, "to perpetuate with his brush the most notable and heroic actions or events of our glorious revolution against the tyrant of Europe". It commemorates the vicious reprisals by the French following a riot in the Puerto del Sol area of Madrid in 1808 in which some of the French soldiers were killed. During the night hundreds of civilians were summarily executed, and in *The Third of May* Goya shows a group of Spaniards at the moment of execution at close range by a firing squad of French troops. One of those being executed throws his arms wide in a gesture that helplessly asks "Why?" In this and other works relating to the French occupation, Goya is concerned with both the specific events of recent history and also with the realization that they are derived from a universal phenomenon, which is that when placed in a position of absolute power over his fellow humans, man is easily capable of sadistic violence and evil towards them.

In old age and deafness Goya retreated even more

Friedrich firmly believed that "art is not and should not be merely a skill. It should actually be completely and utterly the language of our feelings, our frame of mind; indeed, even of our devotion and our prayers." Paintings such as *Abbey in the Oakwood*, 1809, are laden with symbolism relating to the spiritual journey that Friedrich believed each human must make before ultimate salvation can be reached. Here the bleakness of the twisted trees and ruined abbey, in Friedrich's vocabulary of symbols referring to outmoded religious worship, is alleviated by the shining candle which represents the human spirit. The dead monk has escaped the barren temporal world and through death has achieved salvation.

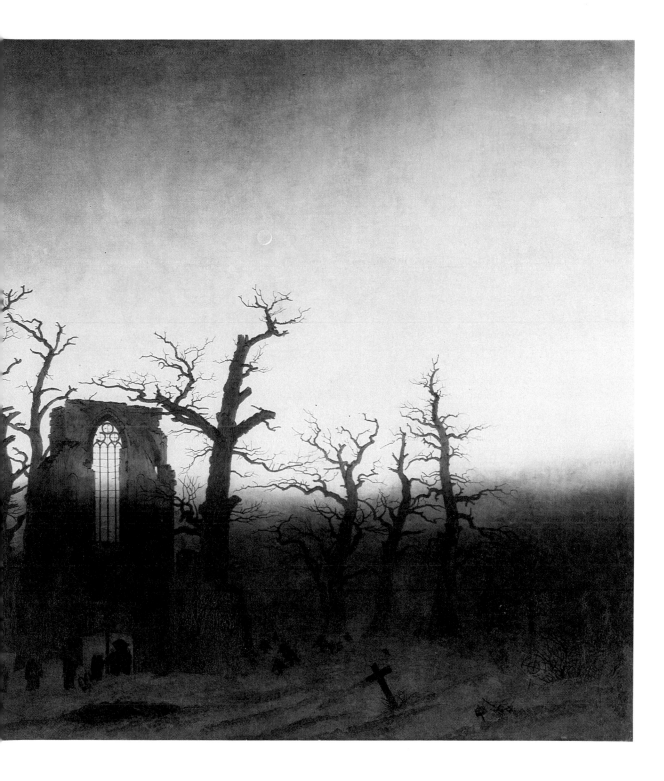

into himself, retiring to a country house outside Madrid known as Quinto del Sordo — "house of the deaf man". Here he decorated his rooms with hideous and disturbing visions, executed in sombre colours, the so-called "Black Paintings". These include *Saturn devouring one of his Children* of c.1820–3 (Prado, Madrid) which must be one of the most horrifying images of the Romantic period.

ROMANTIC SKETCHBOOKS

It was in their sketchbooks that Goya, Friedrich, Delacroix, Géricault, Constable, Turner and Blake, in common with most of their Romantic colleagues, recorded the genesis or inspiration for exhibited pictures, although their sketchbooks contain much else besides. Artists who were happy that the public should flock to see their exhibition pieces could be highly protective of their working drawings and sketchbooks, treating them very much as private. The post-Impressionist artist Paul Gauguin described the visit of a critic to his studio: "A critic at my house sees some paintings. Greatly perturbed, he asks for my drawings. My drawings? Never! They are my letters, my secrets, — the public man, the private man." This kind of reticence is entirely understandable; even the choice of a particular subject can be in itself a revelation of the workings of the artist's mind. Fuseli's sketches often reveal a tortured spirit that was probably very different from his public persona, and from such sketches one can form a coherent idea of the psychology of the artist, a glimpse of the often darker side of the soul.

Sketches are invariably more personal and revealing, more immediate, whereas finished, exhibited works are often made only to fit in with established tastes and genres that have little to do with the artist's psyche. The approach to a subject and the manner in which it is executed can be equally revealing, often displaying a way of working which an artist would never use for an exhibition piece. It is also possible to see how work developed from an initial idea and

INTRODUCTION

sketch, through more extensive and detailed sketches and studies to the finished work. Constable's water-colour *Stonehenge* of 1836 (Victoria and Albert Museum, London) was preceded by several works, the first of which was a sketch the artist had made in his sketchbook years before.

The variety of subjects found in artists' sketchbooks is enormous; such drawings as Samuel Palmer's imaginary visions of landscape or mythical figures are impossible to categorize. Firm categorizations of subjects can be wholly artificial, but sketchbook sheets can be brought together in groupings of subjects that cover exercises, the academic and the figure; travel and tours; studies of nature; and fantasy and the imagination.

Artists used their sketchbooks to work out and resolve compositions, to experiment with line and form and resolve areas of relative light and shade before transferring a design onto a larger scale and often into a different medium. Sometimes in the consecutive pages of a sketchbook one can witness an artist drawing and redrawing the same composition over and over again, altering here, improving there, recording over the pages the evolution of the final design. It is also an interesting exercise to note the great differences that may exist between the initial sketchbook drawing and the final work that is pro-duced from it. Landscape artists frequently place picturesque motifs into their finished works, such as a staffage of rustics, or animals, or gently bending trees that were entirely absent when they sketched the original scene on the spot in their sketchbook.

Sketchbooks also served as the artist's library, a record of everything felt or seen, and the books were used as an invaluable source of subject-matter when artists came to select a subject or composition for a finished work. J.M.W. Turner carefully labelled all his sketchbooks to give details of the subject matter they contained, "Shipping" for instance, or "Venice to Ancona". They formed a source to which he could return again and again, just as Constable returned to

In the summer of 1816 Turner toured the north of England on horseback. The weather was foul, for it rained constantly, but Turner managed to fill several sketchbooks with observations. High Force is one of the most spectacular waterfalls in the north and Turner made several drawings of it in his *Yorkshire V* sketchbook; on this sheet he includes himself, sitting on a rock sketching. One anecdote relates that Turner stayed there sketching until dark, and becoming hopelessly lost trying to find his way back home.

his sketch of Stonehenge for inspiration, several years after he had executed the drawing. In his *Moroccan* sketchbooks (Louvre, Paris) Delacroix made careful, almost pedantic notes and sketches which recorded every aspect of Moroccan life — people, customs, architecture, landscape, vegetation — to which he could later refer when executing watercolours such as *Seated Arab* (Louvre, Paris) or oil paintings such as *Algerian Women in their Apartment* (Louvre, Paris). There is also a real sense in this sketchbook that Delacroix was relying on it not just for the details of architecture and dress that he could incorporate into his more developed compositions, but also in order to evoke or invoke in himself the spirit or essence of this exotic land.

As precise records of contemporary life, sketchbooks can also be useful historical documents from the pre-photographic age. Artists such as Delacroix in his Moroccan sketchbooks, or Turner in his *Swiss Figures* and *Scotch Figures* sketchbooks (Tate Gallery, Lon-don), make invaluably precise records of the dress and

working activities of the native inhabitants, and it is of immense value to have sketched drawings of buildings and landscapes showing how they looked 200 years ago. A few places have barely changed. The Stonehenge and Salisbury Plain of Constable's 1820 sketch and subsequent watercolours are almost exactly the same today; but the quaint home in his watercolour from the 1821 sketchbook *A Cottage near Reading* (British Museum, London) was long ago engulfed and overcome by the developing sprawl of the town. Quite often, drawings in artists' sketchbooks are the only surviving record of a particular building or location and as such, aesthetic considerations aside, they are historically of immense value.

Sometimes sketches depict a unique historical mo-

An unfinished sheet in Turner's *Hereford Court* sketchbook, from his 1798 tour of Wales, demonstrates his method of working at this time; a detailed pencil drawing of Chepstow Castle was made, and then successive watercolour washes were added. The artist made several visits to North Wales, sketching the picturesque castles and dramatic mountains which were an inspiration for several oil and watercolour exhibition pieces.

ment, such as the quick, brief drawings Jacques Louis David made in his notebook during the momentous Oath of the Jeu de Paume which marked the beginning of the French Revolution. Likewise, Turner made detailed drawings in his *Nelson* sketchbook of the return to England of the *Victory* after the Battle of Trafalgar. He went on board and recorded the battered ship, interviewed members of her crew and noted down details of their uniforms.

REYNOLDS AND ACADEMIC THEORY

In addition to their function in planning the compositions of future work, sketchbooks were also used for the academic exercises that all artists were obliged to make while undertaking their training. During their

youth artists would attend academies where they would be subjected to a rigorous regime of education. They would attend lectures on the theoretical side of art, learning perspective, composition and colour theories, and they would also attend practical classes. The emphasis of this education was upon drawing, and it had to be mastered thoroughly by the artist before any lessons in painting were permitted. This method of teaching is still followed today. In Britain the most important and prestigious place for study was the Royal Academy schools, and there were similar institutions in the capitals of most European countries.

During the late eighteenth and early nineteenth centuries, art was dominated by strict academic views, both on what was a fitting subject for art and how it should be drawn or painted. Joshua Reynolds (1723–92), the first President of the Royal Academy, expounded upon the hierarchies of art in his *Discourses*, delivered at the Academy between 1769 and 1790. Historical subjects were considered to be preeminent, ideally incidents drawn from the literature and history of the Classical world or the Bible, although the depiction of more modern historical events was also viewed favourably. Benjamin West's *The Death of General Wolfe* of 1770 (National Gallery of Canada, Ottawa) was one such painting. It was important, however, that all historical paintings should lend their subjects an epic, noble and morally instructive quality. Portraiture and genre scenes were ranked below this, and landscapes and seascapes were placed last.

Reynolds firmly believed that art should be devoted to the portrayal and encouragement of the nobility of the human spirit, and that this should be communicated through the depiction of pure beauty. "If you mean to preserve the most perfect beauty in its most perfect state, you cannot express the passions, all of which produce deformity, more or less, in the most beautiful faces", Reynolds told the Royal Academy in his Fifth Discourse. Clearly this was a philosophy which the Romantics would have no intention of following. Even if they were taught this, a central

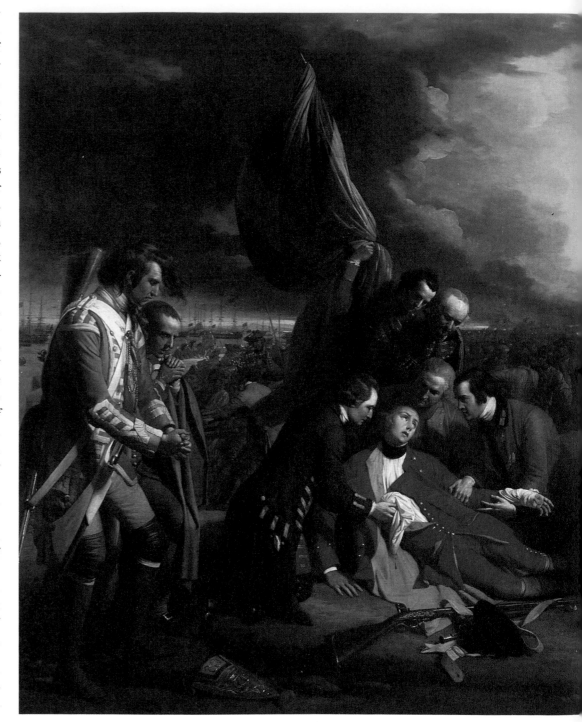

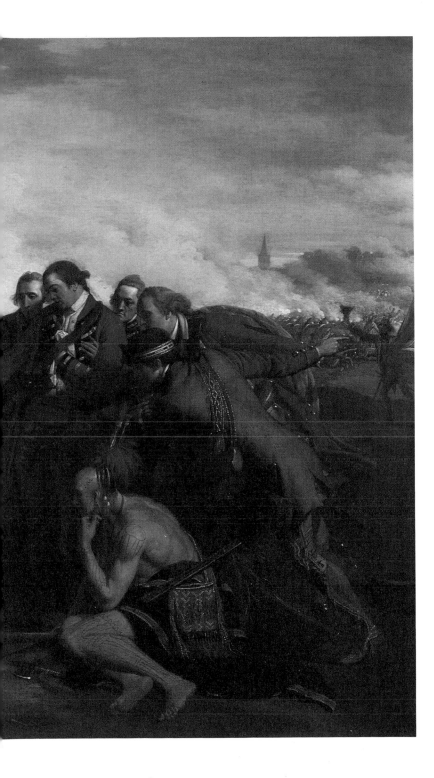

Although scenes from classical history or literature were considered pre-eminent choices for history paintings, subjects drawn from more recent history were looked upon with increasing favour during the second half of the 18th century, as long as they presented the scene in a morally uplifting manner. Bengamin West's painting *The Death of General Wolfe*, 1770, was greeted with enthusiasm when it was first exhibited, although Reynolds had tried to persuade the artist not to show the figures in modern dress. West's composition is highly idealized, for few of those officers shown were present when Wolfe died at the Battle of Quebec in 1759, and the central grouping of the figures is self-consciously imitative of Old Master depictions of the removal of Christ's body from the cross.

precept of Romanticism was its devotion to the need to "express the passions". Reynolds continued in his Fifth Discourse: "We need not be mortified or discouraged at not being able to execute the conceptions of a romantic imagination. Art has its boundaries, imagination none." The Romantics would no doubt have agreed that imagination is boundless, but they nevertheless attempted, admittedly not always successfully, to give vent to their imagination through the medium of art. Society was richer for such an attempt. Blake annotated his copy of Reynolds's *Discourses* with disparaging comments clearly showing the radically different outlooks of the two men. "This Man was Hired to Depress Art", Blake noted bluntly by one of Reynolds's statements.

The art schools and academies that the young artists of the Romantic period attended throughout Europe all prized the artistic achievements of the ancient world, passed down to them through sculptures and reliefs. Students were set to drawing the casts of these statues and, when they were more experienced, copied from life models posed in the same classical attitudes as the statues. An ability to draw the figure accurately and correctly was seen as absolutely essential for all artists learning their discipline during this period, and so we find both drawings from antique statues and nude studies drawn from life in the sketchbooks, mapping out the learning process of artists as they study the human form.

Academies had similarly firm views concerning the discipline of landscape painting, however lowly a form it might be considered. It was believed that ideally artists should follow the example of the works of Old Masters such as Claude, Poussin and Cuyp, and for this reason artists would make copies when they could from such pictures. These are often faithfully recorded in their sketchbooks. Most artists underwent a similar training and were exposed to similar ideas, but it would be incorrect to assume that innovatory artists like Caspar David Friedrich, Turner or Fuseli did not benefit from this kind of training and, even if they are

INTRODUCTION

categorized as Romantic artists, that they did not revere and learn from the art of the Classical world. Romanticism and Neo-Classicism are frequently thought of as being diametrically opposed to each other, but there was a good deal of overlap and cross-fertilization between the two. Even the arch-Classicist David displays an awareness of Romantic-ism, even if it only manifests itself in his rejection of it.

TRAVEL AND THE INSPIRATION OF NATURE

Spurred on by their desire to see the ancient world, or the works of the Old Masters in Europe, or simply to find and record exotic or picturesque subjects for their paintings, artists travelled widely. Travel in the late eighteenth and early nineteenth centuries was both slow and hazardous. The most common mode of travel was still by foot; Wordsworth, as a young man, even successfully completed the astonishing undertaking of walking all the way to Switzerland and at what he described as a "military pace" of 28 miles a day. Travel by horse was a more expensive alternative, and by this time there were also established coaching networks, although it still took several days to travel long distances.

The Treaty of Amiens in 1802, which temporarily suspended hostilities between Britain and France, saw a succession of British artists crossing the Channel, keen to see the treasures Napoleon had looted from all over Europe and gathered together in the Louvre. They also wanted to see and experience the Continent itself, which had been closed off to them for several years. An artist who wished to cross the Channel had to secure passage in one of the many small boats that regularly made the journey, but such a trip could be dangerous, as J.M.W. Turner discovered when he travelled to France for the first time in 1802. His boat was nearly sunk in heavy seas off Calais pier, an event which he faithfully drew in the large sketchbook that he had brought with him. "Our landing at Calais", he ruefully noted by the side of his drawing, "Nearly swampt". This incident served as the inspiration for

his oil painting of the following year, *Calais Pier, with French poissards preparing for sea: an English packet arriving* (National Gallery, London).

Artists travelled and toured not only to make invaluable sketches, but also, naturally, to develop their minds by exposure to the new and unusual. Delacroix relished the exoticism of Morocco and North Africa when he travelled there in the 1830s, and his experiences there were to change the direction of his art. This trip marked a turning-point in his development as an artist. Indeed, picaresque travel fitted in well with the Romantics' desire for explora-tion of the world and of life, and through it the self. However, Delacroix's sketches of Morocco are not merely picture-postcard-like records of his observa-tions. They are also an eloquent testament to his sensations in this strange and unusual land, unlike anything that he had encountered before. As such, they show as much of Delacroix's self as they do their ostensible subject. In the same way, Turner's powerful late watercolour sketches of Switzerland executed in his old age, although on one level only topographical depictions of places, are also moving accounts of the artist's experience of that landscape. They display his admiration and empathy for the often overpowering bleakness and beauty of the Alpine landscape. By communicating what he feels in this place Turner is also expounding more universal sensations concern-ing the position of mankind within the world — that humanity can often rate as a relatively insignificant element in its environment when compared to the monolithic solidity and epic grandeur of a landscape such as the Alps.

Perceptive visions of landscape are related to the Romantic admiration and worship of nature in all her forms, and it was nature that served as the inspiration for much of the work of the Romantics. They believed in recording the immediate and personal effects of nature upon them, and the sense of communion that they felt when confronted with the natural. Sketches of animals, plants and trees abound, sometimes

extremely detailed. There are also works that are devoted to the heavens — to the effects of light in the sky, to rainbows and sunsets or the moon. Many Romantic artists were fascinated by cloud formations and made careful studies of them in their sketchbooks alongside detailed notes. Constable frequently made drawings and watercolours of clouds in his sketchbooks, sometimes also executing small oil studies, and Samuel Palmer also made detailed drawings in his 1819 sketchbook. Other drawings by the Romantics are devoted to the great powers of nature, to storm-laden skies and angry seas, and often portrayed at the heart of this menacing environment is man. Humanity is shown to be an intrinsic part of the world, but it has to battle for survival. Man becomes the true focal point of these works in the struggle against nature. This is the underlying meaning behind sketches for pictures such as Turner's *Shipwreck*.

In other, calmer studies, man is represented more in harmony with his surroundings as a natural part of a synthesized pastoral landscape. Idealized visions of agricultural workers tilling the land are common, especially in the work of Samuel Palmer. Further examples are to be found in the sketchbooks of Peter de Wint (1784–1849) on sheets such as *Landscape Study of a Pond* (Victoria and Albert Museum, London).

BLAKE AND THE IMAGINATION

Imagination and the inner vision were another boundless source of inspiration for the Romantics. Sketchbooks were the natural place to record private flights of the imagination or fantasy, and it is in these sketches that the darker side of the unconscious is sometimes revealed. Henry Fuseli's exhibited work always displays a great degree of imagination and psychological intensity, for instance in his oil painting of 1781 *The Nightmare*, but this tendency is even more pronounced in his private sketches. They have the recurrent subject of either threatening, malevolent women, often with fantastical dress and arrangements

Turner's late watercolours of Switzerland are among the most beautiful and evocative of his *oeuvre*, and none more so than those he produced in 1842. *Lucerne from the Walls*, 1842, is a sketchbook "sample study" – a watercolour made to enable patrons to commission a finished version. Ruskin commissioned the finished version of *Lucerne*, believing that "Turner had never made drawings like these before, and never made any like them again". With the exception of Ruskin and a few devoted collectors, most contemporaries were apparently unimpressed with such work; they could not come to terms with Turner's mature vision of nature, or the brilliant technique which even the artist's agent hesitantly ventured to describe as "a little different from your usual style".

of hair, or tortured-looking men, sometimes racked with physical pain, sometimes with mental anguish. Other sketches are frankly pornographic, with a recurrent theme of the sexual domination of a man by a woman, or sometimes women. In all of his sketches, Fuseli reveals a troubled psyche. He is evidently fascinated by women, but at the same time made deeply insecure and frightened by them. However, he shows himself heroically unafraid to look inside himself and to record what he finds there.

No artist was more reliant upon his inner visions and imagination than William Blake. He eschewed both drawing from nature and from the live model, one of his acquaintances noting: "He professes drawing from life always to have been hateful to him; and speaks of it looking more like death, or smelling of mortality". He was one of the most intuitively perceptive men of his age, aware of the human condition and of the political hypocrisies and issues of his day, but most of his work, both artistic and literary, is couched in such obscure imagery that the complicated web of meanings and · associations is often very hard to untangle. Many of his subjects derive from a detailed and encyclopedic knowledge of the Gospels, which, in today's secularized society, makes it even harder for us to understand his allusions.

Blake is, however, far better known today than he was in his own time. He was never a financially successful artist, and remained virtually unrecognized during his lifetime except for a loyal but small number of artist admirers, including Samuel Palmer. Some of Blake's most famous drawings are his "Visionary Heads", recorded in the smaller *Blake-Varley* sketchbook. Disbound long ago, the book was filled with drawings of both real and mythical figures from history, the result of seances held in the company of the artist John Varley (1778–1842). Varley, who was a firm believer in astrology and the supernatural, had befriended Blake and they made sketches together, sometimes even sharing a sketchbook. Varley was fascinated by the occult, and claimed to be able to

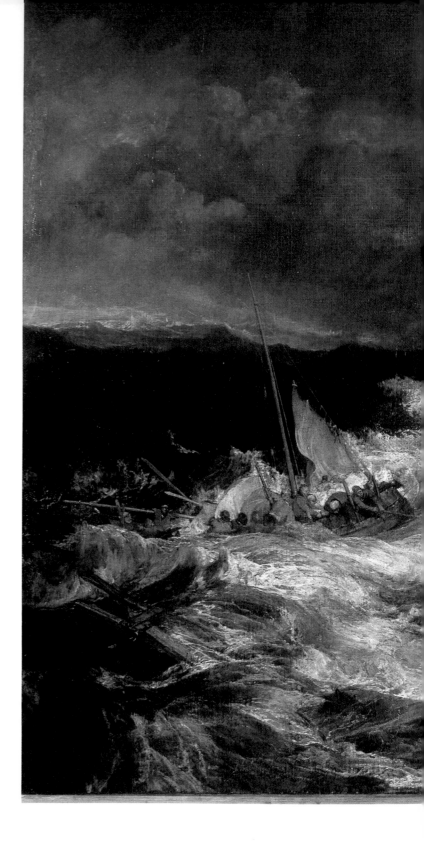

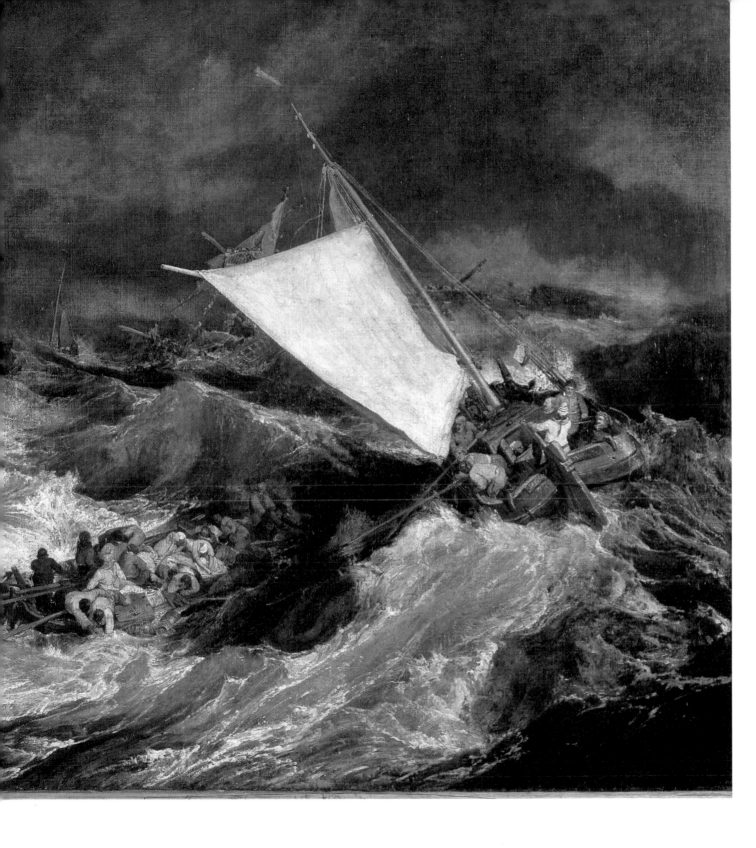

Turner's image of a shipwreck, with a small craft battling to pluck the crew to safety in perilous seas, is a perfect embodiment of the Romantics' fascination with the destructive forces of nature and with humanity's struggle for survival amid a hostile environment. In Turner's painting, *The Shipwreck*, 1805, even the rescuers themselves seem in imminent danger of being engulfed by seas reminiscent in their ferocity of images of the Biblical deluge. Throughout his life Turner was fascinated by storms, particularly at sea, and they are a recurrent subject in his work. In later life the artist claimed that his painting *Snow Storm: Steam Boat off a Harbour's Mouth*, in which a steamer struggles through an apocalyptic, vortex-like storm, was based upon a real incident when he had himself lashed to the mast so that he could experience the full violence of the elements.

INTRODUCTION

foretell the future, one of his major successes being to predict accurately the death of his nephew Paul Mulready by being hit on the knee by a flying cricket ball. Blake led Varley to believe during the course of the seances that he could actually see figures from the past who included Shakespeare's wife, Mary Queen of Scots, Thomas à-Becket, Robert the Bruce, Charlemagne, Robin Hood, the Black Prince, Wat Tyler and Henry V among many others. Although Varley could see nothing, he was convinced that Blake's visions were genuine, and furthermore that these apparitions were actually present in the room.

Also included in this strange procession of individuals was the ghost of a flea, which Blake sketched and then used as the basis for his famous tempera painting. Varley recorded this particular vision in his *Treatise on Zodiacal Physiognomy*, writing: "I felt convinced by his [Blake's] mode of proceeding, that he had a real image before him, for he left off, and began on another part of the paper, to make a separate drawing of the mouth of the Flea, which the spirit having opened, he was prevented from proceeding with the first sketch, till he had closed it. During the time occupied in completing the drawing, the Flea told him that all fleas were inhabited by the souls of such men, as were by nature blood-thirsty to excess."

The truthfulness of these seances has always been a subject of debate among Blake scholars, some believing in the reality of the event, others not. One possibility is that Blake was having an elaborate joke with the credulous Varley, who desperately wanted to believe that such things were genuinely possible. Blake may alternatively have been engaged in an activity which the other, less gifted, artist could barely understand. He may have been engaged in developing and projecting his imagination to transform the reality in his mind in order to arrive at a vision which, while not to be taken literally, could nevertheless shed greater light on reality than the real.

Samuel Palmer (1805–81) was undoubtedly describing a similar process in his own work when he

Towards the end of his life Palmer returned again to the idealized pastoral vision of the Shoreham years of his youth. Palmer himself recognized this, referring to *The Bellman* in a letter that is tinged with bitterness: "I am very glad that you like my Bellman . . . It is a breaking out of village-fever long after contact – a dream of that genuine village where I mused away some of my best years, designing what nobody would care for, and contracting, among good books, a fastidious and unpopular taste." Elsewhere Palmer described the scene more warmly as "seclusion without desolateness; where light enough remains to show the village sheltered in its wooded nest, and the ground heaves well and is rich enough in pasture".

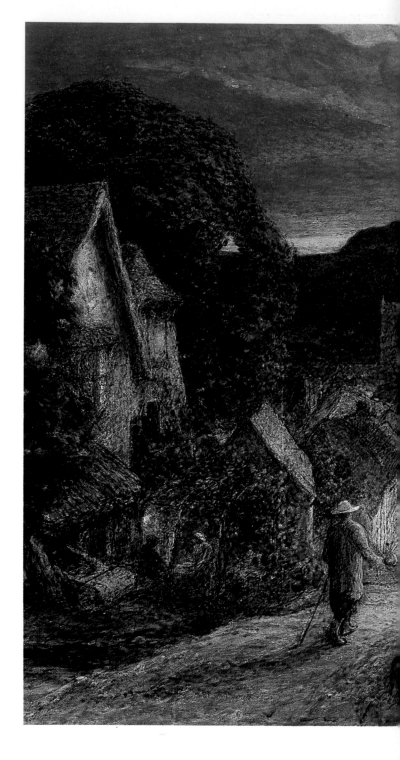

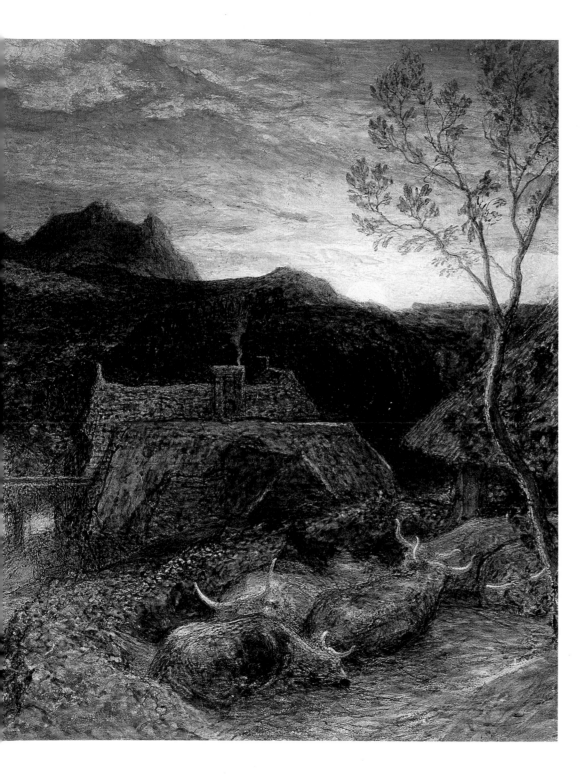

explained in the pages of his 1824 sketchbook:

"Note that when you go to Dulwich it is not enough on coming home to make recollections in which shall be united the scattered parts about these sweet fields into a sentimental and Dulwich looking whole. No but considering Dulwich as the gate into the world of vision one must try behind the hills to bring up a mystic glimmer."

SKETCHBOOK MATERIALS AND TECHNIQUES

If the subjects contained in them were infinitely varied, so were the actual sketchbooks themselves. They can range in size from the very small, small enough to fit into a waistcoat pocket, to the cumbersomely large with sheets three or four times the size of the pages of this book. The binding of the sketchbooks during the Romantic period was also diverse. Some were bound in thick heavy-duty leather, perhaps gilded, with a tooled design, and a brass clasp, which made them highly resilient when they were taken on tours. Some sketchbooks had a loop of leather along one side which could hold a pencil, which might be supplied with the book when it was bought. Others, originally sold as pocketbooks, had a flap inside the cover which could be used to hold visiting cards. Sketchbooks could also have bindings which included beautifully coloured marbled end boards, and frequently these too had a clasp. Less opulent sketchbooks were bound in plain board or just paper. Towards the end of his life J.M.W. Turner often favoured what are known as "roll" sketchbooks, bound with a soft paper cover that could easily be rolled up and kept in the pocket. At the very bottom of the scale, artists would sometimes merely use a wad of paper roughly sewn down one side and without a cover.

Many of the less well-bound sketchbooks have understandably now fallen apart, thanks to the ravages of time and the rough treatment to which they might have been subjected at the time of use. The well-bound sketchbooks have on the whole survived

47

better, although the quality of binding offered no protection against the common practice during this period of breaking up a sketchbook after an artist's death and selling off each sheet separately. This is what happened to most of the sketchbooks belonging to George Romney (1734–1802), and it is a practice that sadly still continues to this day. Once a sketchbook has been broken up in this way it is often very difficult to work out which particular sketchbook a sheet came from, and even if one can, establishing the original order of the drawings presents an additional difficulty. Once a sheet has been trimmed for mounting it is almost impossible to deduce whether it was once in a sketchbook or not.

Sketchbooks might well be used in the studio or at home, but they were commonly also carried around by an artist on his travels and tours, and so the books would have to stand up to the wear and tear of journeys around Europe and even further afield. The visual records they contained were a valuable resource which the artist could draw upon at any time. Such was the value of on-the-spot sketches that landscape artists sometimes borrowed drawings by somebody else and based their own works upon them. This is how artists who might never have visited India, China or the Americas could create convincing images of such places.

The method by which the sketches were made could also vary enormously. Sometimes they take the form of rapid, economic jottings, perhaps trying to capture a fleeting moment or scene. Conversely, sketchbooks of the period also contain carefully executed and detailed studies in which an artist is obviously striving for complete exactitude. Sketches are frequently made in pencil alone, for it was then, as now, one of the quickest and easiest of media to use.

PENCILS Pencils of graphite, originally known as "plumbago", had been used by artists since the sixteenth century. The greatest source for plumbago was Keswick in Cumberland, where the seams of the

This study, reproduced here approximately life-size, from one of Delacroix's Moroccan sketchbooks (*see also page 119*) was executed with pen and ink and watercolour. Its charming fluidity makes a striking contrast with the classical formality of the detail from the David compositional study opposite.

purest graphite in the world were discovered underneath an oak tree that had been uprooted in a storm. Keswick became the world centre for pencil-making, lumps of plumbago originally having been merely wrapped with string. During the Romantic period, however, pencils could be of two designs. The first was exactly like a modern pencil, a length of graphite encased in a wooden cylinder, traditionally made from cedar. The second type was a precursor of the propelling pencil, and was essentially a metal holder which gripped a lump of graphite. As the graphite was used up, the gripper could be released and the graphite moved down before being gripped again. Artists might also just use a length of graphite held in their hand to draw with.

During the Napoleonic Wars there was a trade embargo between Britain and France which meant that no pencils were exported to the Continent. This spurred the French to experiment, and in 1795 Nicolas Jacques Conté developed the process of mixing powdered graphite with clay and water and then baking it in a mould. This had the advantage of making the valuable graphite go further, and also, depending upon the relative proportions of graphite and clay, pencils could be produced of various degrees of softness. The more clay there was in the pencil "lead", the harder it was. This discovery, which incidentally was made almost simultaneously by Hardmuth in Vienna, greatly increased the artistic versatility possible with a pencil, and immediately increased its popularity as a sketching medium.

PENS The other predominant medium in which line drawings were made was pen and ink. In the nineteenth century steel-nibbed pens were common, although they tended to create hard, sharp lines which did not always make drawing with them aesthetically pleasing. Steel nibs were nevertheless excellent for drawing very fine lines, perhaps to add highlights to a finished drawing, and they were highly resilient.

There were two precursors to the steel-nibbed pen

that were used both before and after its advent. The first of these was the quill, a pen made by cutting to a sharp point the end of a long feather, usually from a goose, swan or crow. The end of the feather could be cut to the required size, using a sharp point for a fine line or a slightly wider one to give a broader line, again allowing great versatility. The end of the quill was reasonably soft and flexible and held the ink well, so that long, freely flowing lines could easily be drawn.

The other type of pen used was the reed pen. These were created in the same way, artists the stem of the reed cut to create the desired nib size. However, reed pens on the whole created thicker lines than the quill. They also held ink less well, and so made characteristically short lines. Nevertheless, it is often difficult when looking at a pen-and-ink drawing to distinguish whether it was made using a quill or a reed pen.

INKS A variety of inks was available to artists during the period. Carbon ink was made, as the name suggests, from carbon, often in the form of soot, suspended in water and usually with some form of binder such as gum arabic. Carbon ink is quite resistant to fading, and often retains its blackness rather than turning brown. Iron gall ink was made by suspending iron salts in acid obtained from a gall, a parasitic growth found on oak trees. Galls, or "gall nuts" as they are sometimes known, are created when gall flies deposit their eggs inside the bark of the tree. Iron gall ink typically tends to turn brown with the passing of time, partly because the acid it contains has eaten into the paper and discoloured it. Bistre ink is made solely from wood soot suspended in water, and depending upon the concentration and the type of wood that is burnt it can vary in colour from a golden yellow to a deep browny-black. Sepia is a rich brown ink made from the secretions of the cuttle fish.

All these inks were used in drawings made during the Romantic period, but it is often difficult to distinguish between them when looking at a work. As well as being used with a pen, they could also be

This detail from David's *Compositional Study for "The Oath of the Jeu De Paume"* (*see also page 65*) is reproduced slightly under half life-size. It is a striking demonstration of the detailed precision possible with a steel nib and ink; wash and white gouache were used to work up the shadows and highlights and the figures.

applied with a brush to give a thicker stroke, and were frequently thinned with water and used as a wash. Many of George Romney's sketchbook drawings, for instance, made great use of ink washes. Confusion often creeps in when classifying exactly what a brown wash is made of. Ink washes are a deep, dense brown colour, while brown watercolour washes, for which they are frequently mistaken, are usually paler and more transparent. Often both are described as sepia washes, but this term should be used only to describe specifically those made using sepia ink. Artists would frequently favour making tonal brown wash drawings of subjects when they were planning a finished work so that they could clearly work out the areas of relative tonality, of light and shade.

OTHER MEDIA Sketchbook drawings are sometimes made in charcoal. This can be used to create a very quick, free, vibrant sketch which incorporates the great variety of texture and tonality possible with the medium, due to its ability to be softened by rubbing. Black and white chalks were also used, sometimes as the sole medium but also to add highlights to a drawing executed in a different medium.

Watercolour was sometimes used in sketchbooks, frequently applied over pencil or pen-and-ink drawings that had been made first. This may have been done immediately after the sketched underdrawing, but usually in the work of landscape artists during the Romantic period this is not the case. It could be difficult to handle watercolour paints with the necessary subtlety in the open air. When once asked why he did not normally make on-the-spot watercolours, Turner replied that in the time it would take him to make one coloured drawing he could make four in pencil. It was often more usual for artists to work up drawings in watercolour later on, either in their studio or when they returned to their lodgings if they were on tour. Colour could be applied with the sheet still in the book, as in Delacroix's Moroccan sketchbook, but artists would often tear the sheet out before applying

colour for ease of handling. This is what Constable did with some of his highly worked watercolours made on sketchbook sheets.

PAPER The types of paper used for sketchbooks during this period varied enormously. Wove paper seems to have been generally favoured, probably because of its flat, smooth surface, which was ideal for making pencil or pen-and-ink sketches. Occasionally, however, laid paper was used instead, with its characteristic slightly raised grid-like surface, the result of manufacturing it by using a wire lattice mould.

Sometimes sketchbooks were made up of coloured papers, often several different colours within the same book. At this time one could go to a paper merchant or stationer and have a sketchbook specially made and bound up, specifying the particular types of paper to be included. In order to enhance the appearance of their work, artists in the late eighteenth century and throughout the nineteenth would also frequently tint their paper themselves with perhaps a pink, yellow or green watercolour or ink wash before beginning a drawing, and more than one wash could be applied. A drawing in pencil and black chalk on paper prepared with a grey wash with highlights picked out afterwards with white chalk can be surprisingly attractive.

Although sketchbooks could be bought with ready-tinted pages, some artists preferred to tint their papers themselves and then have them specially bound up. Sometimes the tinting materials could be unusual. According to his friend Joseph Farington, Turner used a mixture of tobacco juice and Indian ink to stain some of the paper which he took to Scotland in 1801.

Laying down a tinted ground on white paper meant that the artist could employ the technique of scratching out once all the media had been applied. This involves scratching through into the paper so that the whiteness of the paper shows through. This practice can give a drawing great beauty if it is not done to excess, and can also give it a pleasing texture. The technique, known as *sgraffito*, was frequently used by

The Graphic Telescope, invented by the artist Cornelius Varley, allowed users to look through it and see the image of what they were looking at projected downwards by prismatic means on to a sheet of paper. By careful orientation it was possible to see one's drawing hand as well, and therefore the image could be copied exactly. Varley's telescope had an advantage over similar systems in that its lenses allowed it to magnify up to 19 times, which could be highly useful when drawing a landscape.

watercolourists during this period.

The combination of techniques, materials and uses unique to sketchbooks and the vast range of subjects, themes and references employed by the artists within these under-explored works gives us a particularly rich and profoundly revealing insight into Romanticism and its inspiration.

OPTICAL INSTRUMENTS There were a variety of devices available which artists could employ as an aide to accurately capturing an image, particularly if they were drawing a landscape or a portrait.

The Camera Obscura was invented in the sixteenth century and consists of lenses or mirrors in a darkened box. The lens at the front of the box transmits the image onto a mirror inside the box, which then reflects it onto a glass screen on the top of the box. If thin paper is placed over this screen then the image may be traced. Portable camera obscura were available from the early eighteenth century onwards. Canaletto

(1697–1768) is known to have used one, as did Philippe James de Loutherbourg (1740–1812), Thomas Girtin (1775–1802) and John Crome (1768–1821). Joshua Reynolds' camera, now in the Science Museum in London, was characteristically disguised, when closed, as a leather-bound folio entitled *Ancient History*.

In 1807 William Hyde Wollaston patented the Camera Lucida. This device consists of a prism on a stem, so arranged that when the user looks through the prism the image of the object is projected downwards onto a sheet of paper placed under it. Careful adjustment of the eyehole over the prism allows the user to see both the object and his hand at the same time, thus enabling him to draw.

The artist Cornelius Varley (1781–1873) patented his Graphic Telescope in 1811. It operates on the same principle as the Camera Lucida but has the advantage

of telescopic magnification. Varley described the instrument at length:

"My said Invention consists in combining one or two reflecting surfaces with a simple kind of telescope that inverts the object, and thereby gaining an erect image without any additional length to the telescope, placing the telescope out of the way of the image, and apparently projecting the said image flat on a table, so that it may be easily traced on paper, &c., the image being seen by one eye, and the pencil or tracer by the other, or by both eyes, and of a table or stand for supporting and using the same."

Another simpler device but immensely popular, particularly with landscape artists, was the Claude Glass. This was a slightly convex blackened mirror which supposedly produced images of a Claudean character. Artists or Picturesque tourists were advised to enjoy a landscape to the full by turning their back and viewing it reflected in the mirror. "The person using it ought always to turn his back to the object that he views," wrote Thomas West in his *Guide to the Lakes*. "It should be suspended by the upper part of the case, holding it a little to the right or left (as the position of the parts to be viewed requires) and the face screened from the sun".

The poet Thomas Gray, who possessed a Claude Glass bound like a pocket book, had a nasty experience, however, when following this advice on his tour of the Lake District in 1769. Turning around, he recorded, "I fell down on my back across a dirty lane with my glass open in one hand, but broke only my knuckles: stay'd nevertheless, & saw the sun set in all its glory".

An even simpler device that artists might use was a frame with strings or wires stretched across it to form a grid of squares, perhaps one to two inches in size. Looking through this at his subject the artist would transfer what he saw in each square onto a squared piece of paper, a more exact process of accurate drawing than sketching freely.

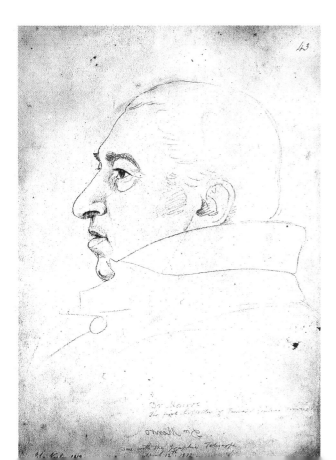

Executed with the aid of his brother's invention, the Graphic Telescope, this sketch by Varley portrays the important patron and connoisseur Thomas Monro. Dr Monro was chief physician of Bethlem lunatic asylum, but he also took a strong interest in art. Farington noted in his diary: "Dr Munro's house is like an Academy in an evening. He has young men employed in tracing outlines." Two of these were Turner and Girtin, and in later life Turner recalled how he was paid "half a crown" for his labours and received an oyster supper.

The Sketchbooks

> A sketch is generally more
> spirited than a picture.
> It is the artist's work when he
> is full of inspiration and ardour,
> when reflection has toned down
> nothing; it is the artist's
> soul expressing itself freely.

Denis Diderot, *Salon Review*, 1765.

CCCLXIV – 273

J.M.W. TURNER
*The Angel
troubling the Pool,*
c. 1843,
pencil and
watercolour,
9 × 11⅜ in
(22.9 × 28.9 cm)
Tate Gallery,
London

The Academy and the Figure

Artistic academies have a long history, one of the first being associated with Leonardo in his Milanese period, the so-called Accademia Leonardo da Vinci. The concept, however, of the academy and the academic can be traced back as far as Plato.

In 1563, in Florence, Giorgio Vasari founded the Accademia di Disegno under the patronage of Grand Duke Cosimo. This body was intended to provide a forum where artists could meet to discuss art, to promote the prestige of artists within society and also, most importantly of all, to provide practical tuition. This last activity was soon abandoned by Vasari's academy, but the precedent had been established. The idea eventually took hold, and by the mid-seventeenth century it was common for artists to meet together to make drawings from the nude, often under the patronage of an enlightened nobleman. Thus private teaching academies were formed, co-existing and to some degree replacing the old system of master-apprentice artistic training.

THE FRENCH ACADEMY

Academies were further developed by the formation in 1634 by Cardinal Richelieu of the Académie Française, the French Academy, which was originally designed to promote the study and preservation of the French language. In 1648, under the auspices of the French Academy, the Academy of Painting and Sculpture was formed. Jean-Baptiste Colbert ex-

ploited it to bind artistic expression towards the promotion and celebration of the personality cult of the "Sun King", Louis XIV, and from this time onwards academies are often closely associated with state control. By 1664 Colbert had given the French Academy a new constitution which, significantly, turned it into a primarily teaching institution. Colbert also, in 1666, founded the French Academy at Rome, where particularly talented pupils would be sent to study the art of the ancient world.

Under the directorship of the artist Charles Lebrun (1619–90) the French Academy achieved its greatest power, taking the form that was to be the pattern for all the other similar institutions founded throughout Europe in the seventeenth and eighteenth centuries. It had become not only a state school for artistic training, but also a learned body in its own right. Artistic training concentrated upon figure-drawing, a mastery of which was felt to be the stem from which all other abilities flowed. Artists had to qualify to be accepted as academicians, and were ranked according to the branch of painting they practised. Thus by the late

This is a sheet from one of David's sketchbooks in use after he became official painter to Napoleon, which contains many studies for the large oil painting *Distribution of the Eagles* (Musée de Versailles). His method of preparing a painting was thoroughly Academic, for he would first make precise nude studies of each of the figures in the composition, and then add the clothing. This process is clearly evident in this study.

V. A. M.

seventeenth century the French Academy had evolved a clear ideology of what was good or acceptable art that was to dominate aesthetics for decades to come.

History painting was seen as being the pre-eminent form. Subjects of a morally instructive nature, or those endowed with an epic or noble quality, should be chosen, preferably drawn from the literature and history of the Classical world or the Bible, and allegorical subjects were also viewed favourably. Such works were perceived as being the highest aim of art. Portraiture came next in this rank structure, while genre and landscape scenes were placed last. Artists

This series of sketches of heads from one of George Romney's sketchbooks appears likely to be studies from the cast rather than from life, executed with his characteristically vigorous pencil technique. Romney himself had a fine collection of casts from the antique, which he had commissioned the artist John Flaxman to bring him back from Rome.

within the French Academy were ranked in order of seniority along these divisions.

ENGLAND'S ROYAL ACADEMY

In England, the Royal Academy was not founded until 1768, a relative latecomer in the history of European academics, for English artists were wary of the degree of state control apparent in the French model, and until this date it was left to private academies to fill the training vacuum. When it was finally born, however, with Joshua Reynolds (1723–92) as its first President, the Royal Academy was constructed along ideological

lines very similar to those of its French counterpart. In his famous *Discourses* given between 1769 and 1790, Reynolds self-consciously reasserted the hierarchies of art that had been formalized in the French Academy under Lebrun.

Tuition in all academy schools always revolved around the mastery of figure drawing. At the Royal Academy prospective students were first required to submit a drawing made as a copy of an antique sculpture. If this was considered worthy by the keeper they would then be asked to make a second drawing from one of the many casts of statues and reliefs from the Classical world that were in the Academy's collection. If this second drawing was likewise considered acceptable, the student was enrolled in the Academy Schools and would be put to work first in the "Plaister Academy" to perfect his drawings from the antique. It was not until fully proficient in drawing from the cast that students were allowed to attend the life class.

Training could be a long process, for the rules of the Academy stated that the combined period of study in both these classes should be a minimum of six or seven years. As in most academies it was also stipulated that complete mastery of drawing had first to be accomplished before tuition could be considered in painting. Alongside the students' regime of figure-drawing, they would also attend lectures on complementary subjects such as anatomy, perspective and colour theory.

THE ANTIQUE MODEL

Artists were therefore inculcated with a reverence for the cool poise, grace and beauty of antique sculpture, and were expected, when they eventually came to create original works of art of their own, to lend their figures these same qualities. Even when the student had progressed to drawing from life in the academy schools, the models were invariably set in poses directly imitative of antique sculpture. Lebrun had produced a treatise — his *Méthode pour apprendre à*

dessiner les Passions — which outlined the precise stereotypical and stylized facial and physical forms that should be used when trying to portray the passions, and by the late eighteenth century this was still considered academically legitimate. Academies considered that the true purpose of art was the encouragement of the nobility of the human spirit, and that this should be communicated through the depiction of pure beauty. To this end, Reynolds admitted in his Fifth Discourse that he doubted that the passions should be a fitting subject at all for art. "If you mean to preserve the most perfect beauty in its most perfect state," he told the Royal Academy, "you cannot express the passions, all of which produce deformity, more or less, in the most beautiful faces."

Despite such apparently doctrinaire and rigid rules,

This nude study, from Samuel Palmer's 1824 sketchbook, dates from the period when he was much under the influence of the artist John Linnell, who encouraged him to improve his ability to draw figures. Palmer's work was also profoundly inspired by his friendship with Blake at that time. This study in pen and ink and watercolour, now in the British Museum, London, closely resembles Blake's figure drawings, both in treatment of anatomy and the dynamism of the twisted form.

by the end of the eighteenth century Academicians themselves did not necessarily follow them, and there is a strong element of defence in Reynolds' reassertion of the traditional and conservative beliefs as to the correct function and forms of art. Reynolds himself was in essence a society portrait painter — an inferior form in the academic hierarchy of subjects — and his forays into historical subjects are rarely entirely successful. Indeed, the Irish-born artist James Barry (1741–1806) was constantly to bemoan both publicly and privately the fact that the majority of his Royal Academy colleagues did not follow his example and commit themselves wholeheartedly to history painting. Reynolds himself even admitted in his final discourse, and very revealingly, that portrait painting was "more fitted to my abilities, and to the taste of the times in which I live".

NATURAL FIGURE-DRAWING

During the second half of the eighteenth century new aesthetic ideas had taken hold, concerning the figure and much else that art ought to portray. Artists became committed to the idea of portraying the figure, not only drawn from life, but also in a natural pose. People began to be portrayed as they were in reality and not in an idealized manner. In truth, of course, artists had always drawn from life what they had seen, their friends and family, fleeting glimpses of daily life, however mundane, and these were often recorded in their sketchbooks. What was new, however, was that such naturalistic treatment was granted increasing aesthetic acceptance, and this was a process that Romanticism actively fostered. That the Scottish artist David Wilkie (1785–1841) should be greeted with so much critical and artistic praise when he exhibited his oil painting *Village Politicians* (Scone Palace) at the Royal Academy in 1806 — a genre scene that depicts entirely natural and convincing-looking agricultural workers in political debate — shows just how far aesthetics had come.

Academy studies from the antique and the nude can

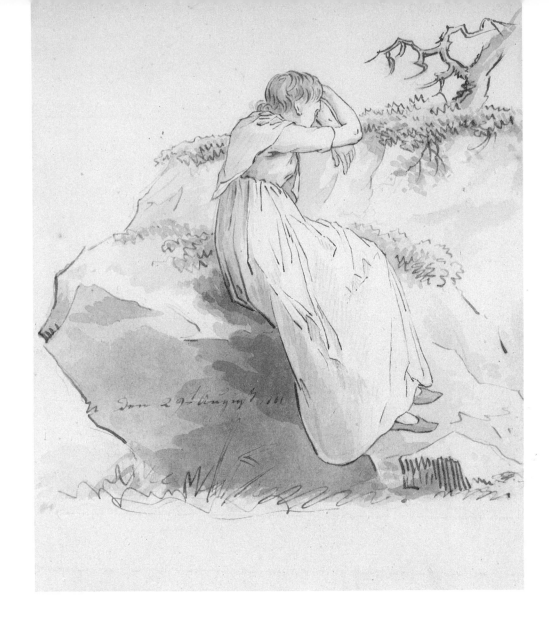

Friedrich's *Woman sitting on a Rock* (1801, Mannheim sketchbook) is laden with the symbolism typical of the artist's work. The setting sun and the dead branch are symbols of the inevitability of death. The rock represents faith and the ivy on the tree symbolizes the hope of the Resurrection.

certainly be found in Romantic artists' sketchbooks, for they undertook and benefited from the same regime of artistic training as all other artists, and, indeed, the mastery of figure-drawing is still implicit in art training today. Alongside such studies, however, there will also be found more natural figure studies drawn from everyday life, and sketches that might have epic or heroic subjects, but with figures set in lifelike poses, whose faces convincingly and naturally communicate the passions.

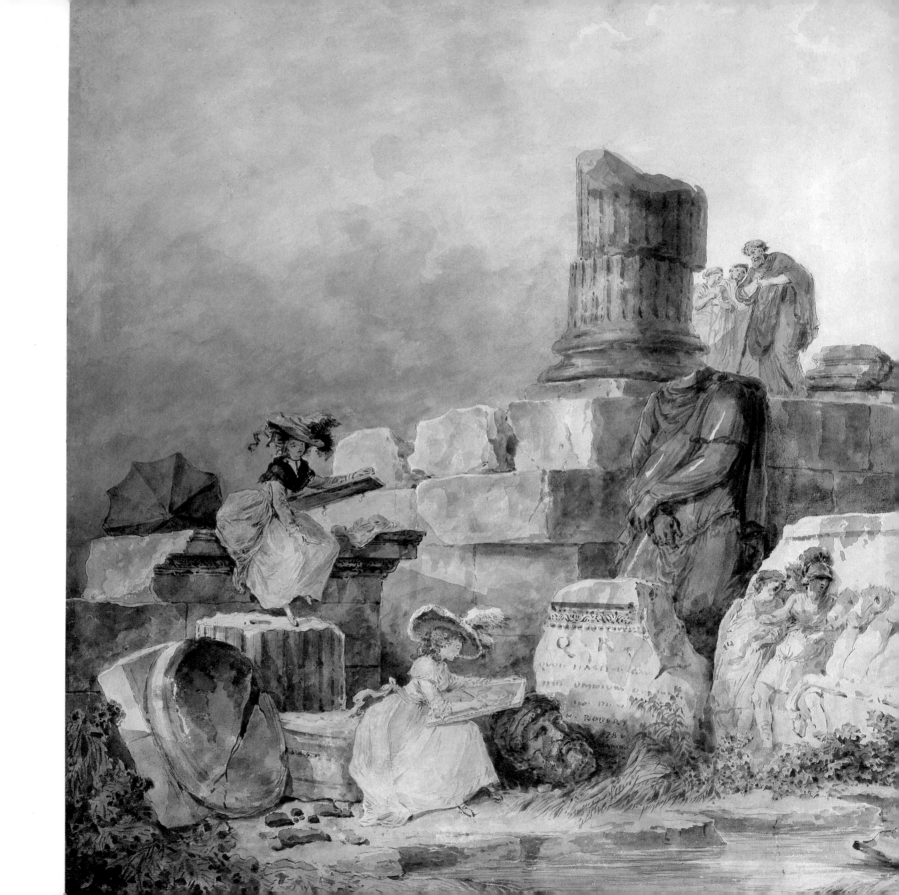

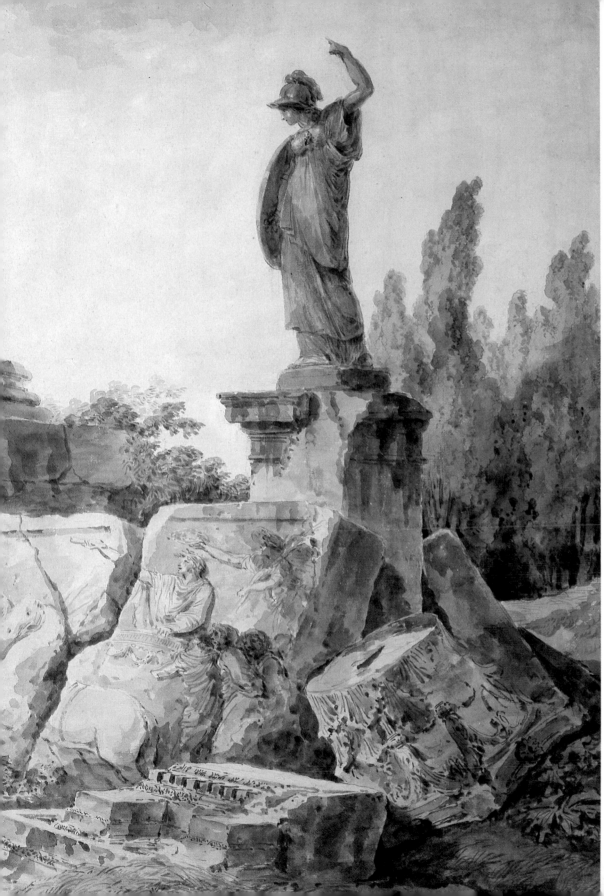

*I*t was generally accepted during the 18th and early 19th centuries, and before, that the highest levels of artistic creation had been achieved in the ancient world in sculptures, reliefs and architecture. Artists therefore tried to imitate the poise and beauty of these works and to make copies of the originals. Copying from the antique was an accepted and important part of an artist's training. Concision of draughtsmanship was one of the great precepts of traditional artistic training, as well as an underlying principle of neoclassical art. Although the Romantic movement, which often stressed colour and texture above drawing, modified these beliefs to a certain extent, they remained the basic tenets of an artist's training. In this finished watercolour the French artist Hubert Robert shows two women studiously making copies of an array of classical statuary and ruins, which is probably a *capriccio* rather than a scene of an actual collection of relics.

HUBERT ROBERT
Women sketching among Classical Ruins, 1786
pen and ink and watercolour,
27⁹/₁₆ × 38⁹/₁₆ in
(70 × 98 cm)
Louvre, Paris

THE SKETCHBOOKS

JACQUES LOUIS
DAVID

Studies of Heads,
c. 1784–5
pencil, 7⅜ × 5⅜ in
(18.8 × 13.6 cm)
Louvre, Paris

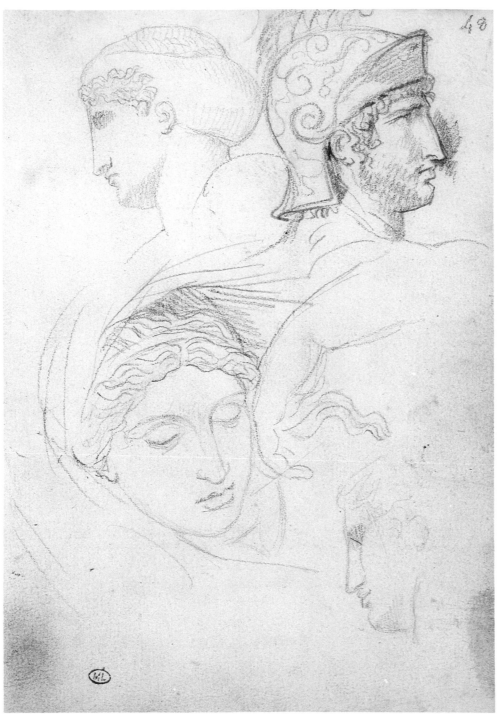

*I*n these elegant but small-scale studies David fully displays his great gift as a draughtsman, employing a confident but measured drawing technique. The sketches of female heads would appear to have been made from the antique, but the male head at the top right of the page is a study for one of the warriors' heads in David's famous painting *The Oath of the Horatii* (Louvre, Paris). When the painting was first exhibited in Rome it evoked great excitement and interest, both for its startlingly austere yet satisfying composition, and also for the Republican overtones of its subject matter. At the Salon of 1785, contemporaries recognized that David had transformed French neo-classical painting.

Jacques Louis David *Studies of Men with Raised Arms*, (1789), pencil, 7⁹/₁₆ × 4¹⁵/₁₆ in (19.2 × 12.5 cm). These studies from the sketchbook that David used to plan his momentous painting of the Oath show the Deputies of the Estates General raising their arms to vote support. His later studies followed established academic practice by first drawing a nude to ensure complete anatomical correctness in pose and structure; and then clothing the study.

Jacques Louis David *Study of The Jeu de Paume*, (1789), pencil, 7⁹/₁₆ × 4¹⁵/₁₆ in (19.2 × 12.5 cm). This drawing shows the royal tennis court where the Deputies met to enact what marked the start of the French Revolution. The figures shown above may predate this view, for David possibly drew them when the Oath took place, as it seems certain he witnessed it; the softness of the style also suggests direct observation.

Each element of the studies David made for the final painting was meticulously planned. He made careful drawings of each figure in the composition, and individuals who would eventually people David's painting are clearly recognisable, including Robespierre, David's support for whom was to lead to the painter's imprisonment when the revolution changed direction and Robespierre fell from favour.

DAVID'S OATH OF THE JEU DE PAUME

oil-painting on a suitably epic scale, which effectively showed the beginning of the revolt against the state. On 20 June, 1789, Louis XVI tried to prevent a meeting of Third Estate Deputies of the Estates General by locking them out of the debating chamber. Instead, they defiantly convened in the royal tennis-court, the Jeu de Paume at Versailles, and swore an oath that was to set in motion the events that culminated in revolution. "The National Assembly, considering itself called to arrange the Constitution of the kingdom, to regenerate public order, and to maintain the true principles of monarchy, can in no way be prevented from establishing itself ... It is decreed that all the members of this Assembly will instantly swear a solemn oath never to separate and to reunite wherever circumstances demand it, until the constitution of the kingdom is established and conformed on solid foundations."

Jacques Louis David *Compositional Study for "The Oath of the Jeu de Paume" (opposite)*, pen and ink, wash and white gouache, 25 × 40 in (63.5 × 102 cm) and *Figure Studies* pencil, chalk, brown wash and oil on canvas, 157½ × 259 in (400 × 658 cm), (both *c.* 1790–5). That David did not finish the Oath is tragic but hardly surprising, for though the studies suggest a flawless epic, the figure studies were drawn life-size, pointing to a truly gargantuan enterprise that would have needed a gallery as big as the Jeu de Paume itself to display the painting.

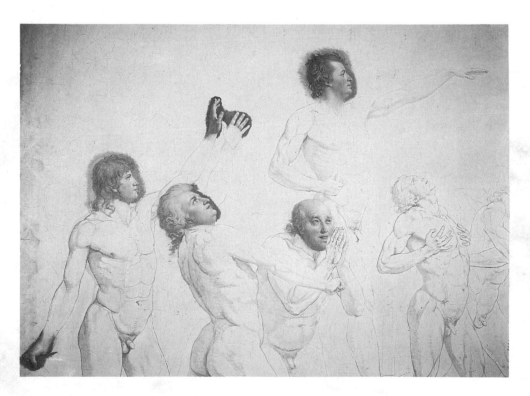

David was present that day and recorded his observations in his sketchbook. Many figures are depicted nude in the manner of heroic classical statuary, and David carried on this working method into the large oil studies that he made. All the excitement and importance of the moment is recorded in the form of a finished drawing (*right*). The Deputies raise their arms in passionate assent to the oath, they cheer or hug each other, while some sit more quietly in silent contemplation of the momentous event. By the time David was ready to make a finished version of his composition in oils, the direction of the revolution had changed. Many of those David depicts had fallen from favour, and official encouragement of the artist's great commemoration had evaporated.

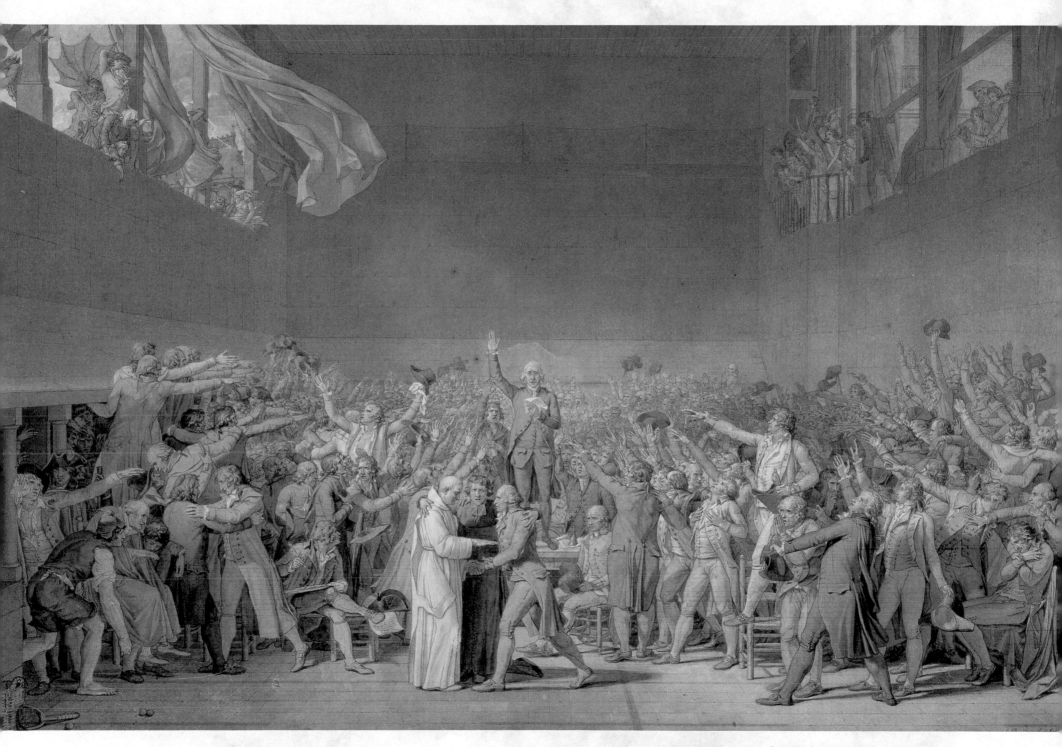

DAVID'S OATH AT THE JEU DE PAUME

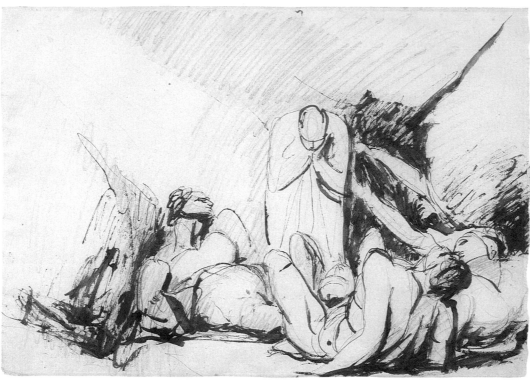

While Academic principles advocated the setting of models in poses similar to those of the statuary of antiquity, or striking heroic or noble attitudes, artists also drew the human figure in more natural and relaxed postures. During the course of the 19th century a greater naturalism began to encroach upon all sectors of art, especially in France. In this sensitive, slightly melancholy study of a young girl, Corot adopts a soft drawing style that accentuates the naturalness of his subject.

GEORGE ROMNEY

John Howard visiting a Lazaretto,
c. 1791–2
pencil, pen and ink
and wash,
13½ × 19¼ in
(34.3 × 49 cm)
Tate Gallery, London

JOHN CONSTABLE

A Music Party, 1806
pencil,
9½ × 7⅞ in
(24.1 × 20 cm)
British Museum,
London

One of numerous sketches made by Romney for a proposed painting to commemorate the life and work of the noted prison reformer of the second half of the 18th century, John Howard. Romney admired Howard because his publications exposing the cruelty meted out to prisoners by the state fitted well with the artist's own republican and reformist political beliefs.

Constable was naturally gregarious, but although he made sketches of his close family, he was not usually in the habit of drawing domestic and social incidents. However, in 1806, he uncharacteristically filled his sketchbooks with portraits of the families that he visited. It is likely that this sketch was made during a two-month tour of the Lake District, and shows a music party during the period when he stayed with the Harden family at Brathay Hall.

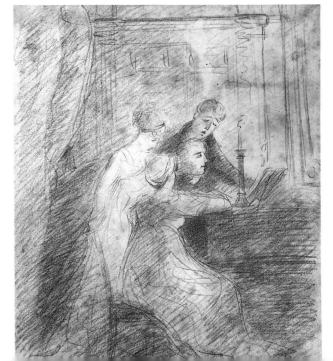

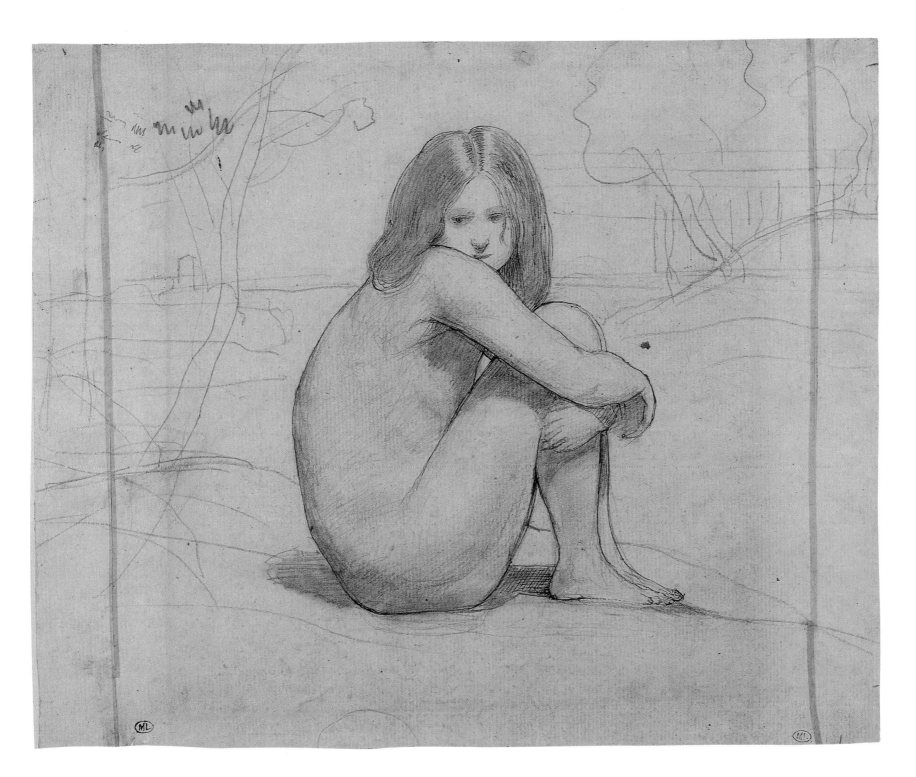

JEAN BAPTISTE
CAMILLE COROT

Seated Nude, 1840
pencil and pen and
ink 8⅞ × 11in
(22.5 × 27.9 cm)
Louvre, Paris

THE SKETCHBOOKS

J.M.W. TURNER

Swiss Peasants at rest, 1802
pencil and watercolour,
6⁵⁄₁₆ × 7¹¹⁄₁₆ in
(16.1 × 19.5 cm)
Tate Gallery, London

Dahl made this entirely naturalistic and relaxed study while staying as the guest of Crown Prince Christian Friedrich at Naples. Although Norwegian by birth, Dahl spent much of his life in Dresden and became a leading proponent of naturalism and *plein-air* painting. "In the conception of landscape," wrote Carl Gustav Carus, "he was a pure naturalist, seizing on the details of rocks and trees and plants and meadows with quite extraordinary mastery; working with amazing facility, but leaving much to chance, he often seemed to surrender himself too much to the objective."

Turner made many studies of the landscape he encountered on his visit to the Continent in 1802. He also made a series of studies of the local peasants in his *Swiss Figures* sketchbook. Turner made rapid pencil notations of the forms of the figures and later washed in their brightly coloured clothing with watercolour. The artist was always interested in the human aspect of landscape, and made frequent brief studies in his sketchbooks of some of the people that he encountered on his tours.

13.

d 14 Sept 1820.

Sr Kongl H dem Prindsen Christian Friedri h

g. Dännmark mit dan quashen — und Schmidt anch

Dahl.

in anser Monten H. Angusta m Caffelamani A

JOHAN CHRISTIAN
CLAUSEN DAHL
*Prince Christian
Friedrich of
Denmark and his
Party*, 1820
pencil and
watercolour,
8¼ × 10¹⁵⁄₁₆ in
(21 × 27.8 cm)
Nationalgalerie, Oslo

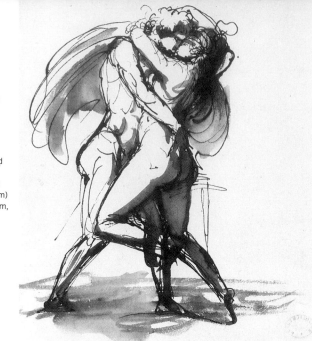

Sergel, a close friend of
Fuseli, is shown at work
on his *Cupid and Psyche*
group, now in the
Nationalmuseum, Stockholm.
Sergel is the figure working at
the centre of the composition
with his back turned, his
studio assistant Carl Gustav
Fehrman is in the background
working on a relief, and the
seated man is Fuseli himself.

Johan Tobias Sergel was
one of the finest neo-
classical sculptors of the
second half of the 18th
century. A highly sensitive
draughtsman, his drawings
were similar in many ways to
those of Fuseli, but had a
more natural quality and a
graceful poise that is
sometimes lacking in the
Swiss artist's work at this
time. Sergel was fascinated by
the theme of lovers, and it is a
subject that recurs many times
in his Roman drawings. Many
of these, such as the present
drawing, are devoted to erotic
subjects.

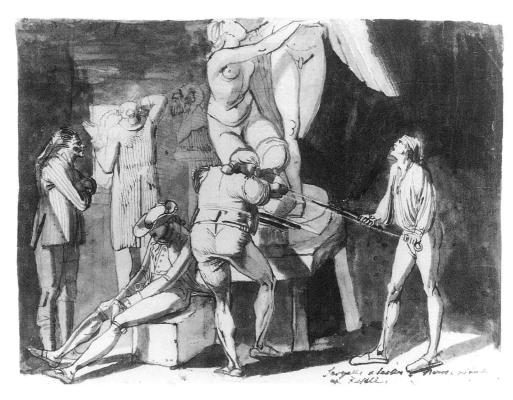

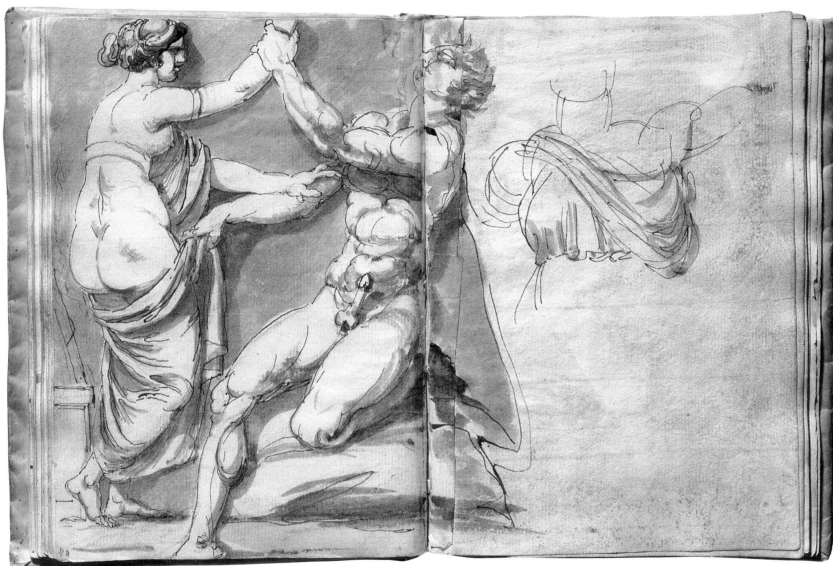

JOHAN TOBIAS
SERGEL
*Study of an
Antique Relief,*
c. 1769
pen and ink and
grey wash,
7³⁄₁₆ × 9¾ in
(18.2 × 24.8 cm)
Nationalmuseum,
Stockholm

During his time in Rome Sergel made many drawings of classical sculpture. This study was based on an ancient fragment from a relief that is now in the Pergamonmuseum in Berlin.

The frankly sexual nature of the subject appealed to Sergel, and it was something that he recorded without hesitation in his *Brising* sketchbook. The sketchbook also contains a number of other overtly sexual drawings. Fuseli, who had originally trained as a Zwinglian minister, drew the same relief, but excluded the male figure, possibly because at this time he was more inhibited than Sergel.

The Royal Academy

The Royal Academy's fine cast collection seen in Burney's drawing *The Antique School of Somerset Home (below)*. Turner's *Seated Female Nude (left)* shows a commitment to life-drawing long after ending his formal artistic training in the Royal Academy schools.

In November 1768 22 artists signed a petition which asked for the permission, protection and patronage of the King of England to form what was to become the Royal Academy. "We only beg leave to inform your Majesty" the petition read, "that the two principal objects we have in view are, the establishing of a well-regulated School or Academy of Design, for the use of Students in the Arts, and an Annual Exhibition, open to all artists of distinguished merit, where they may offer their performances to public inspection, and acquire that degree of reputation and encouragement they shall be honoured to deserve." George III gave his permission enthusiastically, and on 10 December, 1768, the Royal Academy formally came into being, first occupying premises in Pall Mall, but moving on to Somerset House and the National Gallery before finding a permanent home at Burlington House in Piccadilly. Its aims, as the petition states, were to co-ordinate artistic training through the Academy Schools, and also to elevate the standing of artists within English society by investing the best of them with the prestige of the Academy when they were elected. There were 40 Academicians at any one time during the 18th and 19th centuries, the allowance being raised only during the 20th century, and artists could be elected to their number only when a vacancy occurred. In addition there were 20 Associates; artists had first to be nominated as Associates before they could be considered for elevation to the status of full Academicians.

*R*owlandson was a noted social satirist, but he was also a superb draughtsman and printmaker. Here he shows the summer exhibition when the Royal Academy occupied Somerset House. Any artist could exhibit, but work had to be approved by the hanging committee, made up of Royal Academicians. If exhibited, an artist gained much prestige. Paintings were hung on the walls from floor to ceiling, as Rowlandson shows, which led to great competition to have paintings hung "on the line", at eye level.

sculpture. This took place in the so-called "Plaister Academy", and it could be several years before a student had become proficient in drawing from the antique and could progress to the Life Academy where it was possible to draw living models. J.M.W. Turner caused reverberations when as a Visitor (a visiting tutor to the Royal Academy schools) he placed a live model next to a statue and directed the class to draw them together, something the Redgrave brothers recorded as "a capital practice, which it is to be regretted has not been continued". Other artists constructed whole tableaux during their time as visitors, Constable setting up a female nude as "Eve Tempted" next to a laurel tree with oranges fixed to it, while William Etty contrived whole groups of models as dancing Graces, satyrs and fighting gladiators.

The portraitist Joshua Reynolds (1723–92) was the institution's first President and under his direction the Academy became an arbiter of taste. In his famous *Discourses* given to the Academy between 1769 and 1790, and widely circulated in published form, Reynolds expounded and reasserted the validity of the traditional academic hierarchies of the branches of art. Reynolds firmly believed that an artist should "instead of endeavouring to amuse mankind with minute neatness of his imitations … endeavour to improve them by the grandeur of his ideas". For him only history painting could achieve this, depicting mythological, allegorical, religious, historical or literary subjects.

The art and ideals of the ancient world were revered by most artists during the Romantic period, and this was reflected in the Royal Academy schools by a concentration upon making drawings of antique

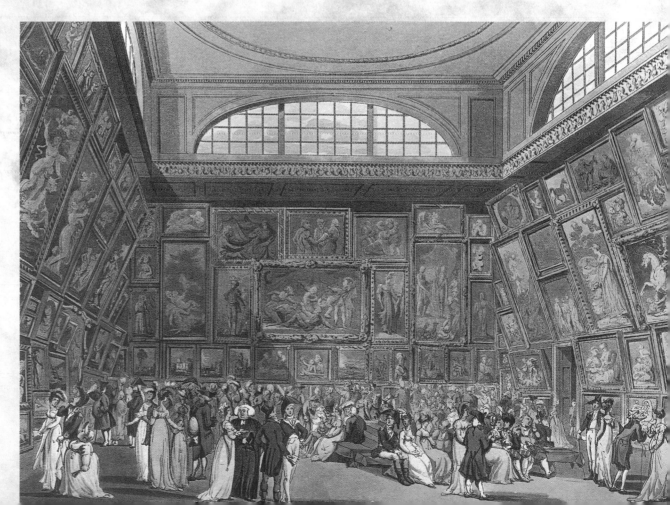

Ramboux studied art in Paris under the arch-classicist Jacques Louis David, and it is from this period that the present sketch derives. The scene may well be a studio tableau of models posed and arranged to portray an incident from classical literature or history – a common academic practice. Ramboux's drawing technique here is careful and measured, almost hesitant, and he has afterwards tinted the sketch with brown wash to denote areas of relative light and shade, and to lend his drawing a more three-dimensional character.

JOHANN ANTON
RAMBOUX
Classical Scene,
1808–12
pencil and brown
wash,
16⅝ × 5⅛ in
(42.3 × 13.1 cm)
Wallraf-Richartz-
Museum, Cologne

This example of Ramboux's more finished work is one of a series of drawings and shows the harvesting of grapes from the vines. The drawings were for a series of frescoes for the home of Matthias Joseph Hayn in Trier. When on the wall the designs would resemble gateways into an idealized and mythologized world. This type of vision was highly popular in Germany at this time, especially among the Nazarene group of artists, of whom Ramboux was an associate. The Nazarenes were a group of German artists who formed themselves into the Brotherhood of St Luke, the patron saint of artists, which resembled a religious order. Ramboux's mural designs were probably much influenced by his observations in Italy in 1816, and he continued his study of Italian paintings of the 14th to 16th centuries when he returned home. From it Ramboux learned the use of clear bright colours.

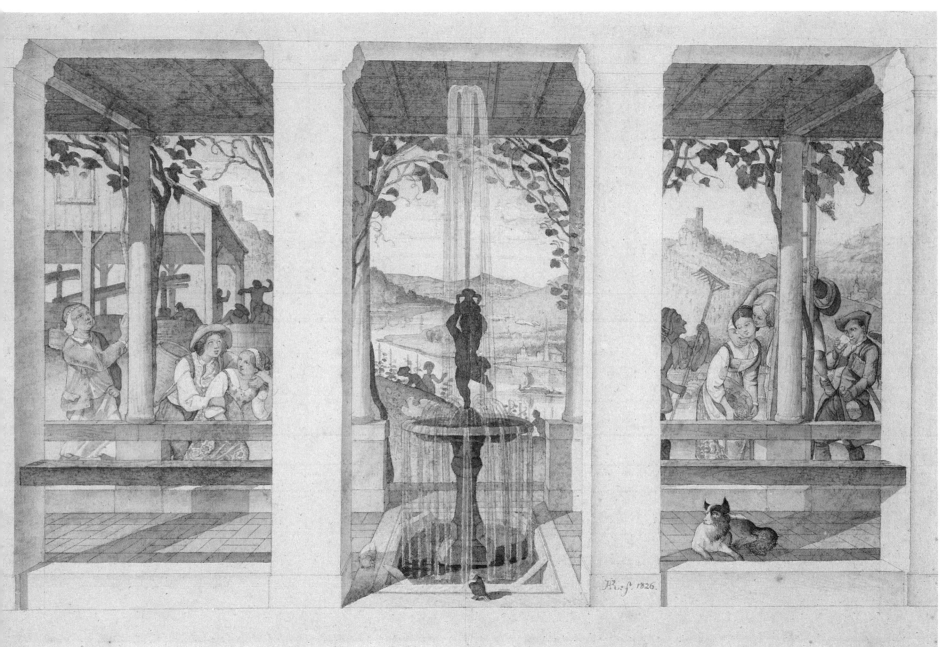

JOHANN ANTON RAMBOUX

Weinernte, 1826
pencil and
watercolour,
13 × 19½ in
(32.9 × 49.4 cm)
Wallraf-Richartz-
Museum, Cologne

THE SKETCHBOOKS

As official painter to Napoleon, David enthusiastically embarked upon a series of paintings which glorified his hero. Foremost among them was the *Sacre de Joséphine*, which commemorates the coronation of the Emperor and his consort, when Napoleon symbolically crowned himself with the ancient crown of Charlemagne. David was required to record the occasion, but it was considered politically expedient for the artist to show not the point at which Napoleon crowned himself, but the touching moment when he placed the small crown on Josephine's head, as she wept at the grandeur of the occasion. David's painting was epic in scale, and he wisely sought the assistance of a scene painter from the Opéra to deal with the perspective. When Napoleon inspected it he noted the extreme realism of the picture, saying, "What do I see? This is not painting; one can walk around in this picture: life is everywhere."

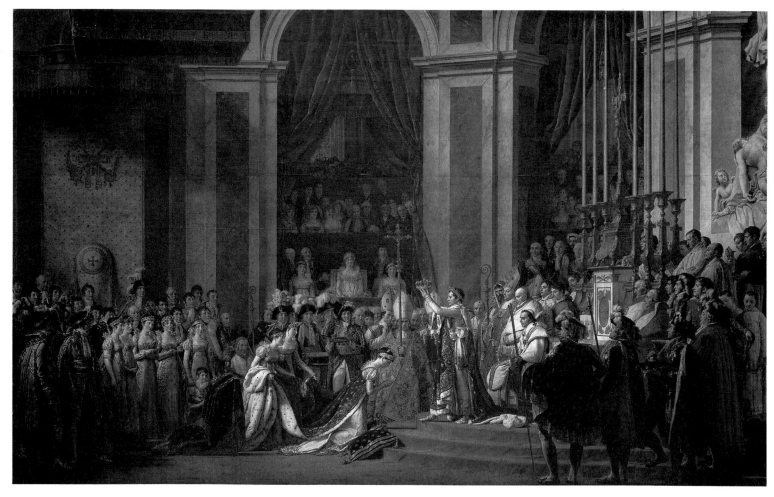

JACQUES LOUIS
DAVID
Sacre de Josephine,
1807
oil on canvas,
228 × 360 in
(579 × 914.5 cm)
Louvre, Paris

JACQUES LOUIS
DAVID

La Maréchale Soult,
1804
pencil and crayon,
8¼ × 6½ in
(21 × 16.4 cm)
Fogg Art Museum,
Harvard University

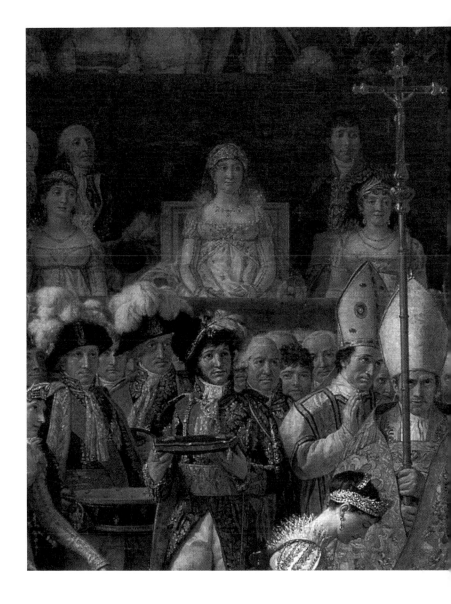

avid attended the rehearsal for Napoleon's coronation in the Cathedral of Notre Dame, and while there took the opportunity to make sketches of the main participants, first drawing them nude and then adding clothes in the traditional academic manner. Many of these studies are in a single sketchbook, now in the Fogg Art Museum (Harvard University), and they are conspicuous for their cool poise, detachment and for David's complete control of drawing.

GEORGE ROMNEY

*John Henderson:
Study for the Head
of Falstaff, c. 1780*
pencil,
5½ × 6⅜ in
(13.9 × 16.2 cm)
Fitzwilliam Museum,
Cambridge

Romney was fascinated by the theatre, which he attended frequently, and theatrical subjects were a great source of inspiration for him. John Henderson was an actor of immense popularity, whose roles in Shakespeare included Shylock, King Lear, Richard III, Don John and Falstaff, and brought him great success. He was engaged by Sheridan for Drury Lane. Romney admired him and became his friend, making sketches of the actor both in role and out, and painted his portrait as Macbeth.

The beautiful Emma Hart, later to become Lady Hamilton, and notorious as the mistress of Nelson, was Romney's favourite model. Their degree of intimacy has led to speculation that at some point they may have been lovers. Romney painted many sumptuous portraits of Emma Hart, one of the most famous being *The Spinstress*. He often posed her in the character of a figure from classical mythological literature, as shown below.

GEORGE ROMNEY

Self-Portrait, c. 1760
pencil 5¾ × 4 in
(14.6 × 10.2 cm)
National Portrait
Gallery, London

GEORGE ROMNEY

*Lady Hamilton as
Circe, c.* 1782
oil on canvas,
21 × 19½ in
(53.3 × 49.5 cm)
Tate Gallery, London

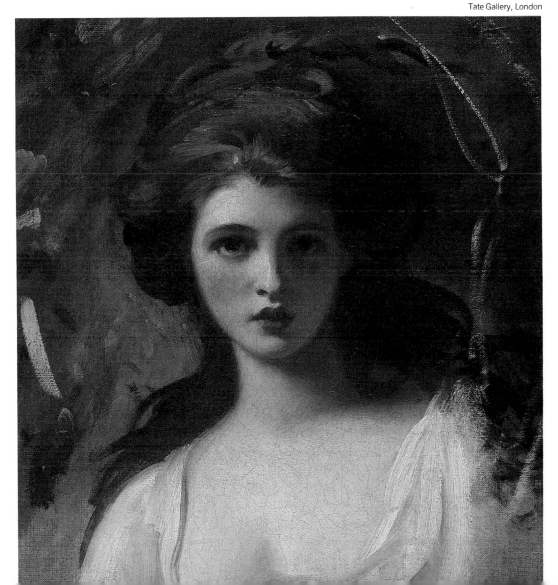

In this sensitive portrait made when Romney was a young man, the artist employs a softer and less vigorous drawing technique than in some of his other studies of this period. Romney had served his artistic training as the indentured apprentice of the itinerant artist Christopher Steele, who travelled the north of England in search of commissions.

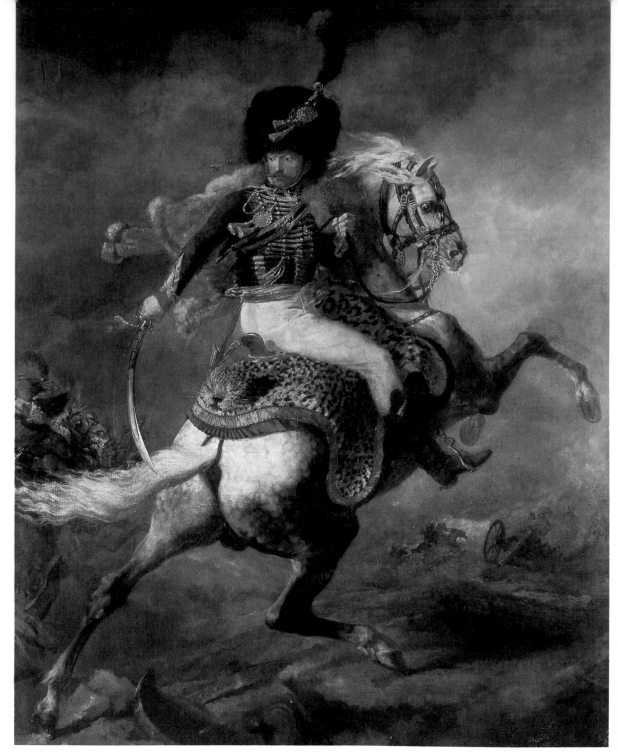

THÉODORE
GÉRICAULT

*Portrait of an Officer
of the Chasseurs
Commanding a
Charge*, 1812
oil on canvas
115 × 76⅜ in
(292 × 194 cm)

Géricault's fascination with horses was manifest in his artistic appreciation of the animal as a symbol of boundless energy. *Portrait of an Officer of the Chasseurs Commanding a Charge* was greeted as a masterpiece when it was first exhibited. The painting possesses a magnificent drama, energy and motion, as the mounted officer turns to urge his troops onwards into the flames of battle. Géricault made his sketches for the painting from a carriage-driver's horse in his studio, but the original inspiration came from an incident when the artist was on his way to a fair. On the road he encountered a magnificent rearing carriage-horse. In the words of Charles Clément: "… the high-spirited animal – red-eyed, foaming at the mouth, mane flying in the wind – reared up in all that dust and heat. The artist found his picture. The blazing sun was the one at Austerlitz. That dust became the smoke of battle. The horse was a combat charger drunk – crazed – with the smell of gunpowder … He saw it mounted by one of those daring, brilliant officers, one of those sons of Mars, those heroes or demigods of the time. It was like a vision."

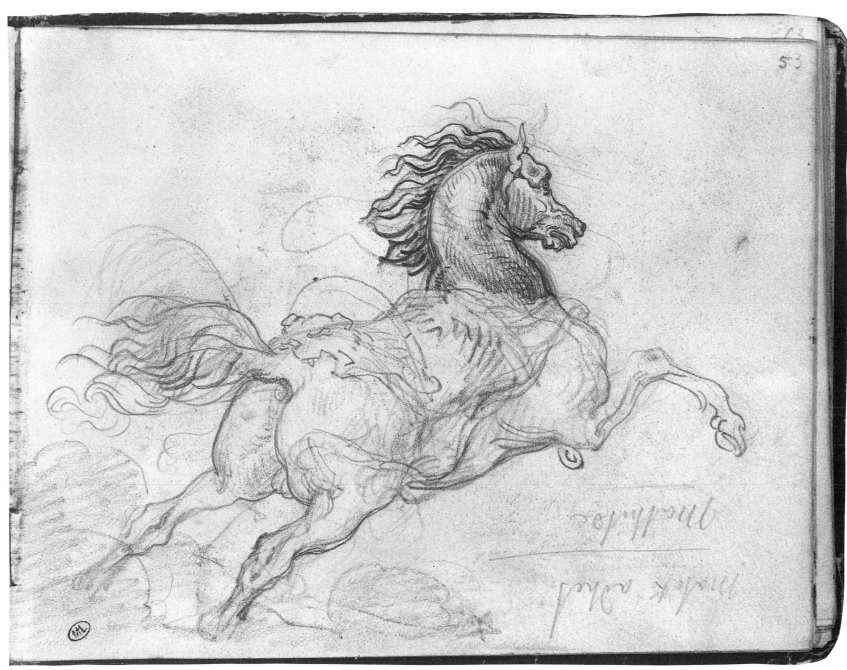

THÉODORE
GÉRICAULT
*Sketch for "Portrait
of an Officer of the
Chasseurs
Commanding a
Charge"*, Zoubaloff
sketchbook *c.* 1812
black chalk,
5 × 7½ in
(14.3 × 19 cm).

THE SKETCHBOOKS

Following Géricault's death a sale was held at the Hôtel de Bullion in Paris on 2 and 3 November 1824. It included some 33 sketchbooks, "filled with studies: figures, animals, landscape views, and compositions", according to the catalogue. Only three of these books now remain intact, the creative order of the others destroyed for ever. The most important of these books is perhaps the *Zoubaloff* sketchbook, held by the Louvre, which dates from the early period of Gericault's career. At the time he was apprenticed in the studio of Pierre-Narcisse Guérin (1774–1833), a master of the neo-classical style who also taught Delacroix and Paul Huet (1803–69). Géricault learnt from Guérin the fastidious academic series of preparations of initial sketches and more developed studies, and the Davidian planning and sketching of each element of the composition that had to be undertaken before the finished work could be begun. It was a discipline that the artist followed for the rest of his life, and such careful planning was entirely necessary for works on such an epic scale as *The Raft of the Medusa*.

The Zoubaloff sketchbook contains many studies for Géricault's dynamic painting *Charging Chasseur*, but it also includes more prosaic sketches, such as this portrayal of a series of classical tableaux, any one of which could easily form the basis of a finished composition. Carefully drawn in pen and ink, they are reminiscent of the narrative quality of a frieze, and it seems likely that each sketch depicts an event from a story or drama for which Géricault was perhaps planning a series of illustrations.

THEODORE GÉRICAULT

Academic Studies, pencil, pen and ink and wash, 5 × 7½ in (14.3 × 19 cm).

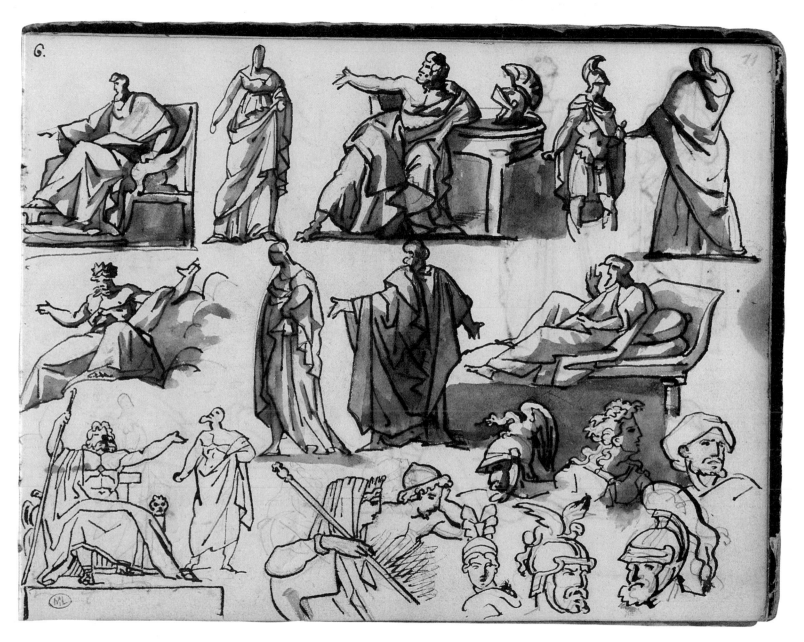

THEODORE
GÉRICAULT
Academic Studies,
pencil, pen and ink
and wash,
5 × 7½ in
(14.3 × 19 cm).
Louvre, Paris

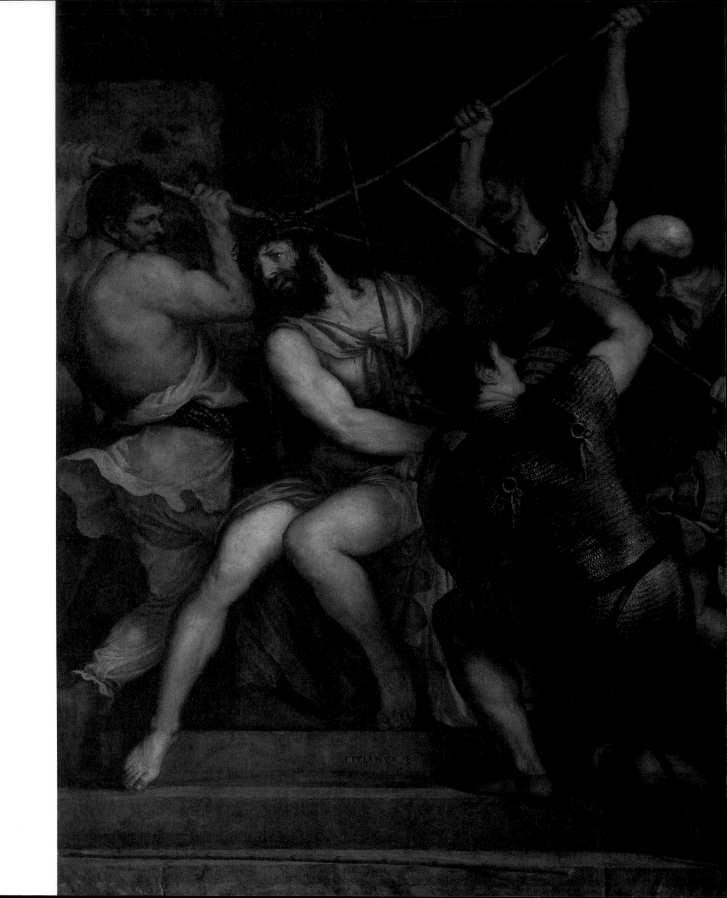

Titian was one of the
greatest proponents of
colour and painterliness of the
High Renaissance. His
paintings employ a
magnificent use of texture and
tone, enjoying a vigorous
application of paint and
sumptuous colouring, usually
at the expense of a more linear
draughtsmanship.
Michelangelo remarked to
Vasari that Titian would have
been a truly great artist if he
had learned to draw.
However, it is clear why
Turner found his paintings so
attractive, for they possess the
same qualities present in his
own work. Making notes on
his copy of *Christ crowned
with Thorns*, Turner writes:
"This picture is wholy
different as to effect the most
power full is the flesh the
drapery consists only to
extend the light upon the
Soldier to the right and by
being yellow to keep up
warmth and mellows the flesh
of the force of the Brutal
Soldier with filial resignation
yet with dignity ..."

TITIAN

Christ crowned with
Thorns, 1542–7
oil on panel,
711 × 462 in
(280 × 182 cm)
Louvre, Paris

J.M.W. TURNER

Copy after Titian's
"Christ crowned with
Thorns", 1802
pencil and
watercolour,
5 × 4½ in
(12.7 × 11.5 cm)
Tate Gallery, London

O n his return journey from the Alps on his first Continental tour of 1802, Turner stayed in Paris. During his campaigns Napoleon had looted paintings, sculptures and artefacts from all over Europe and had collected them together in the Louvre, where they were on view. Turner spent many hours in the new museum studying the works of the Old Masters and making copies of them in his sketchbooks. On this page in his *Studies in the Louvre* sketchbook Turner has carefully copied Titian's masterpiece *Christ crowned with Thorns*. The book contains many other such exercises which detail Turner's fascination with the paintings he was able to see for the first time.

Travels and Tours

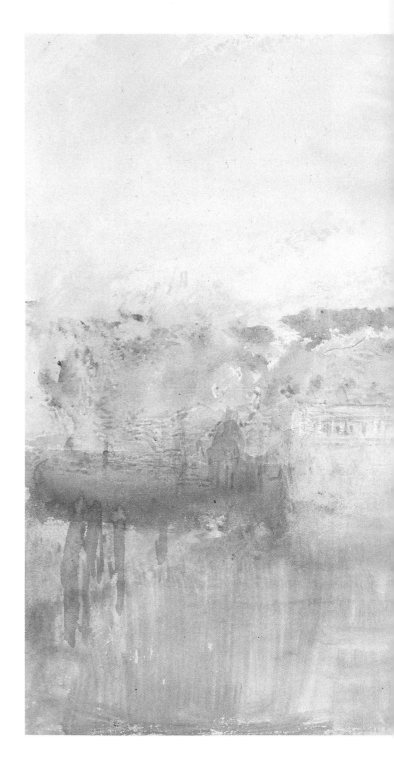

A desire for sensation and experience naturally led artists to explore the world in search of inspiration from nature and the exotic, or merely in pursuit of new material with which to formulate their compositions. Encouraged by the writings of figures such as William Gilpin, who advised the artist to undertake "Picturesque Tours", the desire to travel became more and more widespread during the second half of the eighteenth century. The publication of descriptive accounts of tours had become immensely popular towards the end of the eighteenth century, as had travel guides, so that artists were able to plan their tours in advance and identify places of likely aesthetic interest.

Many of the guides were somewhat pompous in style, but this was not the case with Joseph Craddock's *Account of some of the most Romantic Parts of North Wales*, published in 1777. In his introduction Craddock declares:

"as everyone who has either traversed a steep mountain, or crossed a small channel, must write his Tour, it would be almost unpardonable in Me to be totally silent, who have visited the most uninhabited regions of North Wales — who have seen lakes, rivers, seas, rocks, and precipices, at unmeasurable distances, and who from observation and experience can inform the world, that high hills are very difficult of access, and the tops of them are generally very cold."

Travel was popularly conceived as an activity that

Turner generally used soft-backed roll sketchbooks for his watercolour studies of Venice. His usual technique in such works was to make an initial brief pencil sketch and apply colour later, sometimes finishing by highlighting the details in pen and ink. Here (*Venice: A Campanile and other Buildings with a Fishing Boat, c.* 1840) he has used watercolour alone to evoke the calm, reflective quality of the water, the washes being applied wetly so that some colours bleed into each other, making it unclear in places where object ends and reflection begins.

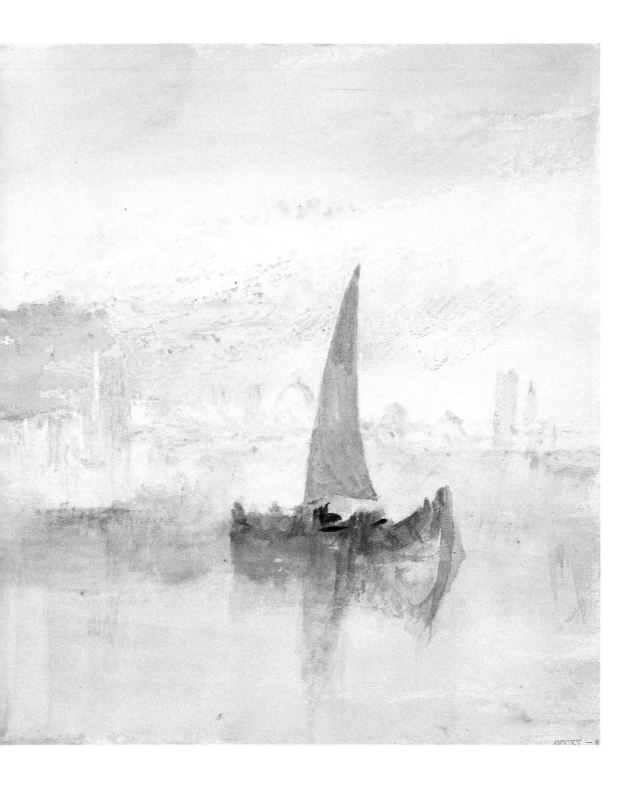

could enlighten and broaden the mind, which fitted well with the Romantics' belief in the immersion of oneself in the natural and of communion with nature.

THE LURE OF BANDITRY

There was also a conscious desire for adventure, and a belief that picaresque travel was a means to achieve this. Tales of the romantic lifestyles of bandits and gypsies abounded in the popular literature of the early nineteenth century, and artists were not alone in wanting to emulate what they perceived as a pleasant, carefree existence. The realities of the hardship of such a life were usually completely ignored or idealized, and bandits were portrayed as Robin Hood figures, committed to the fighting of injustice, rather than as criminals. Brigand bands certainly did exist, especially in some Alpine regions and in Spain, Southern Italy and Greece, but the reality was that they could be quite ruthless, making travel in those areas hazardous. Nevertheless, the attraction of the nomadic existence on the margin of society persisted, and it was a popular choice of subject for more minor Romantic artists. The Swiss artist Léopold Robert painted no fewer than 14 variants, all popularly received, of his *Sleeping Brigand*. The composer Berlioz, while a student at the French Academy at Rome, once even went so far as to go out looking for a brigand band to join, so that he could share the ideal life he believed they led. His search was unsuccessful, however, and he remained disappointed.

CLASSICAL THEMES

Academic perceptions of art in the eighteenth and early nineteenth centuries glorified the culture of the ancient civilizations of Greece and Rome, and artists were encouraged to witness the relics of the Classical world at first hand by visiting these countries. Rome, particularly, offered an unsurpassed assemblage of art. In 1734 the Capitoline Museum, the first public collection of classical sculpture, had been established, and in 1771 the Museo Pio Clementino was founded.

THE SKETCHBOOKS

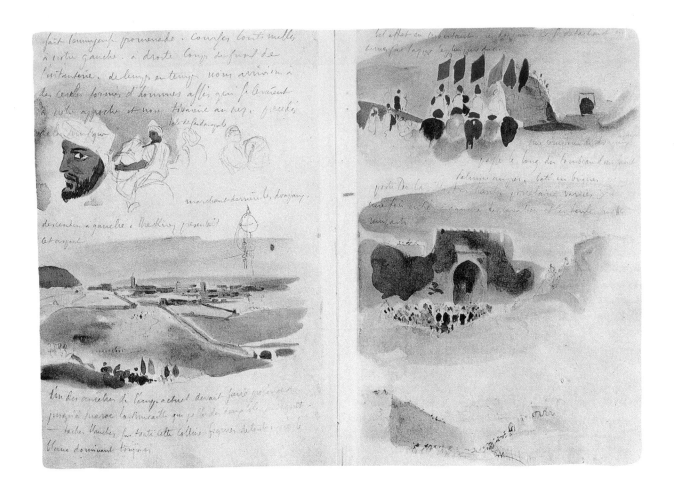

*E*ugène Delacroix, *Moroccan Scenes*, 1832). Two crowded pages from Delacroix's visit to Morocco and North Africa show that there were places other than Rome, with its antique grandeur, that could supply the Romantic artist's yearning for the exotic and compelling.

Artists would also try to visit private collections of Old Master drawings and paintings, notably those of the Villa Borghese and the Villa Albani, and they would naturally visit the Vatican to see the frescoes of Michelangelo and Raphael, making copies of all these works in their sketchbooks. Outside Rome, the picturesque vistas of the Campagna formed a natural source of inspiration for landscape artists, while the city itself contained a plethora of Classical architecture and ruins that were irresistible subjects. Rome became a centre for art study with a number of both formal and informal academies, and by the later eighteenth century it had become a meeting-place for artists of all nationalities, not only to appreciate the culture of the ancient world, but also to be exposed to the influences of their contemporaries. A respect for and interest in antique art was an attribute of almost all artists, whether Neo-Classical or Romantic, although they might approach the material in slightly different ways.

In the final years of the eighteenth century and the early years of the nineteenth, the Napoleonic Wars much disrupted Continental travel, and English artists found themselves particularly isolated. The brief ceasefire of 1802 between England and France, the Treaty of Amiens, saw a flood of artists cross the

Channel to Paris. There they were able to admire the Old Master paintings and antique sculpture that Napoleon had looted from all over Europe and brought together in the Louvre. Many also found much to admire in the figure of Bonaparte himself, whose life was to become the epitome of that of the Romantic hero.

TURNER, CONSTABLE AND DELACROIX

Some artists were by nature more itinerant than others, and were possessed of a different or more developed sense of place. J.M.W. Turner (1775–1851) travelled throughout his own country as well as to France, Switzerland, Italy, Germany and the Low Countries, filling nearly 300 sketchbooks with his observations. Certain places appealed to him more than others. He returned again and again to Venice, the Alps and certain areas of England, using them as the subjects for his work, but neglected the artistic merit of other places such as London, where he spent most of his life. Turner appears to use certain places as a tool to evoke particular moods or sensations within himself, and hence in the works he executes of these sites. His watercolours of Venice record his sensuous reactions to bright light, warm shadows and limpid water, while the cold, inhospitable grandeur of the Alps apparently evokes in him feelings of melancholy as well as admiration.

Turner had the ability to come to terms with a new place relatively quickly and to present the sum of it in his sketches. For John Constable this was more difficult. At an early age he had decided to concentrate his artistic activities upon the depiction of the area where he grew up in Suffolk, which he knew well and for which he had developed deep feeling. His journeys to other places were rarely solely for artistic purposes, as is the case with Turner or Delacroix, and sketching of new sites was almost an incidental activity. Journeys to Brighton were for the benefit of his wife's health, his time in Salisbury primarily a social visit to his friend Archdeacon Fisher, and although it was natural for

*I*n this pencil and watercolour sketch (*View in the Grounds of Arundel Castle*, 1835), Constable has made use of the technique of "scratching out", most notably to give definition to the trunks of the trees to the right, and the tower in the middle distance on the left of the composition.

the artist to make sketches and paintings of these places, Constable seems most at ease and at his most sensitive when depicting the landscape around his home.

Eugène Delacroix's visit to Morocco and North Africa in 1832 marked a turning-point in his development as an artist, and clearly shows how some artists could react entirely favourably to new, strange or exotic scenes. Delacroix found the experience of Morocco, so different from anywhere he had been before, immensely stimulating and inspiring. He made careful notes and sketches of the country in his sketchbooks to record his fascination, and was able to use these on his return as the basis for a large number of drawings and paintings with Arabic subjects.

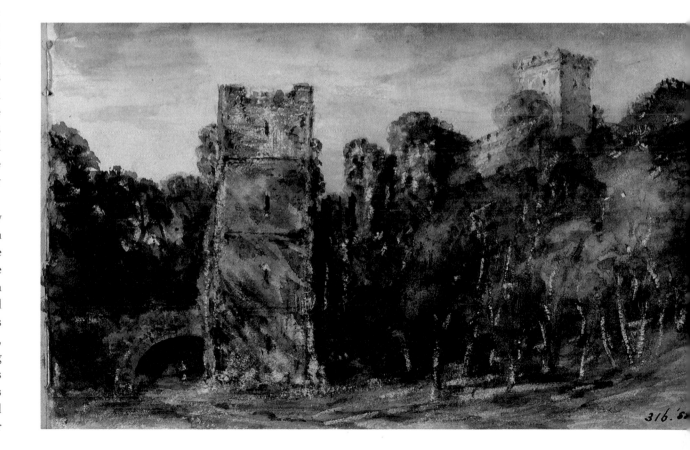

THE SKETCHBOOKS

*L*eaving Dover in July 1819, Turner went to Italy by way of Paris, Lyons and the Mont Cenis Pass, armed with a collection of guidebooks and notes which detailed an arduous itinerary. He visited most of the major towns of Italy, including Turin, Milan, Verona, Bologna, Naples, Florence, Rome and Venice. In this drawing from his *Milan to Venice* sketchbook, Turner displays his magnificent ability and complete confidence as a draughtsman, as across a double spread, and without any use of construction lines, he perfectly and highly accurately captures the view up the Grand Canal from near the Accademia di Belle Arti. The buildings on the left are the Palazzo Balbi and the Tower of the Frari; to the right of the drawing are the Palazzi Garzoni and Grassi, and the Campanile di S. Stefano.

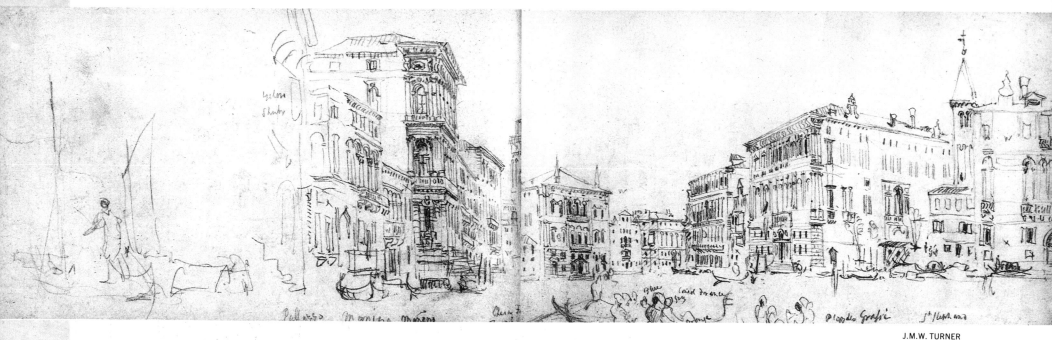

J.M.W. TURNER

Venice: looking up the Grand Canal, 1819
pencil,
4½ × 7½ in
(11.5 × 19 cm)
Tate Gallery, London

PART TWO

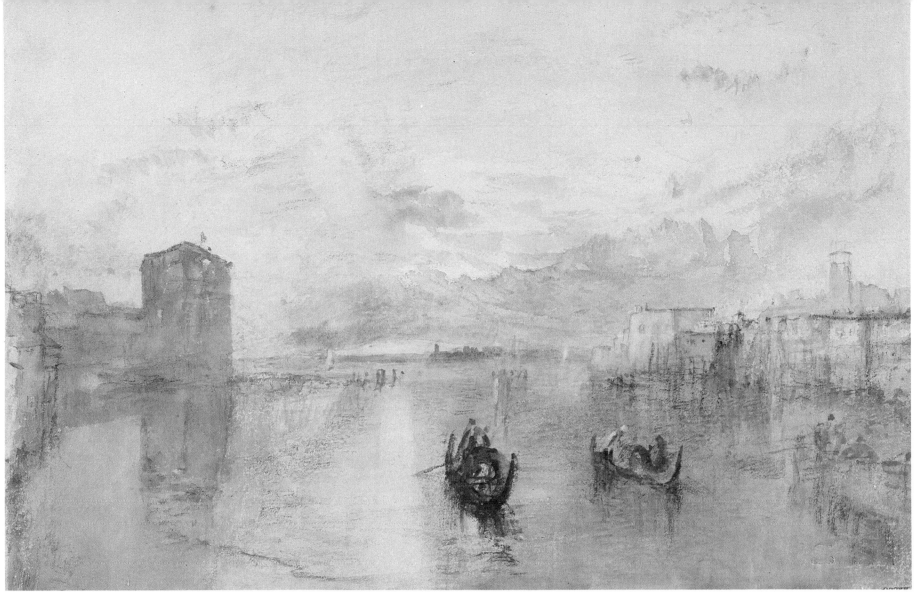

J.M.W. TURNER

Venice: the Giudecca, looking towards Fusina,
c. 1840
pencil, watercolour
and red and black
chalks,
8¹¹⁄₁₆ × 12½ in
(22.25 × 31.75 cm)
Tate Gallery, London

*A*fter making an initial pencil sketch on the spot Turner liked to combine a whole range of techniques and media in his works on paper, and could have a very vigorous approach to watercolour. In this archetypally Turnerian study of a Venetian sunset, with the rays of the sun reflecting out across the water, the artist has employed a wide variety of techniques, ranging from the fluid applications of watercolour of the sky and buildings, to the shorter dappled and hatched brush-strokes of the reflections on the water. Turner has finished the study by applying coloured chalks.

THE SKETCHBOOKS

*I*taly was a country which almost all artists of the Romantic period aspired to visit. In Italy artists could study the achievements of the classical world and the ancients, and by the mid-18th century Rome had become the artistic centre of the world. Dahl travelled to Italy and made many sketches of what he saw in the country. Here he studies the Temple of Vesta at Tivoli. The area in and around Tivoli was considered one of the most beautiful in Italy; the artist Thomas Jones commented that he believed it "formed in a peculiar manner by Nature for the Study of the Landscape-Painter".

*O*n the night of 16 October, 1834, the complex of buildings that made up the Palace of Westminster, some dating back to medieval times, burnt to the ground. Turner witnessed the fire, hurriedly going down to the Thames and watching the progress of the destruction from a rowing-boat on the river which he shared with his friend and fellow Academician Clarkson Stanfield. It seems likely that the series of watercolours in the sketchbook from which this sheet comes were all made on the spot, for not only do they possess a vibrant immediacy, but the reverse of each sheet has blotted colour on it, implying that Turner eagerly turned the pages of his book before each colour sketch had properly dried. The artist subsequently made the fire a subject of two oil-paintings.

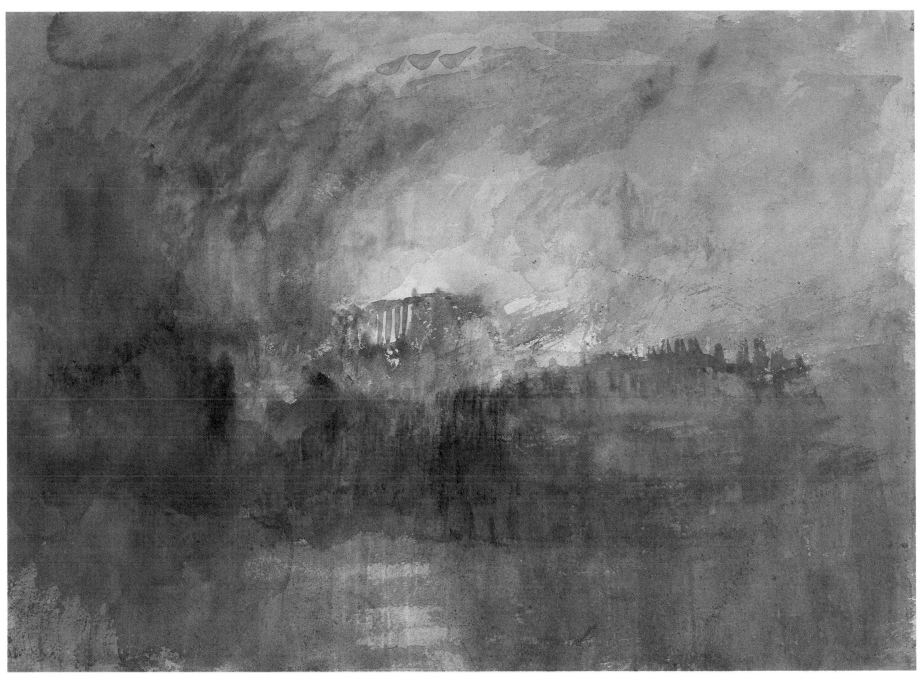

J.M.W. TURNER

The Burning of the Houses of Parliament, 1834

watercolour,
9¼ × 12¾ in
(23.5 × 32.4 cm)
Tate Gallery,
London

THE SKETCHBOOKS

John Constable and Stonehenge

Informal pencil self portrait made in 1806 (*left*). From an original pencil sketch made on the spot (*below right*, 1820), Constable copied the design on to a larger sheet which he squared up for transferral (*below left*, 1836). By marking the paper on which he was to execute the finished work with a grid of larger scale he was able to transfer the composition accurately and to enlarge it.

In 1820, John Constable visited his old friend, John Fisher, an archdeacon at Salisbury Cathedral. He took with him his wife Maria and their two children. The visit lasted some weeks, and during this time Constable sketched Salisbury and the surrounding area. He was especially impressed by the cathedral, and made a number of large open-air oil studies. On 15 July he visited Stonehenge, where he made pencil drawings in his sketchbook. There was much antiquarian interest in the ancient monolith at this time, and it was a popular attraction, but it was 16 years before Constable chose to use it as the subject for the fully developed watercolour.

Constable seems to have been pleased with the result of his labours, for he wrote to his friend and fellow-artist Charles Robert Leslie: "I have made a beautiful drawing of Stone Henge. I venture to use

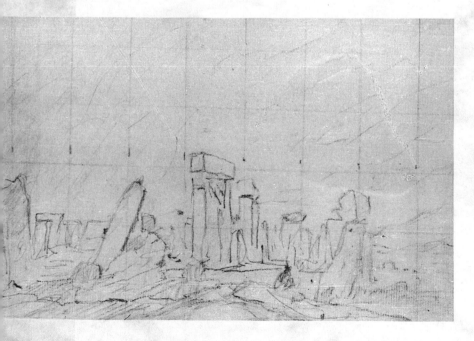

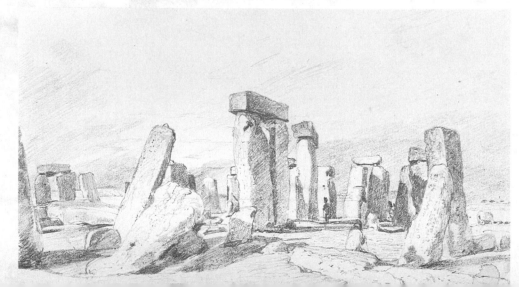

such an expression to you." The mood of the watercolour is quite different from the calmness of the original sketchbook drawing, for Constable uses dramatic and colourful sky effects, supporting his conviction that the sky is "the chief Organ of sentiment". Constable is also concerned with time; the transient rainbow is contrasted with the enduring solidity of Stonehenge.

Constable later made an intermediate version in watercolours, before arriving at the finished watercolour (*below*, 1836) which he exhibited at the Royal Academy.

The watercolour's mount was inscribed, apparently with the words of the artist, "The mysterious monument of Stonehenge, standing remote on a bare and boundless heath, as much unconnected with the events of past ages as it is with the uses of the present, carries you back beyond all historical records into the obscurity of a totally unknown period."

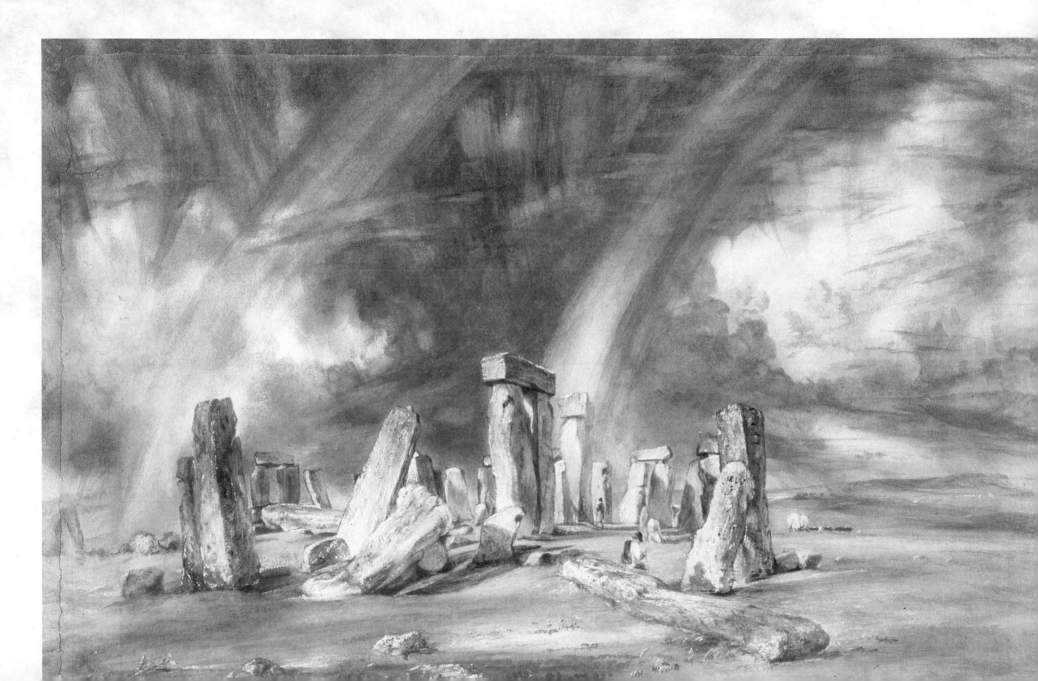

Caspar David Friedrich was foremost among the group of German artists centred in Dresden who sought to take landscape painting further than the realms of reportage and aesthetic idealizations, and imbue it with symbols and allegories that gave it a deeper and more spiritual dimension. Christian faith underlies much of his work, advancing the philosophy that human life was but a transient moment on the journey to spiritual salvation, and for this reason many of his paintings concentrate upon death and transformation. Friedrich grew up in the Pomeranian harbour town of Greifswald, and although he spent most of his professional career in Dresden he returned frequently to the area, which he found a great source of artistic and spiritual inspiration. Here he shows the ruined Cistercian abbey at Eldena, close to Greifswald, in a sketchbook study that was to be the basis of several finished works. In Friedrich's vocabulary of motifs a ruined abbey usually symbolizes an outmoded form of religion and the transitory nature of temporal life, a visual allegory he pursued in finished works such as the oil-painting *Abbey in the Oakwood*.

CASPAR DAVID
FRIEDRICH

*The Ruin at
Eldena*, 1801
pen and ink and
brown wash,
6⅞ × 13³⁄₁₆ in
(17.5 × 33.5 cm)
Staatsgalerie,
Stuttgart

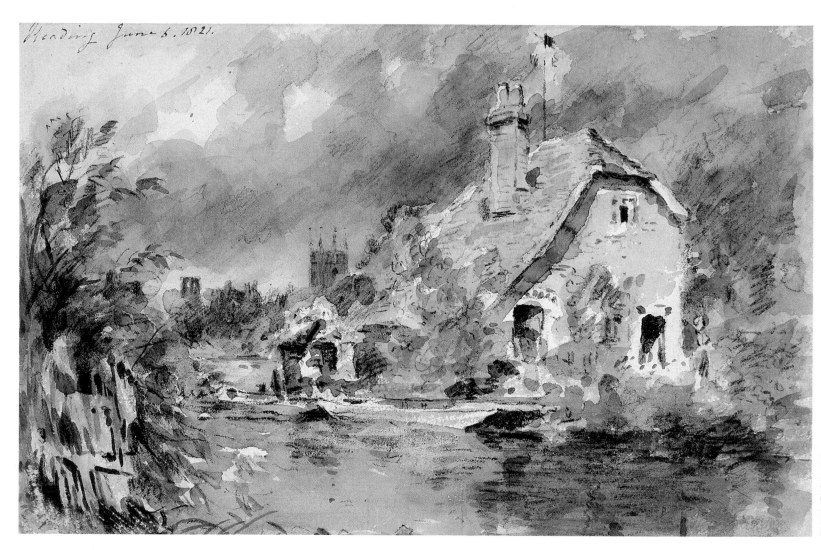

Reading June 6. 1821.

JOHN CONSTABLE
A Cottage near Reading, 1821
pencil and watercolour
6⅝ × 10⅛ in
(16.8 × 25.7 cm)
British Museum, London

Constable's friend Archdeacon Fisher invited the artist to accompany him on his tour of Berkshire and Oxfordshire on Church business during June 1821, travelling to Newbury, Reading, Abingdon and Wallingford. During the tour Constable was unusually industrious, making a number of highly finished watercolour studies in his sketchbook, all methodically (and uncharacteristically) inscribed with the date and location. This watercolour of a cottage by the Kennet at Reading is one of five views Constable made of the town. The intense colouring and fluid, flat washes of watercolour over vigorous pencil underdrawing give it great beauty. The curious object projecting out of the roof of the cottage is a weather-vane.

Thomas Jones was a well-respected landscape painter who trained under Richard Wilson from 1763 to 1765 and attended the Royal Academy schools from 1769. He preferred painting and drawing in the open air to working in the studio, and this was a practice he followed during his travels in Italy between 1776 and 1783. In both his making of oil sketches and approach to the Italian landscape Jones was much influenced by Wilson, whom he continued to refer to as his "Master".

THOMAS JONES
The Lake of Nemi and Genzano, 1776
pencil, pen and ink and wash,
7³⁄₁₆ × 5 in
(18.2 × 12.8 cm)
British Museum, London

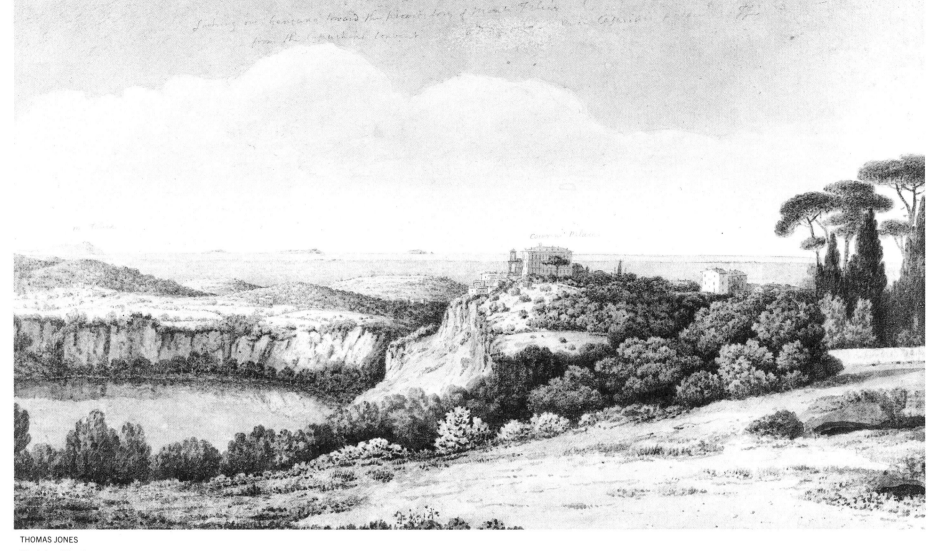

THOMAS JONES

The Lake of Nemi and Genzano,
1777
pencil and
watercolour,
9¾ × 16⁵⁄₁₆ in
(24.7 × 41.4 cm)
Whitworth Art
Gallery,
Manchester

This view in the hills around Lake Nemi was a popular spot for artists drawing Genzano, to the south-east of Rome, as it offered an impressive panorama of the surrounding countryside. Jones's composition in this finished watercolour is based upon the views in his sketchbook that he recorded, especially the sheet reproduced opposite, but his viewpoint is slightly higher up the hill, so that he can include more of the coast on the horizon. As in his sketchbook, the artist has inscribed the sheet to identify the principal features of his view. Jones visited the area several times, for it was a comparatively short distance from Rome.

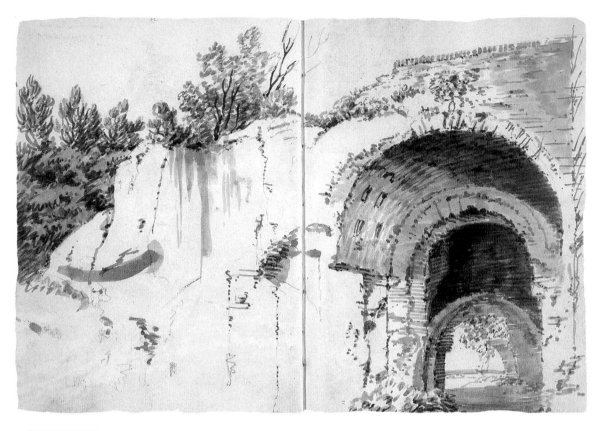

Wright has inscribed one of these sketches "Rome 27 April 74 Memy." and the other "ditto", indicating that the drawings were made later from memory, rather than on the spot. Rome was full of street scenes such as those which Wright recorded in his *Roman* sketchbook, alongside copies from the antique and studies of picturesque ruins. Wright's technique in these sketches of Roman boys is simple yet confident, the pen-and-ink lines drawn unwaveringly. The artist has produced an outline image which he has then hatched with close pen-and-ink lines to suggest shadow and thus give his image a more three-dimensional character.

JOSEPH WRIGHT OF DERBY

Study of Ruins,
1774
pencil and grey washes,
9½ × 6¹¹⁄₁₆ in
(24 × 17 cm)
British Museum,
London

Wright set out for Italy in the autumn of 1773 and arrived at Rome on 3 February the following year, taking rooms in a house in the San Trinità dei Monti area. He was accompanied by his wife, and while they were in Italy their daughter was born; they named her Romana. Wright was fascinated by the art and architecture of Rome, and he spent his first few months in the city making drawings from the antique at the Capitoline Museum and at the French Academy at the Palazzo Mancini. He was also sketching at the Vatican, making studies of the Sistine Chapel, and at the Palazzo Barberini. Later he made drawings of ruins on the outskirts of the city.

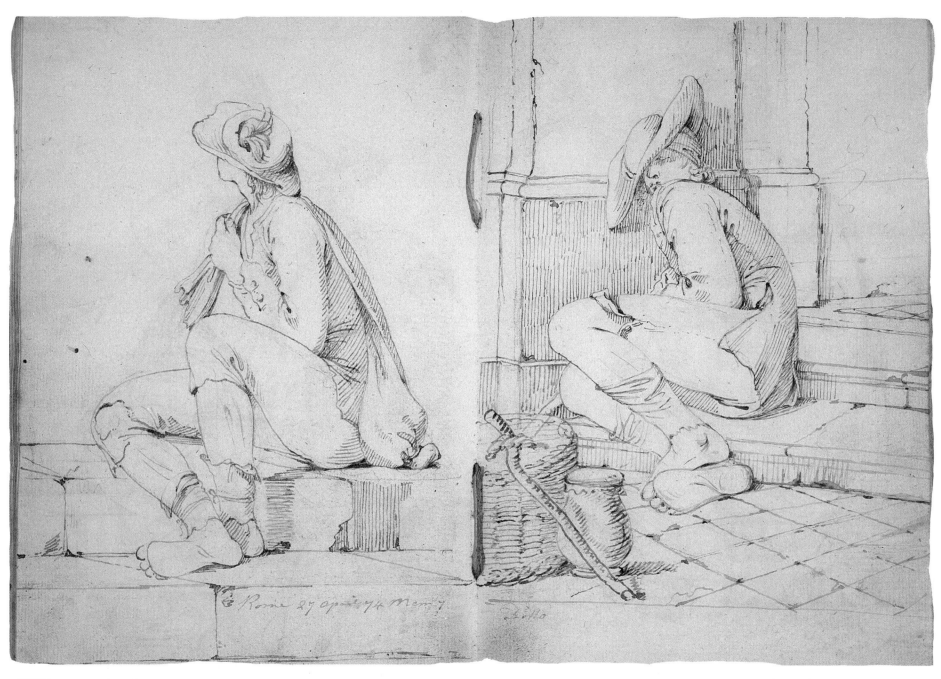

JOSEPH WRIGHT OF
DERBY

Roman Boys, 1774
pen and ink,

9½ × 6¹¹⁄₁₆ in
(24 × 17 cm)
British Museum,
London

THE SKETCHBOOKS

Turner's Calais Pier Sketchbook

In this portrait of Turner, John Thomas Smith shows him in the British Museum print room. Smith was Keeper of Prints and Drawings, and is said to have shown the portrait to the Trustees to demonstrate the vulnerability of works on paper in his care.

Turner's *Calais Pier* sketchbook is a remarkable collection of studies for many of the artist's most famous paintings from the early part of his career, when he was consolidating his youthful success. It is vital to any understanding of his work from this period. In use between 1800 and 1805, the book includes studies for paintings such as *The Shipwreck* and *The Deluge* of 1805, *Sun rising through Vapour* of 1807 and *Snow Storm: Hannibal and his Army crossing*

This print *Ships in a Breeze*, 1808, is from Turner's *Liber Studiorum*, the series of 71 mezzotints which he published between 1807 and 1819, and which he designed as a didactic exercise for every category of landscape painting. *Ships in a Breeze* is a reworking of the composition the artist used in his oil painting of 1802, *Ships bearing up for Anchorage*, which was itself preceded by the studies in the *Calais Pier* sketchbook. The artist used other successful paintings from this period as subjects elsewhere in the *Liber*.

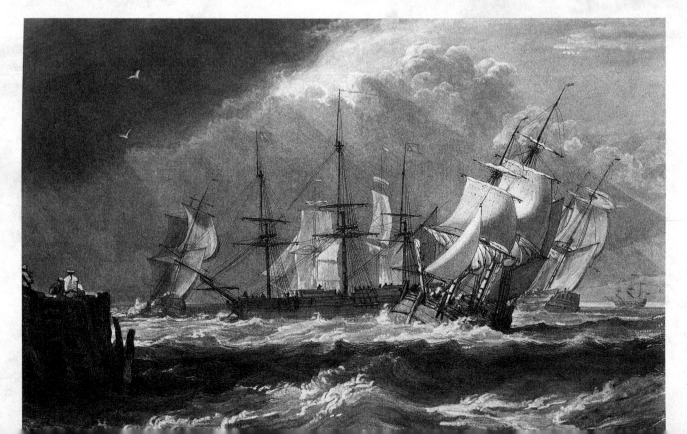

the *Alps*, exhibited in 1812. There are also studies for oil paintings that Turner failed to execute, including a scene from the legend of William Tell and another showing water being turned into blood.

Elsewhere, the sketchbook contains academic figure studies from the nude and a number of sketches of Turner's hazardous landing at Calais on his first trip to the Continent, when the small boat carrying

A sketch for the painting sold to Lord Egremont, this study in pen and ink, wash and black and white chalk on blue paper shows ships "bearing up" for anchorage. Turner shows different stages of the manoeuvre.

him to the shore was nearly swamped by heavy waves.

The sketches are almost exclusively made in pen and brown ink or black and white chalks, or a combination of these media. A small number of the sketches have been tinted with a brown ink wash. The drawing style possesses an enticing vigour and vivacity which fully shows off Turner's complete mastery of draughtsmanship. The book itself is also physically

THE SKETCHBOOKS

Turner has inscribed this spread *"M. Dobree's Lee Shore"*, referring to the buyer of the oil painting for which this sketchbook drawing is a study (*overleaf, bottom right*). The picture shows fishermen trying to put to sea from a lee shore, which is directly into the wind, a dangerous operation which could easily result in the small boat being capsized.

Several *Calais Pier* sketchbook sheets show Turner's arrival at Calais in 1802, when his boat nearly sank in high seas (*right*). This was the inspiration for his famous oil painting, exhibited the following year, *Calais Pier*

our Situation at Calais Bar

impressive, for it is among the largest of nearly 300 sketchbooks left in Turner's studio when he died, and is sturdily bound in blue marbled boards with a leather-covered spine and two decorated brass clasps.

The book's pages are made from a blue soft laid paper that is similar to the type used in the second half of the 18th century as a wrapping-paper. However, it seems likely that in this particular case the paper was specially selected to be used by artists. This type of paper was usually made from a blend of blue rags, rope sailcloth and wool.

Like many of Turner's sketchbooks from this period, the *Calais Pier* book was made by the London binder William Dickie who had premises on the Strand.

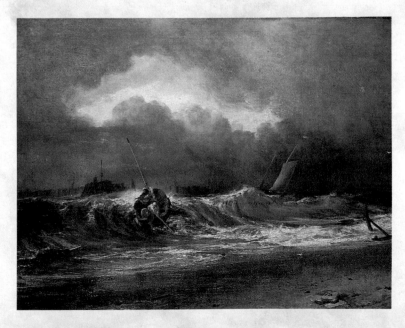

The finished oil painting, *Fishermen upon a Lee-Shore*, 1802, which resulted from Turner's *Calais Pier* sketches is clearly influenced by the Dutch Old Masters, whom the artist greatly admired at this time. Stormy skies separate to reveal an area of light which indicates redemption from the destructive forces of nature, although in more practical terms it also lends the picture greater visual contrast.

THE SKETCHBOOKS

The small sketchbook that Constable took with him on his visit to Sussex in 1835 (which is half-bound in gold-tooled green leather with marbled boards and, curiously, a button with the remains of a green silk ribbon which Constable has sewn on to the back cover) is filled with both pencil sketches and colour studies of Sussex scenes. Constable visited Middleton Church, which is on the coast to the east of Bognor Regis, on 10 July, and the sketchbook contains a number of studies of it. As it was near the sea, the land around Middleton Church was constantly being eroded, and by the time Constable visited it much of the churchyard had been swept away. This could lead to some macabre sights as graves were opened by the sea, and on one of the pages of his sketchbook Constable has sketched a skeleton he saw lying in an exposed chalk bank.

JOHN CONSTABLE
Middleton Church, 1835
pencil and grey wash, 4½ × 7⅜ in (11.5 × 18.8 cm)
Victoria & Albert Museum, London

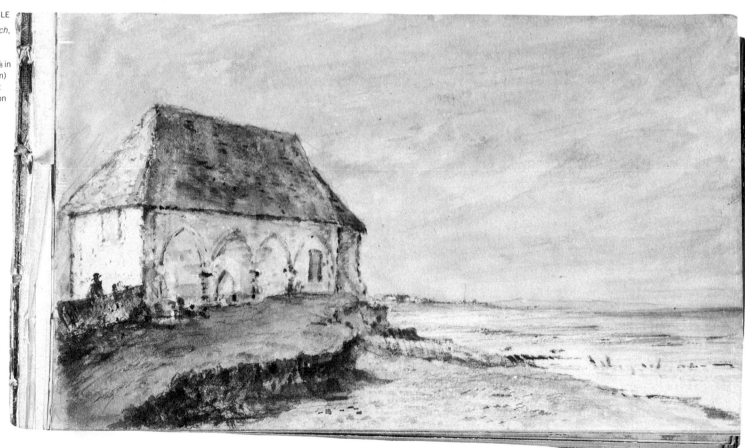

SAMUEL PALMER

St Catherine's Hill near Guildford,
1844
pencil and
watercolour,
7³⁄₁₆ × 10¾ in
(18.3 × 27.3 cm)
Victoria & Albert
Museum, London

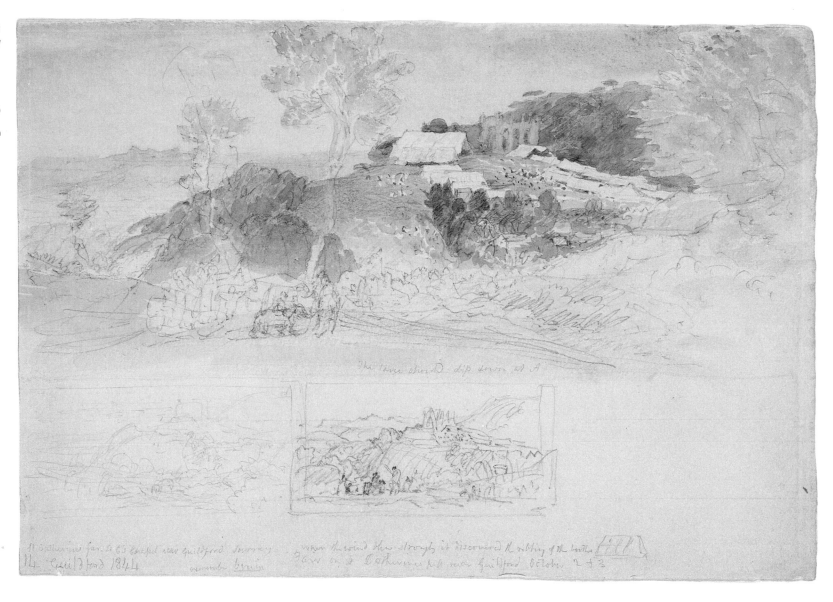

On his sketching tour of the Guildford area in the autumn of 1844, Palmer encountered the fair on St Cathcrinc's Hill, which was held every October from 1752 to 1914. Palmer was much interested in the effects of light at this time, and his preoccupation is evident in this unfinished watercolour sketch, which is suffused with the warmth of the October sun and the russet hues of autumn.

Varley made this careful and precise record of Bamburgh Castle from the south-east while on his Northumbrian tour of 1808. The castle was to form the subject of a finished watercolour, although based on other studies from the same sketchbook. The castle stands on the outcrop of Whin Sill on the Northumbrian coast, commanding views across the sea and surrounding countryside as far as Holy Island. Varley's view is from a position on the beach below the ramparts.

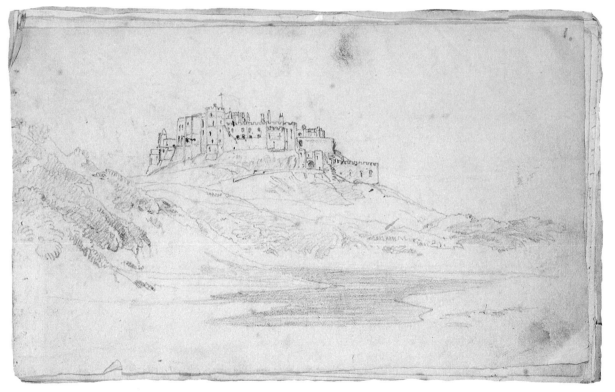

JOHN VARLEY
Bamburgh Castle,
1808
pencil,
4⁵⁄₁₆ × 7¼ in
(11 × 18.4 cm)
Victoria & Albert
Museum, London

Varley was justly famous during the early 19th century as one of the finest watercolourists of the British school, and his work commanded high prices at the exhibitions of the Old Water-Colour Society. His ability to work quickly yet brilliantly was legendary. Varley taught artists including John Linnell, William Turner of Oxford, Peter de Wint, William Mulready, William Henry Hunt and Anthony Vandyke Copley Fielding. This finished watercolour displays all of Varley's capabilities as a watercolourist; the long narrow panoramic format and concentration upon sky effects are typical of his work at this time. Views in Wales, where he had toured extensively, were a particularly favourite subject for the artist; and Dolgelly Bridge was a popular location of noted picturesque beauty which much appealed to artists and travellers alike.

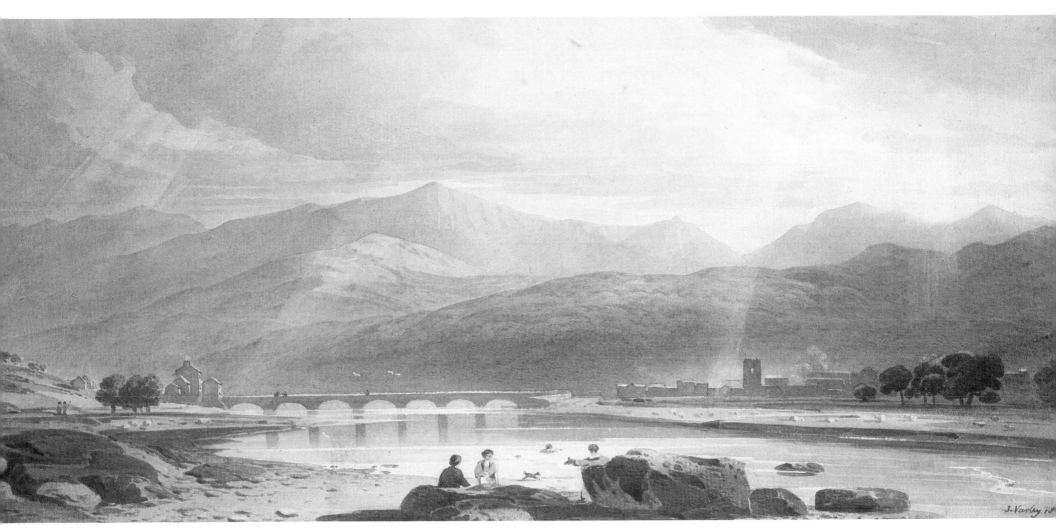

JOHN VARLEY
Dolgelly Bridge
North Wales, 1811
pencil and
watercolour,
$8^{11}/_{16} \times 18^{7}/_{8}$ in
$(22 \times 48 \text{ cm})$
Victoria & Albert
Museum, London.

THE SKETCHBOOKS

Before Turner left on his first visit to Italy he consulted a number of guide books to the country and made a careful itinerary. This sheet from his *Italian Guide Book* sketchbook is one of many in the book which includes a large number of small studies of famous Italian landmarks, and are interesting because they were executed before Turner ever left England. The designs are all copied from the plates in *Select Views in Italy, with Topographical and Historical Descriptions in English and French* published by John Smith, William Byrne and John Emes in 1792–6, and it seems that Turner was making a visual directory of all the places he wanted to visit on his tour.

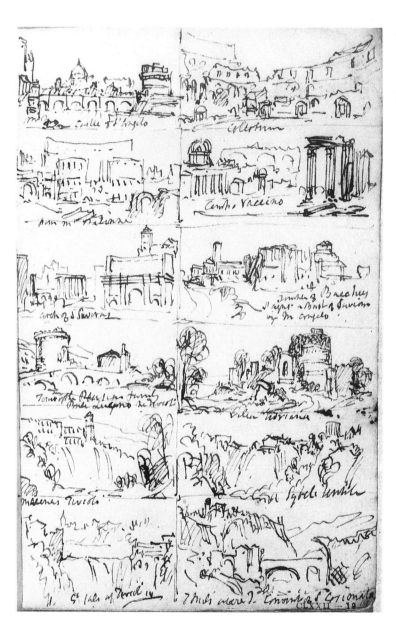

J.M.W. TURNER
Italian Scenes
1819
pen and ink,
6⅛ × 3¹⁵⁄₁₆ in
(15.5 × 10 cm)
Tate Gallery,
London

J.M.W. TURNER
Lausanne, with the Lake of Geneva,
1841
pencil, watercolour
and pen and ink,
9⅛ × 13¹⁄₁₆ in
(23.2 × 33.2 cm)
Tate Gallery,
London

This sketchbook sheet was one of 15 studies which Turner made to give an indication to potential clients of what a finished version of each subject might look like. These sketches are, in fact, the apotheosis of Turner's mature watercolour style, something the artist himself recognized, and his Swiss material from this last stage of his career is among the most emotionally intense of his entire output on paper.

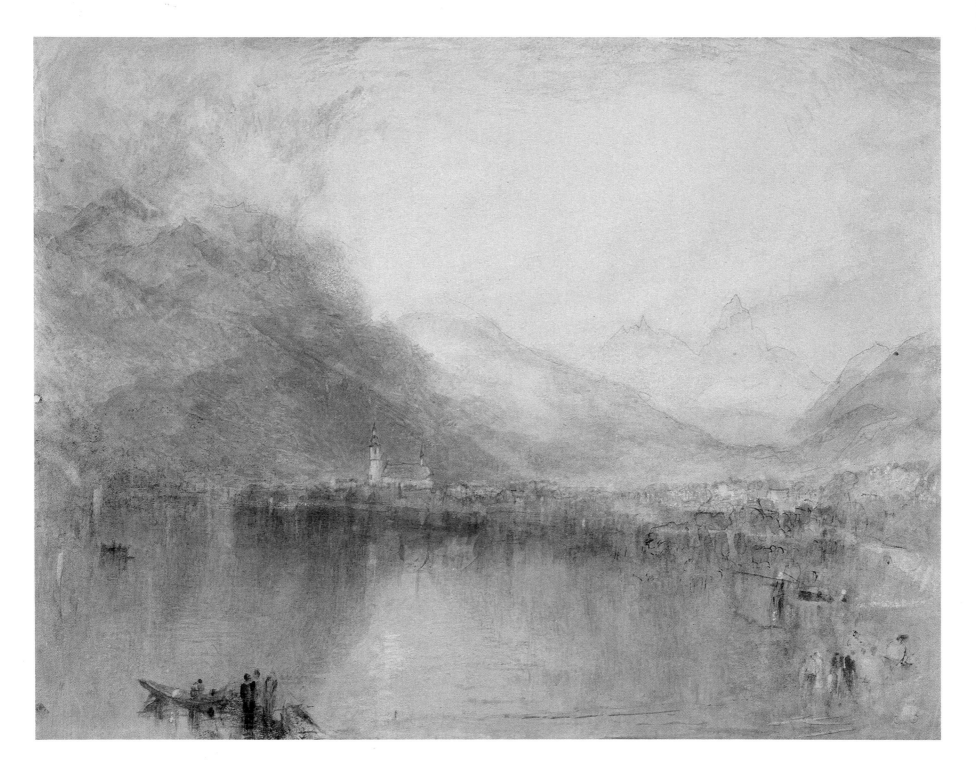

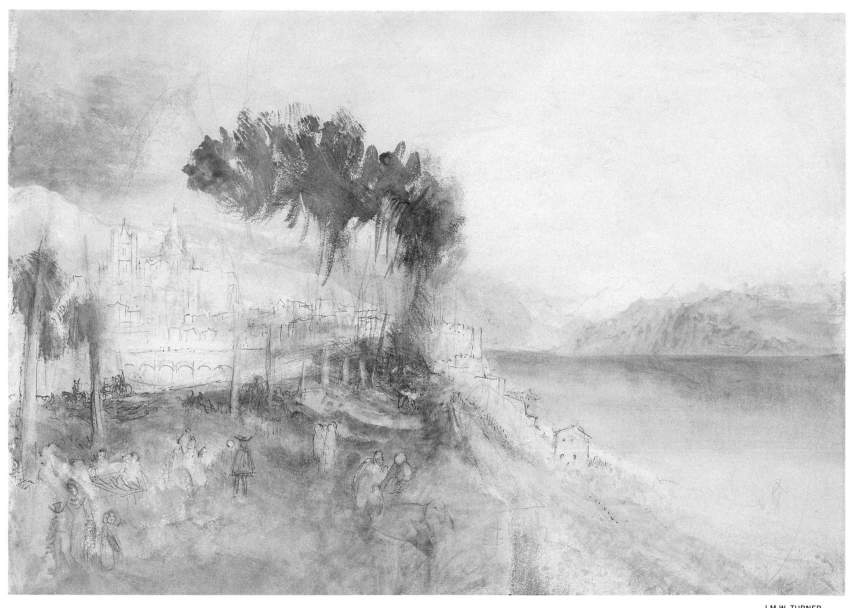

J.M.W. TURNER

Arth from the Lake of Zug, c. 1842
watercolour,
9¹⁄₁₆ × 11½ in
(23 × 29.25 cm)
Tate Gallery,
London

The artist has first made a rapid and broad sketch in pencil, and then applied watercolour washes in a range of techniques from wet washes to dry brushwork and textured brushstrokes. Turner has finished by briefly outlining some of the main architectural features and people in pen and red ink to give the entire composition definition and cohesion.

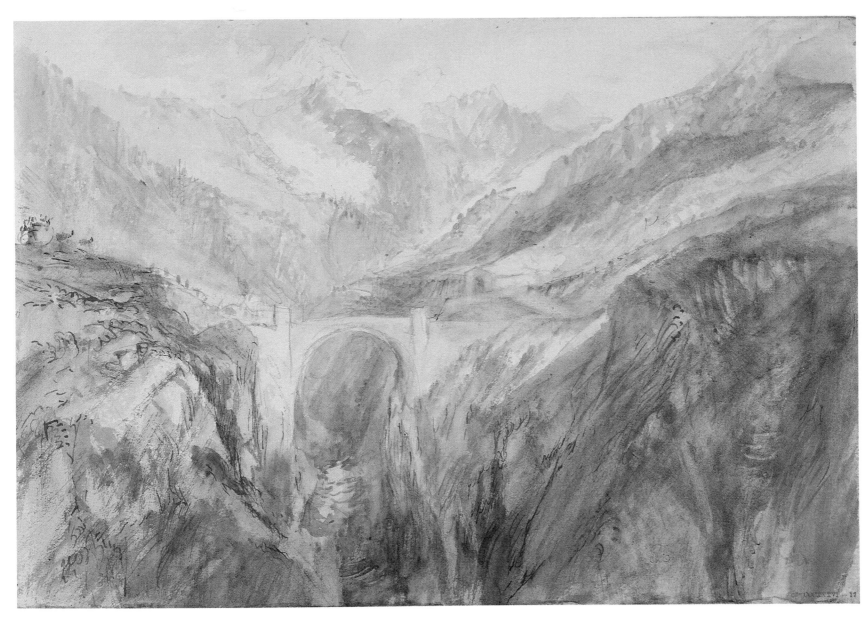

J.M.W. TURNER

*Bridge on an
Alpine Pass*, 1843
pencil, watercolour
and pen and ink,
8¹³⁄₁₆ × 12⁷⁄₈ in
(22.4 x 32.7 cm)
Tate Gallery,
London

In this watercolour, where the artist has made great use of pen and ink work to suggest the striations of the rocks in the foreground and middle distance, he perfectly evokes the immensity and sombre atmosphere of the Alps. Sensations of height and depth are polarized by his concentration on the bridge, built by Napoleon, which he has placed at the same level as the viewer, a familiar device in several of his Alpine views.

Delacroix's Moroccan Expedition, 1832

Eugène Delacroix *Interior with Women* (1832), pencil and watercolour, 7¹¹⁄₁₆ × 5⅛ in (19.5 × 13 cm). Delacroix carefully recorded what he saw, often making notes for full accuracy in later works based on the sketches. Here, he noted that the door posts were red.

When Delacroix's friend the Duke de Mornay was appointed as Louis Philippe's envoy to the Sultan of Morocco, he invited the artist to accompany him on the overland trip to North Africa. The party arrived in Tangier in January 1832 and Delacroix was immediately struck by the exotic quality of the country, and also its historical links, which allowed him to imagine he had been transported back to the classical world. "Just imagine", he wrote to his friend Pierret in February

Eugène Delacroix *Arch and Doorway* (1832), pencil and watercolour, 7¹¹⁄₁₆ × 5⅛ in (19.5 × 13 cm). Views through doorways or arches are a common subject in Delacroix's Moroccan sketchbooks, enabling the artist to present compositions with interesting perspectives and also frequently allowing him to show contrasts of light and shade to beautiful effect.

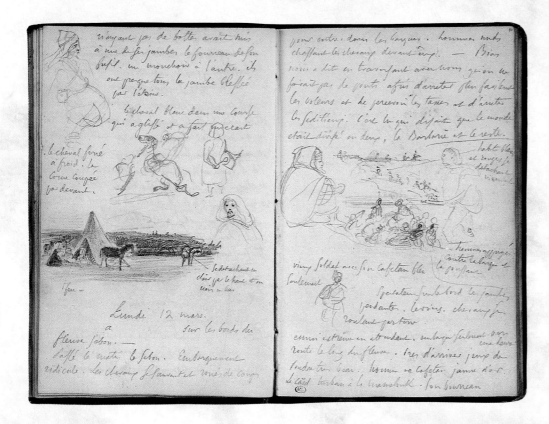

Notwithstanding the fact that many of them already reminded him of images from the classical world, Delacroix found the Moroccans infinitely more exotic and compelling. His enthusiasm bubbles over in a letter he wrote to a friend: "The Romans and Greeks are here at my door ... If art schools continue to restrict young sucklings to subjects such as the Muses, the families of Priam and Atreus, I am convinced ... that it were infinitely better for them to be shipped off as cabin boys to Barbary on the first ship, rather than weary any longer the classical land of Rome. Rome is no longer to be found in Rome."

The sketches were often made rapidly, sometimes executed while the artist was on horseback during the journey from Tangier to Meknès, where the envoy's party were received by the Sultan. Baudelaire reported that Delacroix "had a passion for notes and sketches and made them wherever he was", and it does seem that the artist must have drawn almost compulsively. Entirely typical of his crammed sketchbooks is one spread in which he has included various studies of Arab men, a view of the city of Meknès, some

1832, "what it means to see, lying in the sun, walking the streets, repairing shoes, Consular types, Catos, Brutuses, not even lacking the disdainful air which the masters of the world must have worn ... I tell you, no one will ever believe what I am bringing back." What he brought back were seven sketchbooks filled with notes and drawings which recorded every aspect of Moroccan life – the customs and dress of the people, their architecture, and the landscape, animals and vegetation of their country. Delacroix was fascinated by his tour of Morocco and North Africa, and his experiences of a culture that was ripe with colour and exoticism was a revelatory inspiration that marked a turning-point in his development as an artist, an interlude after which his art completely changed.

Delacroix seems to have been particularly entranced by the Moroccan people, sketching them endlessly.

Eugène Delacroix *Studies of Arabs and Moroccan Scenes* (1832), pen and ink and watercolour, 7¹¹⁄₁₆ × 5⅛ in (19.5 × 13 cm). "The picturesque is plentiful here. At every step, one meets ready-made paintings that would bring twenty generations of painters wealth and glory," Delacroix wrote in a letter in April 1832. This spread bears this out – any of the compositions could easily be employed for a large-scale finished work.

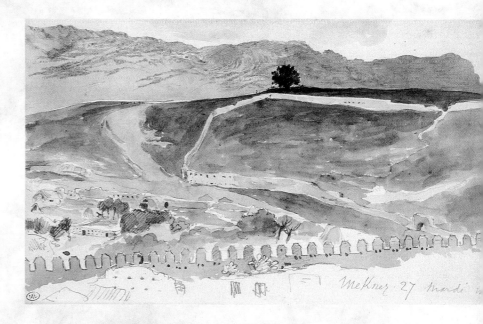

DELACROIX'S MOROCCAN EXPEDITION, 1832

115

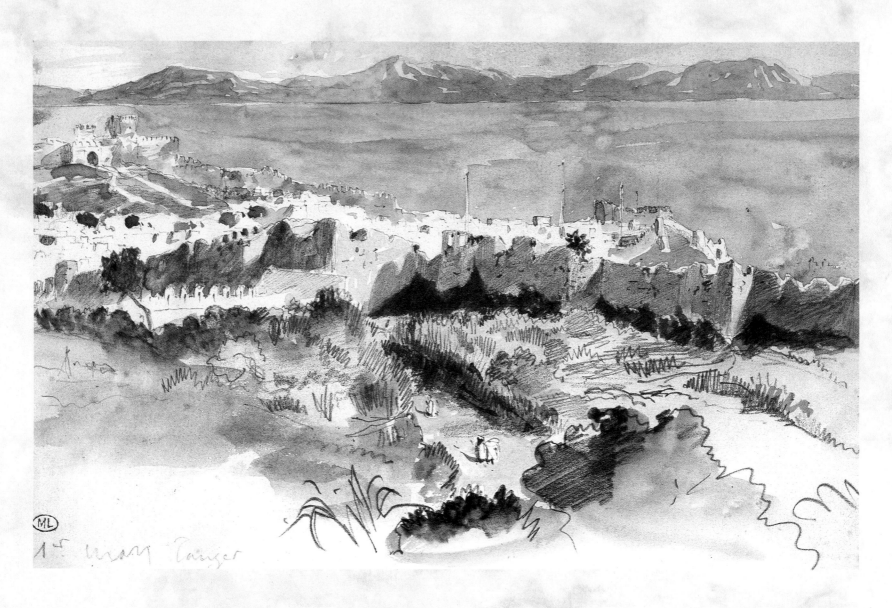

E ugène Delacroix *View of Tangier* (1832), pencil and watercolour, 4¾ × 7½ m (12.1 × 19.1 cm). In later life Delacroix was to reject the fastidiousness of his approach to sketching and painting in Morocco, commenting in his journal in 1852 that he "had been pursued by the love of exactness, which most people mistake for truth." His later Arabic scenes and sketches "retained only the striking and poetic side."

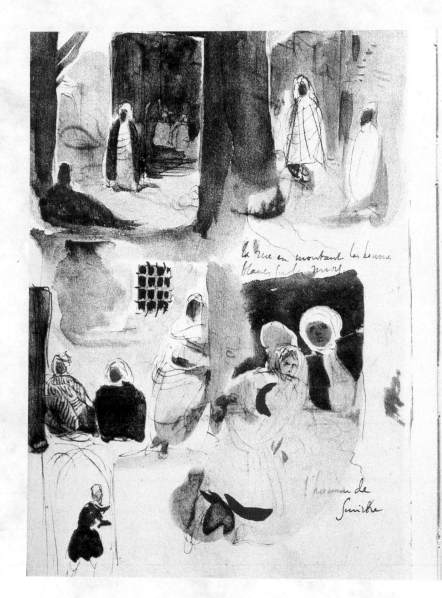

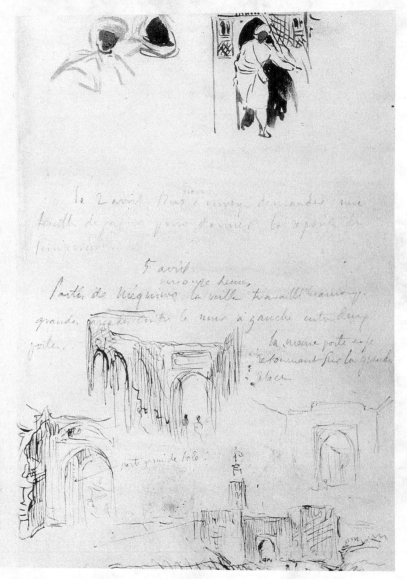

E ugène Delacroix *Studies of Arabs* (1832), pen and ink and watercolour, 7¹¹⁄₁₆ × 5⅛ in (19.5 × 13 cm). Delacroix was fascinated by every aspect of Morocco, its landscape, vegetation, architecture, customs and of course its inhabitants. Here he shows men in Arab dress staring back at the artist as he sketched them. Although using a limited palette, through skilful employment of a varied tonality he achieves a remarkable vibrancy.

DELACROIX'S MOROCCAN EXPEDITION, 1832

mounted Arab horsemen with brightly coloured flags, and the city gates of Meknès. Delacroix fully appreciated the value of his sketches, none more than those he had made in Morocco, writing in his journal: "A fine suggestion, a sketch with great feeling can be as expressive as the most finished productions."

Although few of his Moroccan sketches were to form the basis of specific compositions in his finished work, Delacroix must have referred to them constantly

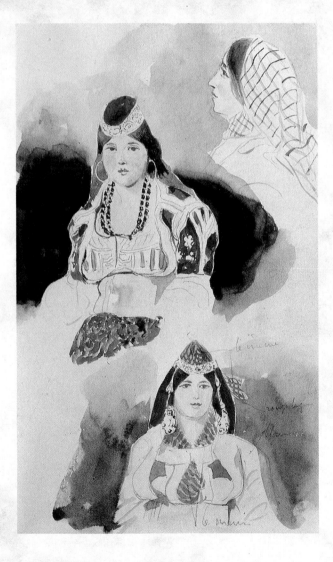

Eugène Delacroix *Moroccan Figures*, (1832), pencil and watercolour, 7¹¹⁄₁₆ × 5⅛ in (19.5 × 13 cm). "They are closer to nature in a thousand ways", Delacroix wrote in his journal, "and so beauty has a share in everything they make…Their ignorance produces their calm and happiness; but we ourselves, are we at the summit of what a more advanced civilization can produce?" Delacroix particularly admired the relaxed grace of the Moroccan women, but Islamic custom forbade women to allow any man outside of their close family to see their faces, and so they wore veils. Delacroix, keen to make portraits of Moroccan women as well as men, circumvented the problem by making studies of prostitutes and Jewish women who were exempt from the custom. Delacroix was particularly impressed by the beauty of the Jewish Moroccan women that he encountered, describing them as the "Pearls of Eden."

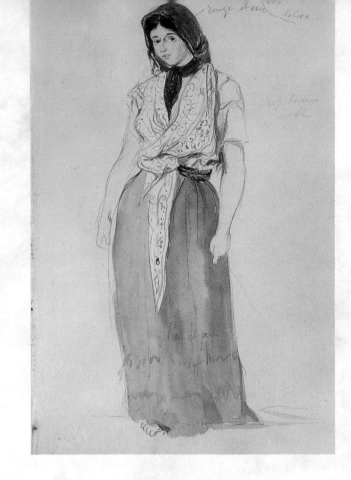

while painting the many Arabic scenes that he executed following his return to France, probably using them to evoke in his own mind the ethos and essence of the country that had fascinated him. Writing in his journal, Delacroix analysed the attraction of sketches over finished work. "Perhaps the sketch of a work is so pleasing because everyone can finish it as he chooses," he wrote. "The artist does not spoil the picture by finishing it; only, in abandoning the vagueness of the sketch he shows more of his personality by revealing all the range but also the limitations of his talent. To finish requires a heart of steel: one must make a decision about everything."

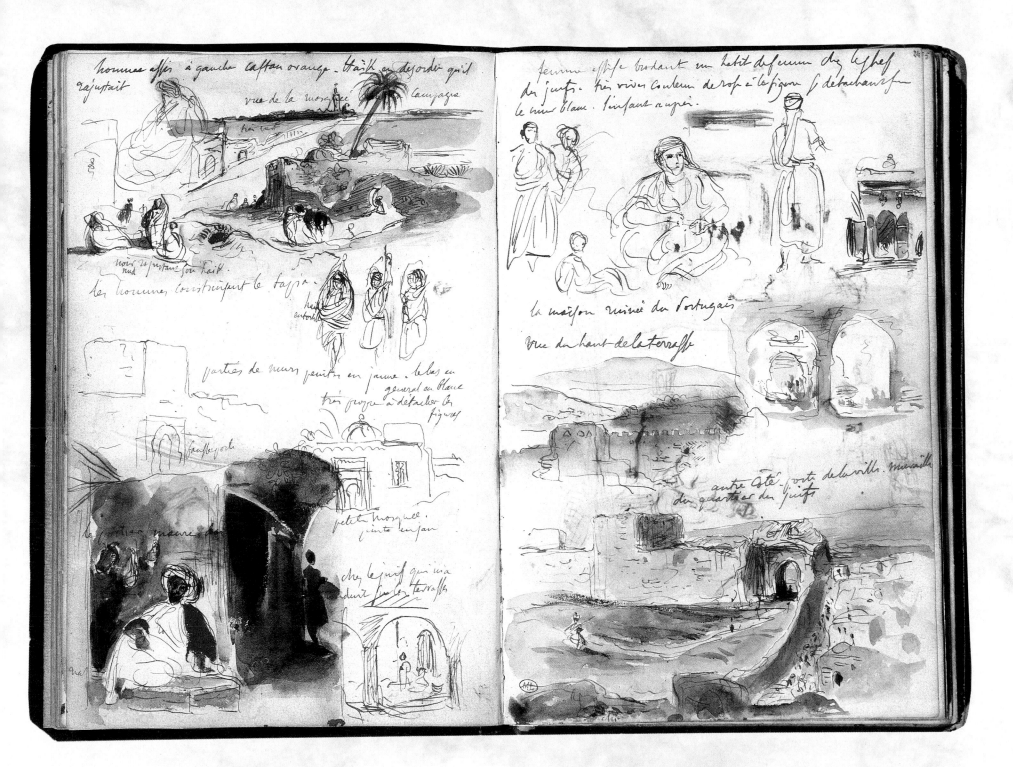

DELACROIX'S MOROCCAN EXPEDITION, 1832

Studies from Nature

The second half of the eighteenth century saw an aesthetic rediscovery of nature as a valid subject for artistic depiction, although how it should be portrayed remained a matter of some debate. In London in 1757, Edmund Burke published his influential *Philosophical Enquiry into the Origin of our Ideas of the Sublime and the Beautiful*, which sought to define and categorize different types of beauty. Burke put forward the thesis that objects could be classified as "beautiful" that possessed such innate characteristics as smallness, smoothness, variety, delicacy and subtle coloration. Immensity, obscurity, power, infinity and the ability to evoke fear in the viewer were attributes which he identified to define the "sublime". Black, brown and deep purple were the colours he considered most suitable for the portrayal of the sublime, while "clean and fair" colours were the attributes of the beautiful.

THE PICTURESQUE

The amateur artist Rev. William Gilpin (1724–1804) contributed to the debate with his accounts of "Picturesque Tours" throughout Britain, and he formalized his assertions in 1792 with the publication of his *Three Essays: On Picturesque Beauty, On Picturesque Travel, and on Sketching Landscape*. In these works Gilpin identified what he termed the "picturesque" — the original meaning of which was "worthy to be included in a picture" — as being situated between Burke's classifications of the sublime and the beauti-

Eugène Delacroix *Greenwich Park* (watercolour, 1825), painted during the artist's visit to England. He was inspired to make this trip by his interest in Constable's *The Hay Wain*. Delacroix met Constable, viewed the work of the major English artists, and sketched the countryside they depicted.

ful. He encouraged artists to portray landscapes of variety, relying upon roughness, deformity and contrasts in form, light and colour for picturesque effect and visual interest. Much of his theory was adapted from landscape gardening, and he argued that nature should be portrayed as a series of interesting and varied vistas or rustic tableaux. Gilpin asserted that prospects should be well laid out, diversified with fields and meadows, woods and rivers, and outlined strict rules concerning what was permissible and preferable in a picture of landscape, be it the correct disposition of hills in the view, or the precise number of cows that could be depicted in a painting. It was Gilpin whom Thomas Rowlandson satirized in the form of Dr Syntax.

The picturesque promoted an interest in nature as a valid subject for painting and, equally importantly, it also stimulated artists to draw and paint from nature itself. Many Romantic artists, whether consciously or unconsciously, began to choose subjects that might be categorized as sublime, picturesque or beautiful.

MAN AND NATURE

Indeed, nature itself became an important facet of the Romantic philosophy. The expressive potential and significance of nature and landscape had already been well comprehended, and subsequently there developed a firm reassertion of the belief that man was inextricably bound to nature, and that communion between the two was highly desirable. This view was fostered by English poets such as Gray, Thomson and later Wordsworth. The Dresden artist Adrian Ludwig

Johann Christian Clausen Dahl, *Morning After the Storm* (oil on canvas, 1829). The elemental forces of nature exerted a great fascination for the Romantics, particularly the image of the storm. The symbolism of this painting is clear – the rock represents faith, the sunrise suggests rebirth after death.

Richter (1803–84) wrote in 1824: "For the first time I am going to venture into the romantic field, where man and nature dominate equally, each gives meaning and interest to the other." Thus artists tried to record their responses to nature and portray its essence as honestly as possible, without artifice. "When I sit down to make a sketch from nature," Constable is reputed to have said, "the first thing I try to do is forget I have seen a picture." He distinguished between painters who studied their forebears's achievements and those who

sought "perfection at its PRIMITIVE SOURCE, NATURE", as did Caspar David Friedrich (1774–1840), who argued that the artist must "study nature after nature and not after paintings".

REYNOLDS'S REACTION

Joshua Reynolds was set against such notions. In his Fourth Discourse, given to the Royal Academy in 1771, he asserted that Claude, whom he cited as an example of the finest kind of landscape painter, "was convinced, that taking nature as he found it seldom produced beauty ... His pictures are a composition of the various drafts which he had made from various beautiful scenes and prospects." According to Reynolds, the artist who faithfully reproduced nature was inferior to the artist who idealized, an idea which had first been expounded by Aristotle.

Such dry academic theory was out of step with the thoughts of most artists by the end of the eighteenth century. Writing in 1795, Chateaubriand firmly argued that "landscape should be *drawn* from the *nude* if one wants to give it resemblance, in order to reveal, so to speak, the muscles, bones and limbs. Studies made indoors, copies after copies, will never replace work after nature." Such attitudes were firmly part of Neo-Classical as well as Romantic ideology.

Constable was one of the keenest artistic observers of nature and rural life, and this tiny sketchbook, which he used in the autumn of 1819 is filled with views of Hampstead Heath, East Bergholt, agricultural workers, trees and animals.

NATURE AS A SPIRITUAL EXPERIENCE

The communion between man and nature could achieve spiritual and mystical proportions. E.T.A. Hoffmann, in his 1816 story *Die Jesuitenkirche in G.*, wrote that

"The painter who is initiated in the divine secrets of art hears the voice of nature recounting its infinite mysteries through trees, plants, flowers, waters and mountains. The gift to transpose his emotions into works of art comes to him like the spirit of God."

Carl Gustav Carus (1789–1867), in his *Letters on Landscape Painting*, similarly asserted:

"... stand on the peak of the mountain, contemplate the long ranges of hills, observe the courses of rivers and all the glories offered to your view, and what feeling seizes you? It is a calm prayer, you lose yourself in unbounded space, your whole being undergoes a clarification and purification, your ego disappears, you are nothing, God is everything."

Similar feelings were again expressed by Wordsworth in his poem of 1798, *Lines composed a few miles above Tintern Abbey*:

> ... the tall rock,
> The mountain, and the deep and gloomy wood,
> Their colours and their forms were then to me
> An appetite; a feeling and a love,
> That had no need of a remoter charm,
> By thought supplied, nor any interest
> Unborrowed from the eye.

Wordsworth's relationship with nature certainly contains elements of Romantic love, as Hugh Honour has pointed out, "even if he was, as Shelley wrote, 'a kind of moral eunuch, / He touched the hem of nature's shift, / Felt faint — and never dared uplift/ The closest all-concealing tunic.'"

The thirst for experience and sensation was central to Romantic belief, and so artists strove to present the form of their experiences of nature, no one more

unremittingly than J.M.W. Turner (1775–1851). Turner depicted the destructive potential of nature's forces in oil paintings such as *Snowstorm: Steam Boat off a Harbour's Mouth*, *Hannibal crossing the Alps* and *Avalanche in the Grisons* (all Tate Gallery, London), and his sketchbooks contain drawings of natural phenomena such as storms and raging seas, and his experience and interpretation of them. Turner also depicts rural landscapes of calm pastoral beauty, limpid views of Venice and barren, melancholy scenes in the Alps. All reflect his sensation at being in that particular landscape, and as such they are ruminations on the wider question of humanity's position within the world, and our complex relationship with nature.

This sheet from a sketchbook that has been broken up shows a landscape either in Saxony or Bohemia. The obelisk that is such a prominent feature in Friedrich's design usually represents a milestone on the path of life in the artist's system of allusions. Friedrich's landscapes, although usually resonant with symbolism and allegory, are nevertheless also truthful representations of nature.

Romantic art, then, often followed a holistic philosophy in its depictions of nature and the world. Carus once claimed that he would much rather replace the term "landscape" with the word *Erdlebenbildkunst* — painting of the life of the earth, which to him seemed a more precise term for the depiction of nature. A similar understanding of the way in which humanity is inextricably bound up with nature, and of the difficulty of the portrayal of that relationship by the artist, was perhaps echoed by John Ruskin when he advised: "There is nothing that I tell you with more earnest desire that you should believe than this — that you will never love art well till you love what she mirrors better."

THE SKETCHBOOKS

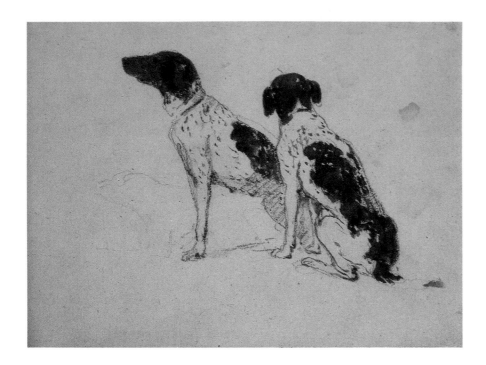

J.M.W. TURNER

Study of two Pointers,
c. 1809–10
pencil and
watercolour,
3⁵⁄₁₆ × 4½ in
(8.4 × 11.5 cm)
Tate Gallery,
London

*L*n their studies from life during the 18th and 19th centuries, artists would frequently use their sketches to show the underlying bone and muscle structure of their subject, be it the human form or an animal, as here. Ramboux's studies of horses' heads concentrate upon the musculature of his subject, but it is possible that they could have been drawn from the antique rather than from life, especially as they are in a sketchbook which he used in Italy. The heads bear a close resemblance to those of the two horses in the sculpture group *Alexander and Bucephalus*, which stands in the Piazza de-Quirinale in Rome, as it has probably stood since antiquity.

*T*his sheet is from Turner's *Lowther* sketchbook, which he took with him on his tour of Cumberland in 1809. It contains several studies connected with shooting, a sport that the artist enjoyed. Game dogs, some figures on a moor and a man sitting by an ale barrel with a gun all feature in the book, and it seems likely that he made these observations during a stay with his patron Walter Fawkes on his estate at Farnley in Wharfedale. When at Farnley, Turner usually joined his host in shooting or fishing, and the artist made several large watercolours of game birds and fish during his career. One of Fawkes' most famous commissions was the series of watercolours of British birds, now in Leeds City Art Gallery.

JOHANN ANTON
RAMBOUX
*Studies of Horse
Heads, c.* 1818
crayon,
$5\frac{1}{16} \times 6\frac{5}{16}$ in
(12.9 × 16 cm)
Wallraf-Richartz-
Museum, Cologne

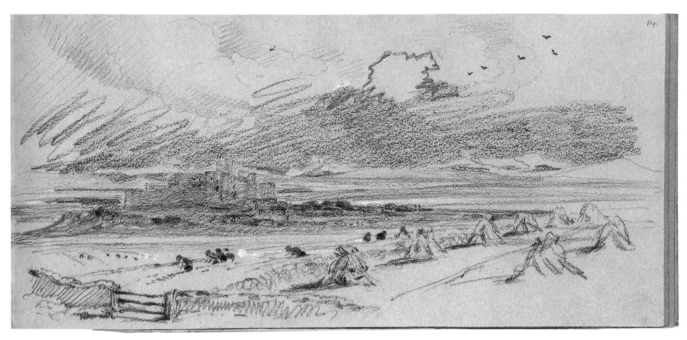

*P*eter de Wint filled many
sketchbooks with
drawings to which he could
return when called upon to
select a subject for a finished
work. John Ruskin (1819-
1900) noted in a letter: "De
Wint . . . hardly ever paints
except from nature . . . and
produces sketches of such
miraculous truth of
atmosphere, colour and light
that half an hour's work, has
fetched its fifty guineas." In
these two studies from the
same sketchbook (*above* and
right), de Wint turns first to a
scene of pastoral simplicity
and then to an interior.

PART TWO

Towne appears to have viewed his pursuits in watercolour as exercises for his own amusement and satisfaction, but his drawings were both innovative and beautiful. His highly individual technique consisted of making a careful outline in pencil or pen and ink and then filling in these areas with flat washes of watercolour. Towne usually made the drawings in sketchbooks, and would often remove sheets and join them together, as in this drawing of James White's estate near Exeter.

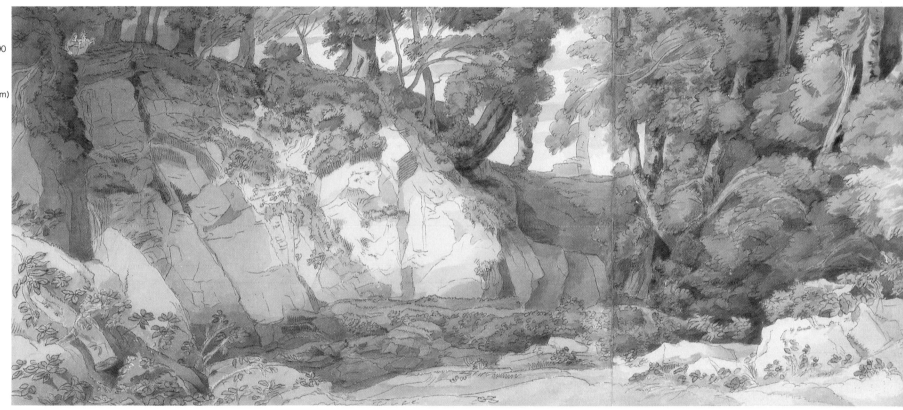

FRANCIS TOWNE

A View on James White's Estate at Dunsmoor, c. 1790
pencil and watercolour,
7 × 15⅝ in
(17.75 × 39.75 cm)
Private collection

Studies
of the Sky

J.M.W. Turner *Rising Moon*, (c. 1818), watercolour, 4¹³⁄₁₆ × 9¹¹⁄₁₆ in (12.5 × 24.7 cm) (*far right*). The *Skies* sketchbook from which this sheet comes contains whole series of such studies. Volcanic eruptions in the southern hemisphere at this time led to spectacular sunset effects.

"I have done a good deal of skying," Constable wrote to his friend Archdeacon John Fisher in 1822. "It will be difficult to name a class of Landscape, in which the sky is not the keynote, the standard of scale, and the chief Organ of sentiment ... the sky is the source of light in nature – and governs every thing." Artists had been making studies of the sky since the 17th century, but during the Romantic period such observations had a special appeal. Artists as diverse as Constable, Turner, Linnell, Dahl, Carus,

J.M.W. Turner *River Scene with Rainbow* Hesperides sketchbook (*c.*1805–7), watercolour, 6⁹⁄₁₆ × 10½ in (16.7 × 26.6 cm) (*right* and *detail*). Most likely a view on the Thames to the west of London, where Turner was living during this period. It is a scene of enchanting beauty as a rainbow arcs over boats gliding through the still and glassy water of the river.

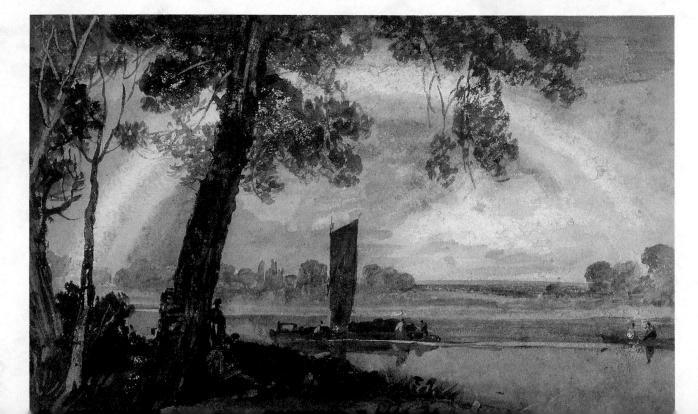

Samuel Palmer, *Cloud Study* (1819), pen and ink and watercolour, 4⅜ × 7¼ in (11.1 × 18.4 cm). Palmer has carefully numbered this study, and the key provides both a description of the colour and texture of the clouds, and notes as to how to achieve these effects with watercolour.

Granet and Blechen all made detailed records of cloud formations, rainbows or the effects of the sun, sometimes in their sketchbooks but also in small oils done out of doors. Such interest was stimulated by the Romantics' affinity with nature, and is also a recognition of the ability of sky effects to inspire and uplift. The American Jasper Cropsey described how he would study the clouds for relaxation and inspiration: "Grand masses of dreamy forms floating by each other, sometimes looking like magic palaces, rising higher and higher, and then toppling over in deep valleys, to rise again in ridges like snowy mountains, with lights and shadows playing amongst them, as though it were a spirit world of its own."

The popularity among the Romantics and other artists of making direct studies of the sky signified part of a wider development towards a more naturalistic treatment of landscape and nature which was based upon direct observation. The tensions between art and nature, between improvement or interpretation by artists and exact copying, dates back to Aristotle and was a subject of lively debate during the Romantic period. Joshua Reynolds robustly championed the artistic interpretation of landscape in his *Discourses*, concluding that even Claude, a painter vaunted as a

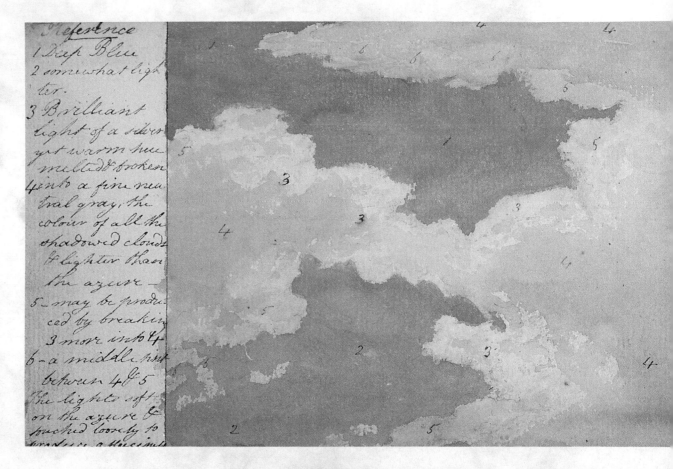

role model for all artists of this period, "was convinced that taking nature as he found it seldom produced beauty." Reynolds believed that "A mere copier of nature never produces anything great," a statement echoing Aristotle's analysis that "Art completes what nature cannot bring to a finish. The artist gives us knowledge of nature's unrealized ends". Bernini advised great caution when approaching nature, for "Students would be ruined if at the beginning they were set to draw from nature, for nature is always feeble and trifling ... Those who make use of nature should be sufficiently skilful to recognise its defects and correct them." Nature was therefore seen, in academic circles, as far from perfect and that its use in art was only justifiable through judicious interpretation and improvement by the artist. Such beliefs can only have been strengthened by publications on aesthetics in the eighteenth century such as Burke's writings on the Sublime and Gilpin's accounts of the Picturesque, both of which stressed the importance of direct observation of the landscape, but at the same time impressed firm qualitative and subjective judgements upon the choice of scenes worthy of representation. Gilpin even argued that in certain scenes a particular number of cattle should be included before they might legitimately be described as 'Picturesque'. It is obvious that all art involves some degree of interpretation, but much eighteenth-century writing seems draconian in its rigid rules for the selection of a landscape worthy of artistic endeavour.

Yet by the turn of the eighteenth century slightly different ideas were beginning to percolate through the artistic community. The tradition of making direct *plein-air* oil sketches or drawings was a long one, oil-sketching having been adopted by artists such as Richard Wilson and Thomas Jones in the second half of the eighteenth century in Britain, and which began to be taken further by Constable and other artists there and abroad. Constable believed firmly in the directly observing nature by making outdoor studies, often directly onto canvas or into his sketchbook. His cloud

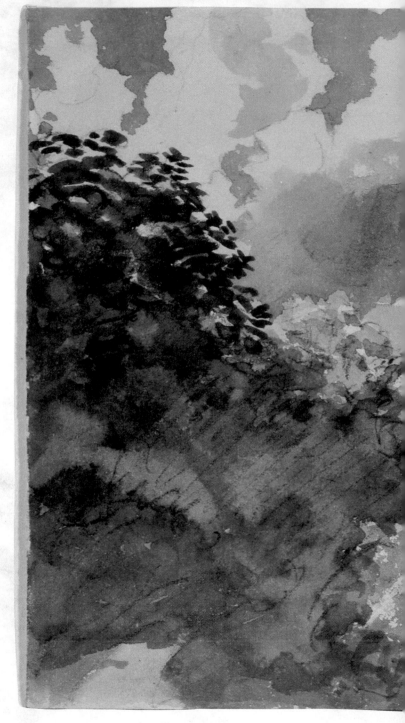

John Constable *Trees, Sky and a red House at Hampstead* (1821), pencil and watercolour, $6^{13}/_{16} \times 10$ in (17.3 × 25.5 cm) (*left*). Constable and his wife first took a house at Hampstead in the summer of 1819, and they were later to rent houses there for part of each year thereafter. Constable made many studies of the sky from Hampstead, this sheet depicting the view from the garden of Number 2 Lower Terrace, which he rented during the summers of 1821 and 1822.

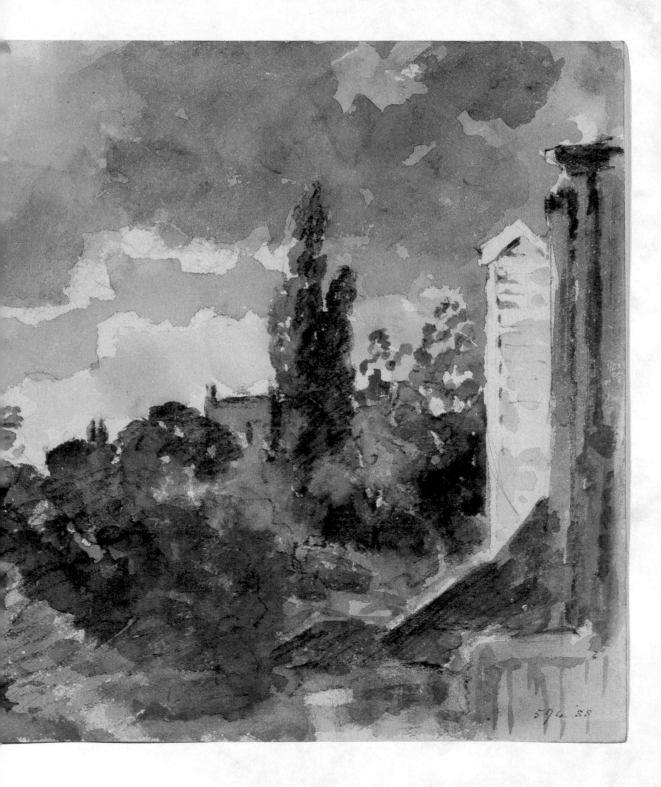

studies, almost all made during 1821 and 1822, are usually inscribed with the date and time of execution, revealing a committed and almost scientific approach to his enquiries and observations of nature. Constable's on-the-spot sketchbook studies of the heavens could frequently form the genesis of a finished work, the sheet often being torn from the book and then fully worked up. Constable sometimes employed the process with his oil paintings, starting the canvas in front of the landscape. Although Constable claimed that he tried to forget he had ever seen a painting when he set out to portray a landscape, he nevertheless often made a number of idealizations in his pictures in order to achieve greater aesthetic or dramatic effect. Indeed his engraver, John Burnet, claimed that Constable "seldom painted a picture without considering how Rembrandt or Claude would have treated it," implying the carefully considered approach that was necessary in such large scale works as *The Lock* or *The Leaping Horse*. Constable's direct studies of nature, and particularly the sky – the successful evocation for which his paintings were particularly noted – allowed him to incorporate their ethos into his pictures and lend them a convincing naturalism that led Stendhal to write in 1824 "In the paintings of the old school, the trees have *style*; they are elegant but they lack accuracy. Constable, on the contrary, is truthful as a mirror, but I wish that the mirror were not placed vis-à-vis a hay wain fording a canal of still water."

Amidst this general movement towards naturalism, a direction that in France was eventually to lead to the development of the Barbizon School and Impressionism in the second part of the nineteenth century, the study of skies was consequently especially strong. Interest was also stimulated by scientific publications published during the late eighteenth and early nineteenth centuries which were devoted to cloud formations, sky effects and meteorology, and it was during this period that the correct differentiation between cloud types and a scientific nomenclature was evolved.

STUDIES OF THE SKY

Turner was an avid fisherman throughout his life, devoting many hours to the pastime, particularly when staying at Farnley in Yorkshire with his friend and patron Walter Fawkes, whose estate had well-stocked trout streams. Fishing was also an activity that he could carry on while he sketched, and this is likely to have been the case with this drawing, made in a sketchbook entitled "Fishing at Weir", after the activity. It is possible that Turner has actually included himself in this particular sketch, for it is thought that the man in the top-hat and coat may well be the artist. One of his fishing rods still survives and is in the collection of the Royal Academy, London.

J.M.W. TURNER
Fishing at Weir,
c. 1830–5
pencil, $3\frac{1}{16} \times 3\frac{15}{16}$ in
(7.8 × 10.1 cm)
Tate Gallery, London

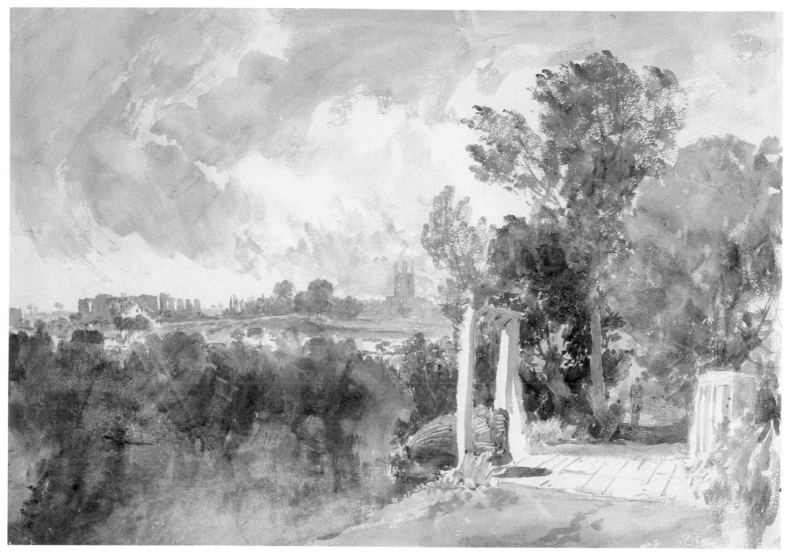

J.M.W. TURNER

Benson, or Bensington, near Wallingford,
c. 1805–6
pencil and watercolour,
10¼ × 14⅝ in
(25.9 × 37.1 cm)
Tate Gallery, London

*L*n this sheet from Turner's *Thames from Reading to Walton* sketchbook, the artist has skilfully employed bright colours, freely applied with a minimum of pencil underdrawing, and has left exposed areas of white on the paper to suggest the bright, flickering light of a blustery English summer's day. The drawing is an eloquent exercise in pastoral beauty, and shows figures in the foreground standing in the shade of some trees, with a small footbridge and eel trap nearby. In the distance Wallingford Church rises against the skyline, and to the left of this is a looming, massive structure which may be Wallingford Castle.

Varley economically but eloquently depicts a scene of pastoral simplicity, a rustic family walking beside a river, a natural composition he recorded in his sketchbook while on one of his many sketching tours throughout the country. His friend and fellow artist John Preston Neale recalled Varley's great enthusiasm for sketching, noting that "He was ever with his pencil, either drawing from nature, or copying the work of distinguished masters."

JOHN CONSTABLE

Folkestone from the Sea, 1833
pencil and watercolour,
5⅛ × 8¼ in
(12.9 × 21 cm)
Victoria & Albert
Museum, London

Constable rejected criticisms of his concentration on skies, as here, they could be used to elegant effect. The textural effects of the billowing clouds, built up by successive applications of loose watercolour washes, contrast with and enhance the more lateral lines of the sea. Although the watercolour is freely handled Constable includes a wealth of detail such as the church towers and the flag at the entrance to the harbour.

JOHN VARLEY

River Bank with Willow and Figures,
c. 1806
black chalk on blue paper, 5⅞ × 7½ in
(14.9 × 19 cm)
Victoria & Albert
Museum, London

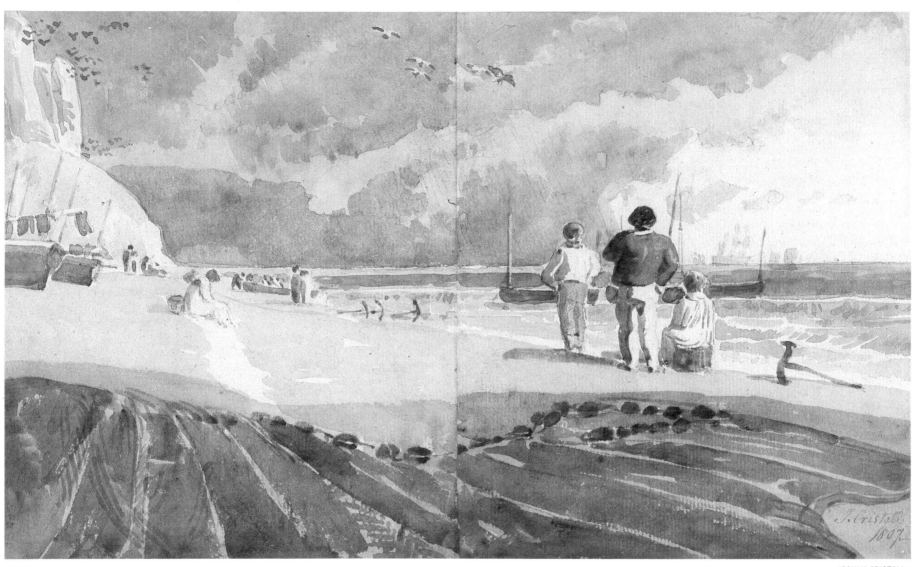

JOSHUA CRISTALL

*Beach Scene,
Hastings, c.* 1808
watercolour,
7³⁄₁₆ × 11¹³⁄₁₆ in
(18.3 × 30 cm)
Tate Gallery, London

Cristall would appear to have begun this watercolour on the spot on two pages of a sketchbook joined together, although it is possible that it was done from memory. The artist stayed at Hastings on the advice of his doctor, according to the artist and great diarist Joseph Farington, in order to cure "a state of despondence . . .owing to a want of success [encouragement] in consequence several Artists put down their name for 5 guineas each to make up a sum for him." Cristall's loosely applied washes of watercolour and the effective use of areas of light eloquently convey the contrasting lighting effects of a blustery day on the beach.

Pastoral Landscape

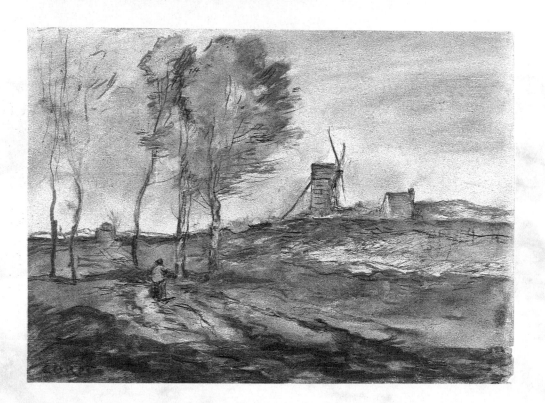

Jean Baptiste Camille Corot *The Windmill on the Plain*, (1871), pencil, watercolour and black and white chalk, 8¹⁵⁄₁₆ × 12⅜ in (22.7 × 31.4 cm). Corot's rural studies are often idealized, but here cool tones convey harshness.

Within the category of landscape painting artists frequently chose to depict pastoral subjects, idealized rustic scenes from country life. Views of the rural countryside, romanticized idylls of country life, farm workers tilling the land in harmonious union with their environment or picturesque groups of cottages were all considered worthy subjects and might all be classed as pastoral in character. The Romantics' awareness of nature and landscape no doubt engendered an interest in those who were closest to it, although the poverty and harsh working regimes that were the reality of agricultural labour could often prove to be a disturbing contrast to the rural idyll which many artists expected to find. It is certainly not accidental that this surge of interest in the rural countryside occurred when it did, for it coincided with an era of great change. From the second half of the eighteenth century onwards the landscape of many countries in northern Europe began to change rapidly as new farming methods came into use and towns and industry began to grow. Rural communities began to diversify in their range of economic activities, and in England at least, many farm labourers were lured into the factories, work that whilst it may have been more dangerous and regimented, paid better wages.

It was at this very point in many European societies, when the old world of the rural communities and farming methods that had remained unchanged for centuries were beginning to disappear, that a con-

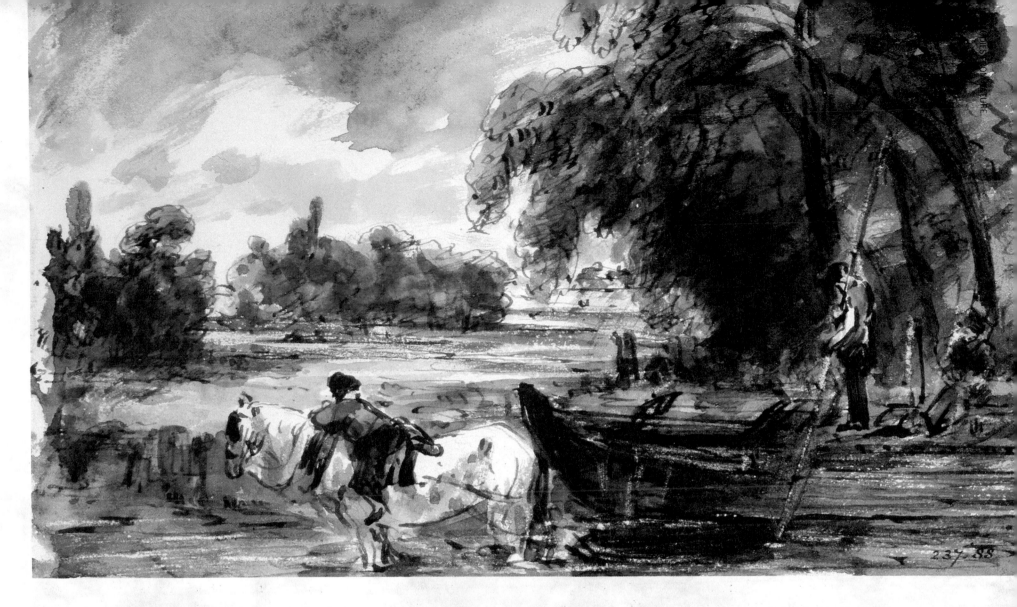

sciousness arose that led artists to paint idealized, celebratory views of the land and the people that toiled upon it. The causality of this process was without doubt highly complex, and the motivation of painters who chose such scenes was perhaps far from being a conscious decision, but the coincidence of timing is too precise for there to be any doubt that rapid changes in society and a rise in interest in depicting rural subjects were not inextricably bound together.

The Romantics, nevertheless, were already deeply interested in landscape for its symbolic potential and

John Constable *A Barge on the Stour*, (1832), pencil, pen and ink and watercolour with some scratching out, 4⁹⁄₁₆ × 7⁹⁄₁₆ in (11.5 × 19.2 cm). The River Stour was a recurrent subject throughout Constable's life. On this sheet he shows the river as a place of great beauty as well as of work, as a horse tows a barge laden with goods.

also for its embodiment of the natural, an observation of which many artists extended almost into the realms of religiosity. Throughout Europe landscape painting had gained in stature and had become one of the most popular artistic subjects despite still being viewed in academic circles as an unworthy discipline because it could not approach the intellectual content of history painting. However, as the nineteenth century progressed, landscape painting became almost a preeminent form of artistic expression, in part due to the development of the genre by painters such as Turner,

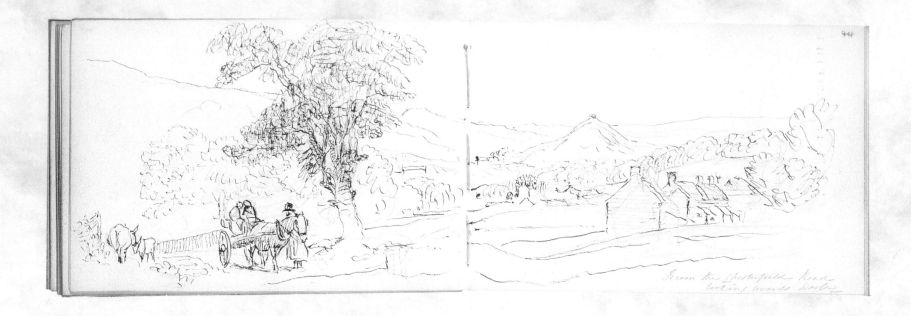

Constable, Friedrich and Dahl, who imbued their landscapes with symbolic meaning, a great departure from the topographical tradition of the eighteenth century. Genre scenes, equally low in the academic hierarchy of art, also began to grow in popularity during this period, and these artists frequently turned their attention to depictions of the inhabitants and activities of the countryside.

As the nineteenth century progressed, landscape painting became legitimized to the point where the artist Charles Robert Leslie (1794–1859) could state in a lecture that "The love of Landscape is a love so pure, that it can never associate with the relishes of a mere voluptuary, and wherever such a love is native, it is the certain indication of a superior mind." In contrast to the epic, sublime or picturesque which could be rugged, awesome or even threatening, pastoral landscape subjects presented a harmonized, peaceful view of nature, where humanity is presented in synthesis with its environment. Agricultural workers are depicted happily going about their labours in what appears to be Eden, totally in harmony with their

Peter de Wint *From the Chesterfield Road looking towards Derby*, c. 1845, pencil and pen and brown ink, 7⅛ × 14½ in (18.1 × 36.8 cm). De Wint was noted for his celebratory visions of the English countryside and those who lived and worked there; as a contemporary observed, "They are common scenes made very uncommon." Despite the great changes that were happening in the countryside, including the mechanization of manual work, the artist continued to produce nostalgic designs showing rural life as it had once been. He attempted to portray a world of continuity that was vanishing.

surroundings and living an enviable life of rural simplicity and peace. Such idealizations have clear political overtones, for the reality was rather different. Agricultural workers during this period were for the most part poorly paid, worked from dawn to dusk in all weathers, and in times of failed harvests were quite likely to starve. Samuel Palmer was genuinely shocked when the countrymen of Shoreham began to riot and burn corn-ricks in the early 1830s, their behaviour so different from the rural idyll that he wanted to find in the countryside. Palmer found that even the very landscape of Shoreham could be problematically out of step with his expected vision. "I have begun to take off a pretty part of the village," he wrote, "and have no doubt but the drawing of choice positions and aspects of external objects is one of the varieties of study requisite to build up all kinds of knowledge: though at the same time I can't help seeing that the general characteristics of Nature's beauty not only differ from, but are, in some respects, opposed to those of Imaginative art."

It was perhaps part of the Romantics' disposition to

favour a romanticized view of the rural world, a similar phenomenon occurring in subjects devoted to the mythical, epic past of the Nazarene's vision of medieval Germany, the alluring portraits of honourable bandits or the dignity of the exiled Napoleon. Landscape artists, in their depictions of pastoral scenes did not always portray reality either, but on occasion their activities give us a greater understanding of the subjective processes that are present in the artist's interpretation. Constable's peaceful depictions of the Suffolk countryside lend it an ideal balance, the labourers of his *Barge on the Stour* fitting harmonious-

*P*eter de Wint *Pastoral Scene*, (1832), pen and ink, brown wash and black and white chalks on buff paper, 7⅛ x 14½ in (18.1 × 36.8 cm). De Wint uses an economical technique, that is nevertheless sumptuous, to convey the beauty and simplicity of his composition, the geese skilfully indicated with dashes of white chalk.

ly into the landscape they inhabit, and giving no hint of the unstable and spirited political situation of the workers in that area during the 1830s, who might well be involved in rick-burning and rioting. That Constable presents such a scene of perfect synthesis and peacefulness against this background suggests some indication of his attitude towards rural society and landscape, and of his own political ideology.

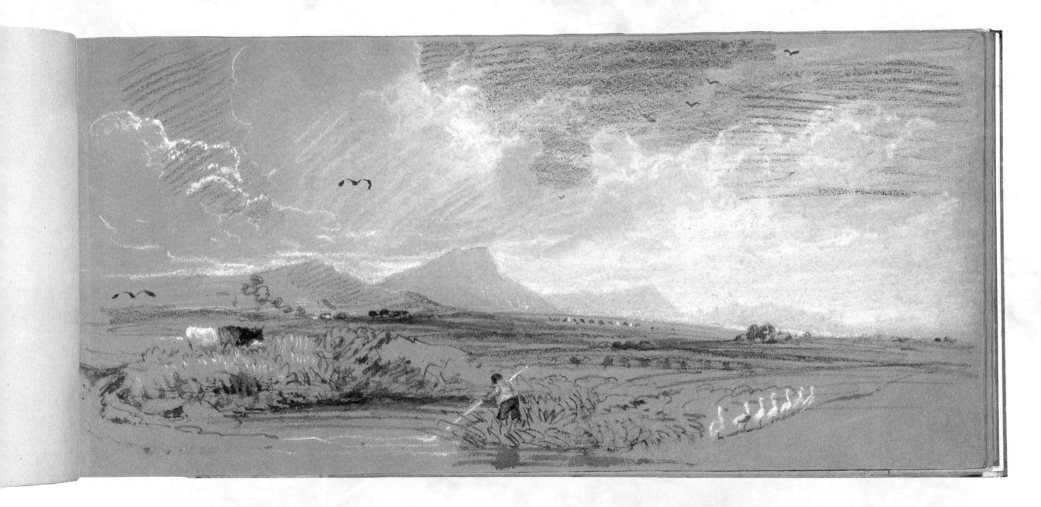

The Lake District was a great attraction as a subject for English Romantic artists, spurred on by Wordsworth and William Gilpin, and was accepted by many as the worthy equivalent of the Alps or the other grand landscapes of the Continent. Towne toured the area in the summer of 1786 and produced some of his most sensitive and elegiac views of the English landscape, clearly displaying the stylistic advances he had made during his Alpine tour of 1781–2. Towne made his panoramic view of Elterwater and the surrounding peaks across two pages of his sketchbook. The pen and ink sketch was made on the spot, as was his usual practice, but the watercolour was not applied for a period of four years, as is made clear by Towne's careful inscription of the date of this completion on the reverse of the sheets.

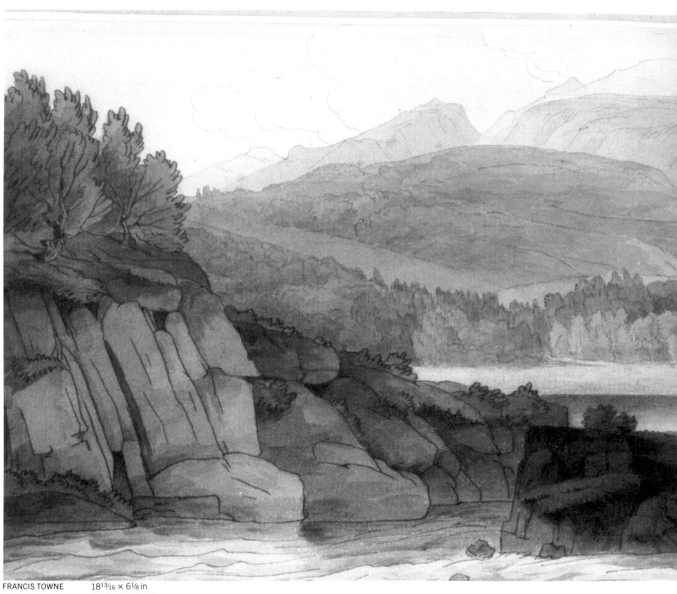

FRANCIS TOWNE

Elterwater, Westmoreland, 1786 pen and ink and watercolour,

18¹³/₁₆ × 6⅛ in
(47.7 × 15.5 cm)
Wordsworth Trust,
Grasmere

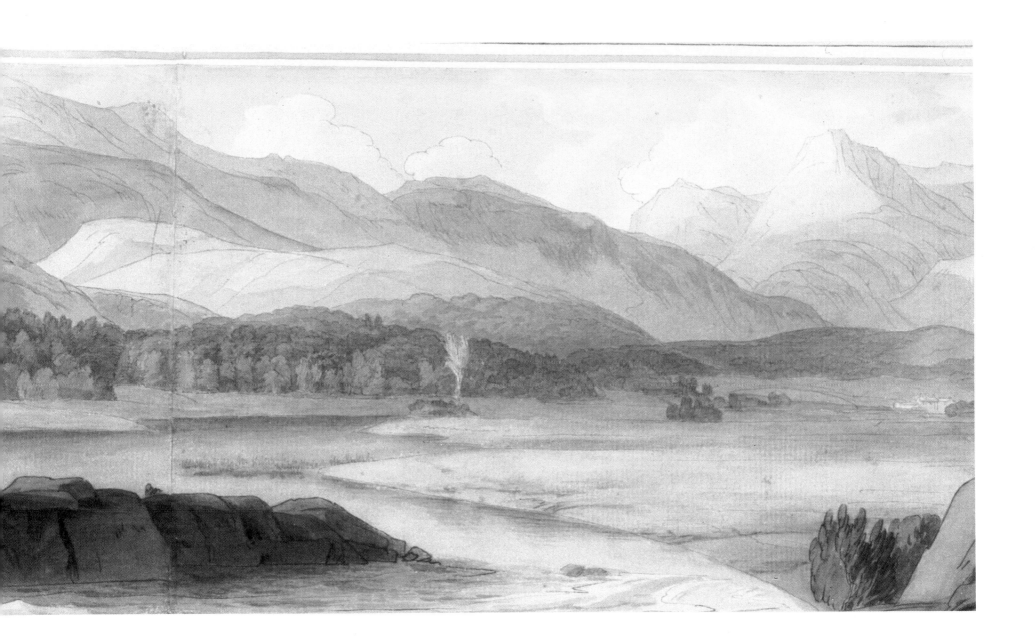

Corot produced sensitive landscape watercolour sketches which were as individual as they were beautiful, and he stood outside most of the French mainstream artistic movements. Corot's relationship with nature was at the core of his depiction of landscape, and it was a relationship that was based upon the sensations that he experienced rather than minute observation, but in concentrating upon his feelings he produces a truthful image and one with which the viewer can easily associate.

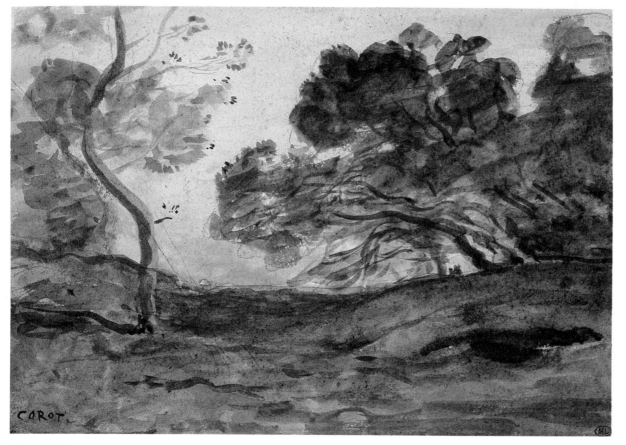

When Corot went to Italy in 1825 he made a conscious effort to devote himself fully to the landscape and architecture of the country rather than to copy in its museums. He was already a firm advocate of working directly from nature, and executed small studies in oil whilst he was there, *pochades*, such as this view of the ruined Ponte d'Augusto over the Nera. Corot perfectly applies the same sensuousness and immediacy that is present in his sketchbook studies to the medium of oil, and he captures his impressions directly from nature.

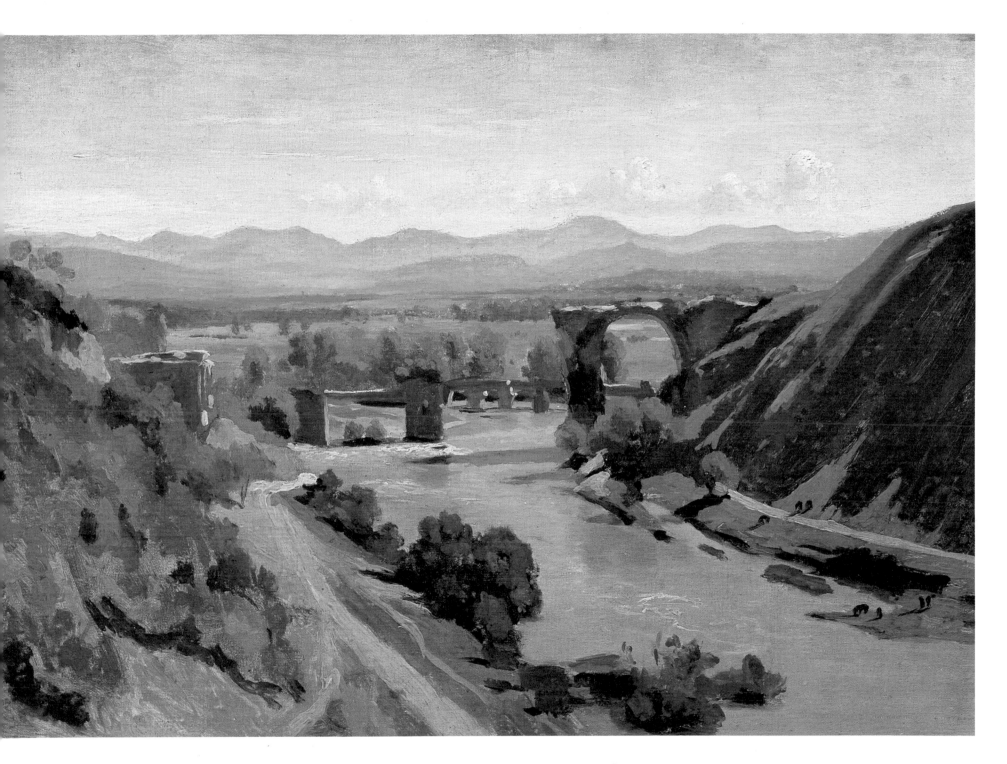

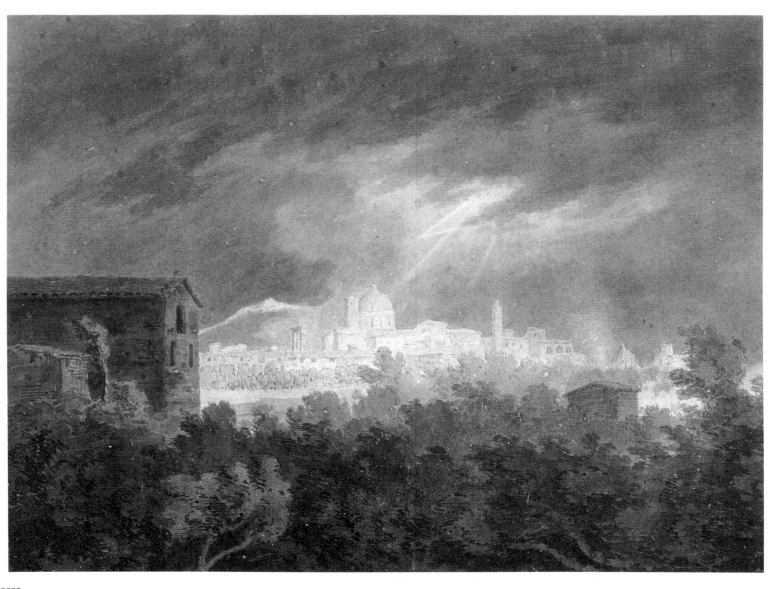

JOHN ROBERT
COZENS

Padua, c. 1782–3
watercolour,
10¼ × 14⅝ in
(26 × 37.1 cm)
Tate Gallery, London

John Robert Cozens was one of the most gifted and original watercolour artists of his generation, and greatly influenced many of the younger artists such as Turner and Girtin, who were set to copying his work by Dr Thomas Monro. Constable declared him "the greatest genius that ever touched landscape". In this large watercolour Cozens shows Padua in the grip of a violent thunderstorm, the dark surrounding countryside contrasting markedly with the town itself, which is dramatically lit up by the lightning. Cozens captures the compelling beauty and grandeur of the forces of nature while also showing their threatening capabilities.

June 1782

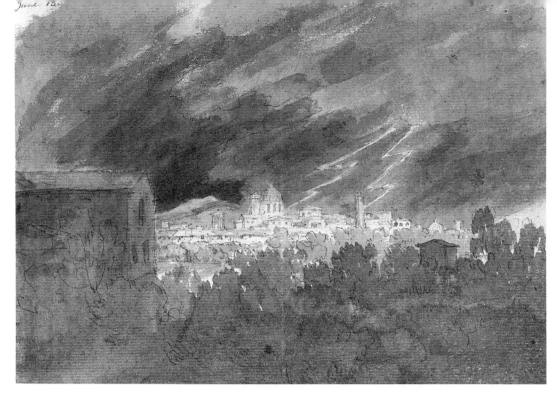

The lengthy but precise title is that which Cozens inscribed on his sketch, along with the date, 20 September. This sketch was made after the hurried return of Beckford to England, leaving Cozens to continue the tour alone. Beckford and Cozens had enjoyed an uneasy and perhaps even antagonistic relationship, and after the former's return to England the artist's friend Thomas Jones, then resident in Italy, commented that Cozens was "once more a Free Agent and loosed from the shackles of fantastic folly and Caprice."'

JOHN ROBERT
COZENS

Padua, 1782
pencil and grey
wash, 7 × 9⅜ in
(17.8 × 23.8 cm)
Whitworth Art
Gallery, Manchester

JOHN ROBERT
COZENS

Vietri and Raito on the Bay of Salerno with Monte Petuso in the Background, 1782
pencil and grey
wash, 7 × 9⁹⁄₁₆ in
(17.8 × 24.2 cm)
Whitworth Art
Gallery, Manchester

This sketchbook sheet (*above*) was the basis for Cozens' finished watercolour *Padua* (*left*). It probably depicts an actual scene that the artist witnessed during his stay in the town, for he has dated it 18 June. Cozens toured the Alps and Italy during 1782 and 1783 as part of the entourage of the eccentric William Beckford, author of the Gothic novel *Vathek* and designer of the fantastic but ill-fated Fonthill Abbey. The artist filled seven sketchbooks with views of his travels, and later referred to them for finished works.

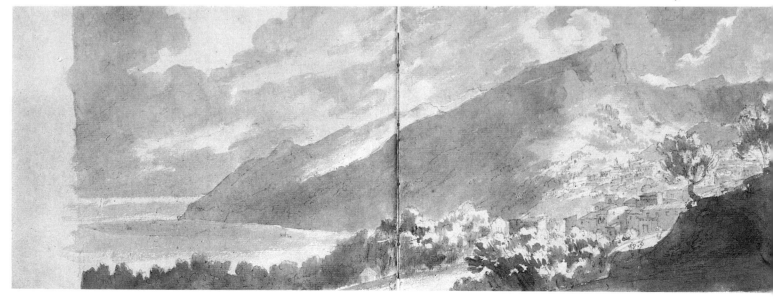

145

Destructive Potential: Turner and the Imagery of Storms

J.M.W. Turner *Storm Effect* (*c.* 1825) watercolour, 4½ × 7⅜ in (11.4 × 18.7 cm). Turner's brisk dry brush makes dragged effects of breaking waves and rolling clouds and perfectly captures a storm's fury.

Turner frequently used the effects of weather in his paintings for their symbolic possibilities, never more powerfully than in his depiction of storms. The storm is a recurrent motif in Turner's work, a central theme in oil paintings such as *The Shipwreck*, exhibited in 1805, and *Snow Storm: Hannibal and his Army crossing the Alps* of 1812, right through to later masterpieces such as *Snow Storm: Steam Boat off a Harbour's Mouth*, exhibited in 1842. Turner uses storms to show the sheer force and destructive potential of nature, to show clearly that for all its achievements humanity is at the mercy of the world which it inhabits. Turner was fascinated by the sea throughout his life, and storms at sea allowed him particular scope to show the uneasy relationship between humanity and nature, for the sea is in a state of constant change, sometimes calm but often whipped up by violent storms into an immensely destructive force. In this vein, *The Shipwreck*, one of Turner's most celebrated oil paintings, shows maritime endeavour dwarfed by the stupendous force of nature. Even the boats that are trying to rescue the crew of the doomed ship are themselves in danger of being swamped by water. The swirling waves give the painting a sense of realistic movement.

Towards the end of his life Turner spent much of his time staying at Margate with his mistress Mrs Booth, and he filled his sketchbooks with melancholy studies of the effects of sea and sky, his eye perfectly attuned to the changing elements.

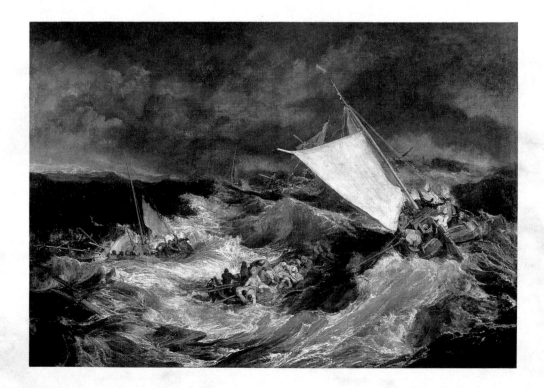

J.M.W. Turner, *Study for "The Shipwreck"*, Calais Pier Sketchbook (*c.* 1805), black and white chalks on blue paper, 17 × 10 in (44 × 26 cm). *The Shipwreck* (1805), oil on canvas, 67 × 95 in (170 × 241.5 cm) (*opposite, bottom left*), was painted after Turner had made several studies for it, and it seems likely that he based them on actual observations.

DESTRUCTIVE POTENTIAL: TURNER AND THE IMAGERY OF STORMS

J.M.W. TURNER
Goldau, c. 1843
pencil and
watercolour,
9 × 11⅜ in
(22.75 × 29.25
cm)
Tate Gallery,
London

July 1834 saw Constable's first visit to Sussex; he stayed in Arundel at the home of his friend and namesake George Constable. During this visit, he was invited to stay with Lord Egremont of Petworth House, an invitation that Constable did not take up until September the same year, when he made trips into the surrounding countryside in a coach supplied by his host. "He was most delighted with the borders of the Arun," Leslie recorded, "and the picturesque old mills, barns, and the farm-houses that abound in the west of Sussex."

JOHN CONSTABLE
Fittleworth Mill,
1834
pencil and
watercolour,
8⅛ × 10¾ in
(20.6 × 27.2 cm)
Victoria & Albert
Museum, London

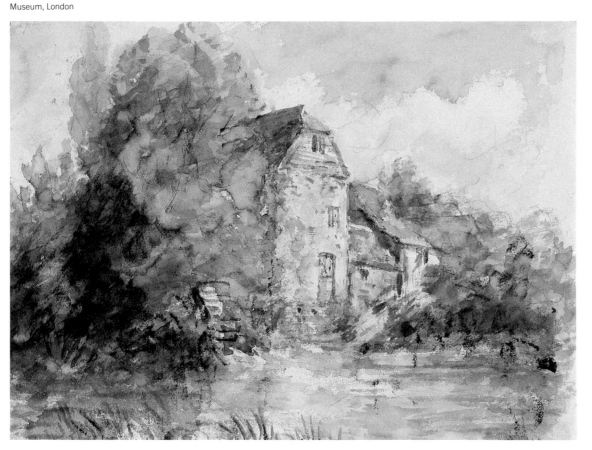

The late Alpine watercolours of Turner are among some of the most powerful and moving of his works on paper. This watercolour of Goldau, in which the deep glowing fire of the sunset contrasts with the cooler tones of the mountains and rocks, was a "sample study" for a finished version he executed for Ruskin. During the 1840s, especially with his Alpine subjects, Turner would make a series of fairly elaborate but unfinished watercolour designs in his sketchbook and then show them to prospective clients who could select and commission a finished version. In the picture Turner alludes to the death of 456 people in the village when, in 1806, massive boulders from the Rossberg fell on the settlement, and the foreground is occupied by these very rocks. Ruskin noted that Turner used red sunsets to signify death, and here, "the death of multitudes".

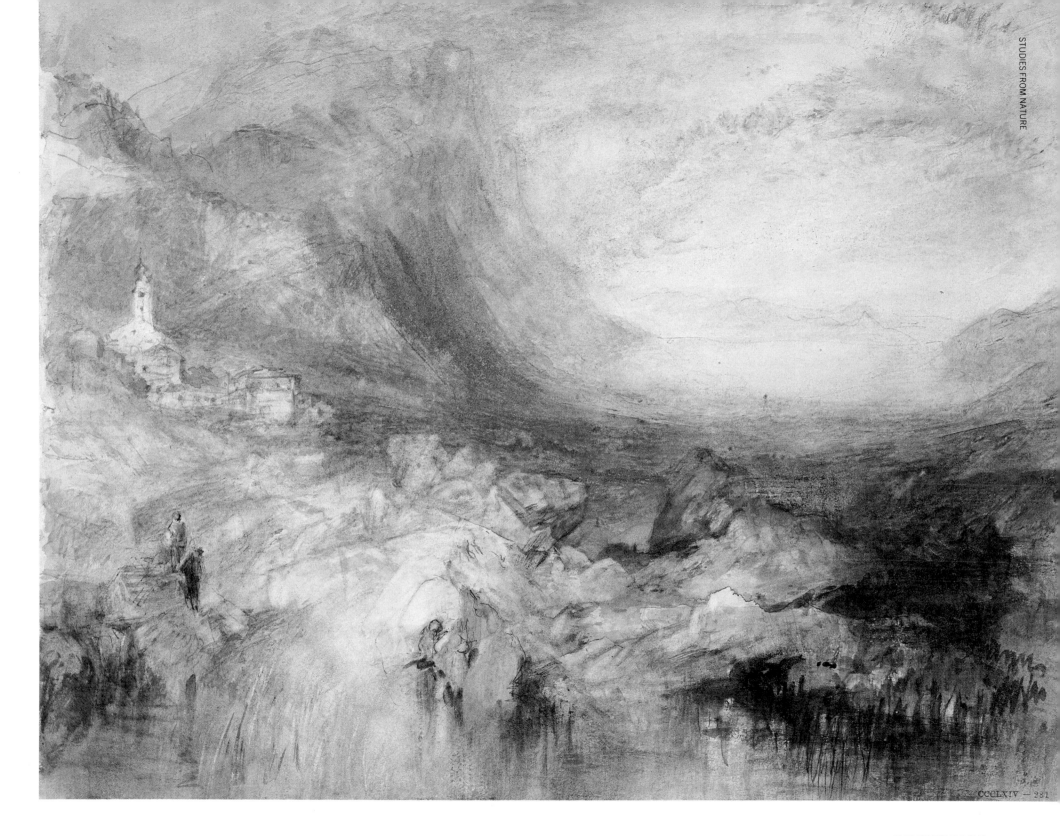

CCCLXIV — 281

THE SKETCHBOOKS

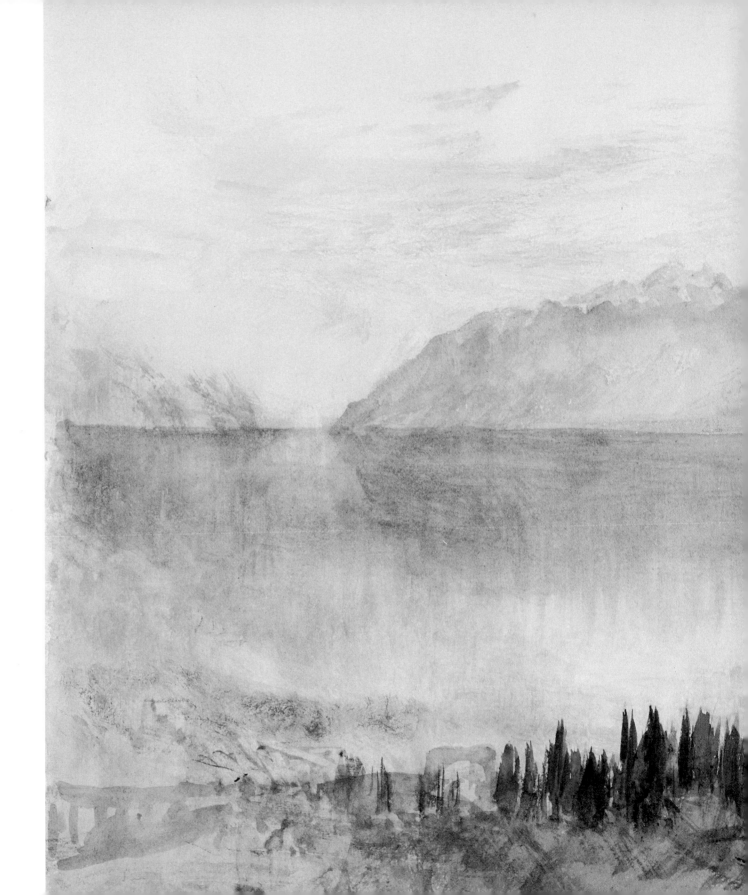

This is a page from
Turner's *Lausanne*
sketchbook which he used on
his 1841 Swiss tour. In this
final period of his career
Turner favoured the use of
so-called "roll" sketchbooks,
soft-backed books that could
be rolled up and easily stored
in the pocket, and it is from
this type of sketchbook that
this sheet is taken. Ruskin
provides a description of how
the artist used the books on
tour, writing "Turner used to
walk about a town with a roll
of thin paper in his pocket,
and make a few scratches
upon a sheet or two of it,
which were so much
shorthand indication of all he
wished to remember. When
he got to his inn in the
evening, he completed the
pencilling rapidly, and added
as much colour as was needed
to record his plan of the
picture." In his final years
Turner was fascinated by
Switzerland, making annual
tours there between 1841 and
1844 and only prevented from
returning again due to failing
health and arduous Royal
Academy duties. In the
watercolour sketches made in
these years the artist
discovered a solemn
bleakness in the alpine
grandeur, and devoted his
studies to the interplay of light
between sky and water. Here
he shows the Dent d'Oche
from Lausanne in the stages
of sunset as its reflected
shadows begin to lengthen on

Lake Geneva, the mountain
bathed in a mixture of warm
golden light from the sun, and
the cooler colours of shade.
The simple yet highly effective
composition of the mountain
outlined against the sky, the
glassy stillness of the lake
below, was an approach that
Turner repeated many times
in his late Swiss watercolours.
Some mountains exerted
particular fascination,
especially the Rigi, a subject
for a whole series of studies,
Turner showing it at different
times of day and under
various lighting conditions.

Ruskin thought these late
works the best of Turner's
watercolour output, and saw
in them both a magnificent
summation of the artist's
talent and experience, and
also a deeper revelation of his
state of mind during this final
period of his career. "What I
call the 'sunset drawings'",
Ruskin wrote, "marks the
efforts of the soul to recover
itself, a peculiar calm and
return to the repose or
youthful spirit, preceding the
approach of death."

J.M.W. TURNER

*The Lake of Geneva
with the Dent d'Oche
from Lausanne,*
1841
pencil and
watercolour,
10¹/₁₆ × 13 in
(25.5 × 33 cm)
Tate Gallery, London

Fantasy and Imagination

To the Romantics the imagination was an immeasurably rich source of inspiration for their art and some artists, including Blake, Samuel Palmer and Goya, used their visions or fantasies to form the subjects for their paintings. An interest in the products of the mind — the imaginary, the fantastic or the visionary — was not the sole preserve of the Romantics. However, to those of them who held the individualistic, the personal and the mystical dear, it could hold particular significance.

During the Enlightenment science had striven to make sense of the world and, with great success, to put forward a rational explanation of all that was within it. By the end of the eighteenth century formalized rational analyses and explanations of the solar system, of human anatomy, climate, geology and nature were all readily available. Much of the world had been explored and mapped. Humanity had made innumerable discoveries and inventions that would have seemed unbelievable in previous centuries. Science had changed the world, not just through the creation of new machines, processes and products, but through a fundamental alteration in the way in which people perceived the world around them.

Scientific analysis and discovery, though miraculous and compelling in its own right, had destroyed much of that which was mysterious and magical in the world and which had fascinated humanity for centuries. It was now difficult, for instance, to look at a plant or animal without being aware of its categorization by

William Lock was a gifted amateur draughtsman. Henry Fuseli paid regular visits to the family home at Norbury Park, Surrey, and encouraged the artist. One contemporary recorded: "Fuseli not only regarded Mr. William Lock junior, for the amiability of his character and his extensive knowledge, but also for his taste and critical judgement in the fine arts, as well as for the power which he displays in historical painting." In this sketch (*One of the Priests of Baal when mocked by Elijah*, 1780, pencil and grey wash) Lock turns to the Bible for his subject; Fuseli's influence is clearly discernible.

Linnaeus (1707–78), and the other species within that genus to which he had related it. It was no longer possible to look at the sun, moon and stars without a sense of the scientifically ordered and rational organization of the universe. Such discoveries and constructs destroyed ignorance and superstition, but also diminished the sense of magic and of wonder.

"Oh Reason, miserable Reason," wrote Heinrich von Kleist.

SPIRITUALITY VERSUS SCIENCE

The second half of the eighteenth century saw something of a backlash against the cold rationality of science; many intellectuals, such as Emmanuel Swedenborg (1688–1772), championed that which was mystical and spiritual within the world. This movement was particularly strong in Germany.

If science had explained some elements of the world, it was incapable of explaining others, for instance why exactly human beings dream, and it was wholly unable to address some of the prime philosophical or spiritual questions of human existence. Scientific discoveries in solving one question had in many cases also raised further questions to which it was impossible to find answers.

The Romantics had always cherished the personal and the individual, and they were committed to the idea of sensation and experience as the path both to personal and universal revelation. In addition, a strong strand of anti-intellectualism and anti-rationalism runs through much of their thought, and so they were receptive to philosophies that emphasized the mystical over the rational.

Many artists cultivated an interest in the occult. John Varley (1778–1842) was interested in all branches of the supernatural, but firmly believed in his ability to make predictions through astrology. He was the companion of Blake, whom he persuaded to indulge in seances at which a procession of real and mythical characters from history made their appearance one by one and who were in turn drawn by Blake.

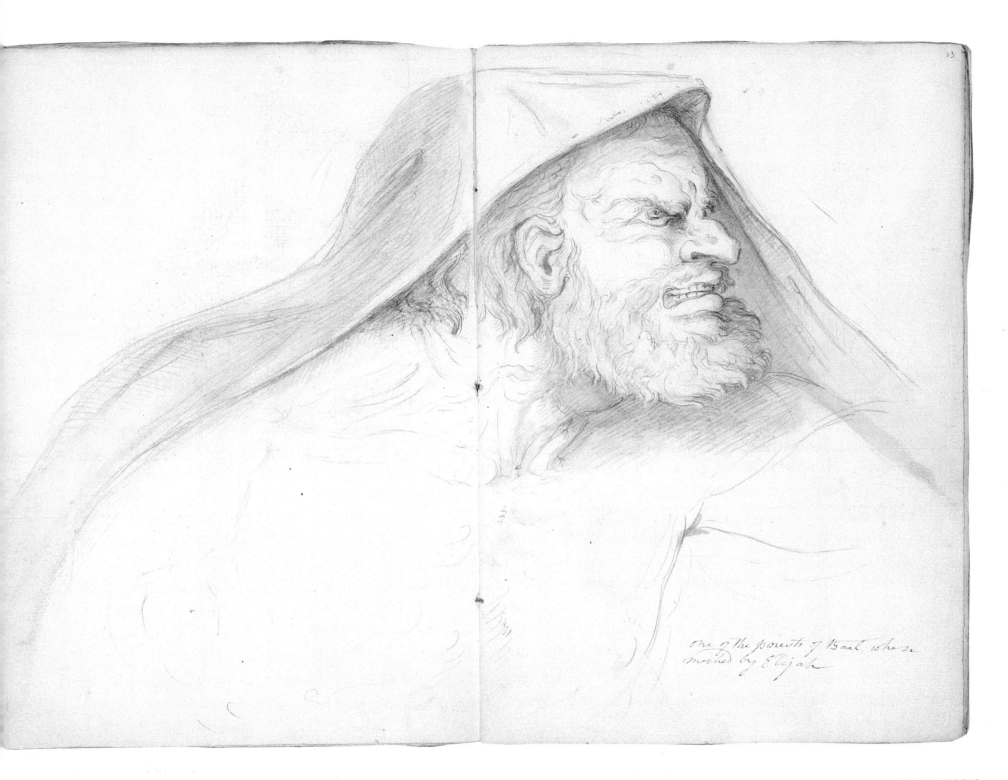

one of the priests of Baal who are
mocked by Elijah

What Blake actually saw or imagined can only be speculated upon, but Varley believed absolutely in the reality of these visions, although he himself saw nothing. Philippe James de Loutherbourg (1740–1812) actually abandoned painting during the 1780s under the influence of the charlatan Count Cagliostro, and pursued a brief career as a faith-healer. An altercation with an angry and thoroughly dissatisfied crowd swiftly terminated this activity, and the painter returned to art.

Against the background of a resurgence of commitment to the mystical and spiritual in the world, and with their belief in a life of sensations and feelings rather than intellectual rationalizations, it is not surprising that the Romantics looked inwards to the world of the imagination for inspiration and discovery. "The mysterious way leads inwards," wrote Novalis.

BLAKE'S INNER WORLD

Dreams, visions and the imagined were all considered fitting inspiration for art. Blake justified and explained it when he wrote:

"This world of imagination is the world of Eternity; it is the divine bosom into which we shall all go after the death of the Vegetated body. This world of Imagination is Infinite and Eternal, whereas the world of Generation, or Vegetation, is Finite and Temporal. There exist in that Eternal World the Permanent Realities of Every Thing which we see reflected in this Vegetable Glass of Nature."

Blake here clearly equates the imagination with the soul. He believed the senses to be "the chief inlets of the soul" but elsewhere stressed that the mind must be receptive to make real the visionary:

To see a World in a Grain of Sand,
And a Heaven in a Wild Flower,
Hold Infinity in the palm of your hand,
And Eternity in an hour.

Blake portrayed the world of reason in his large colour

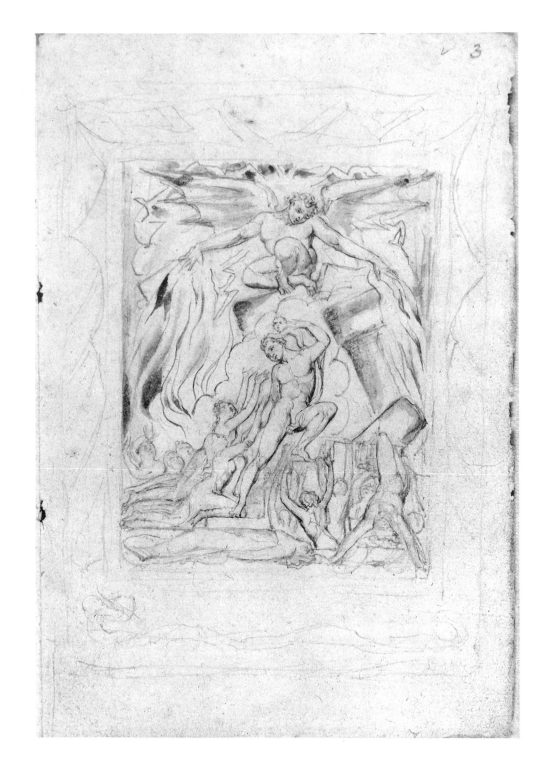

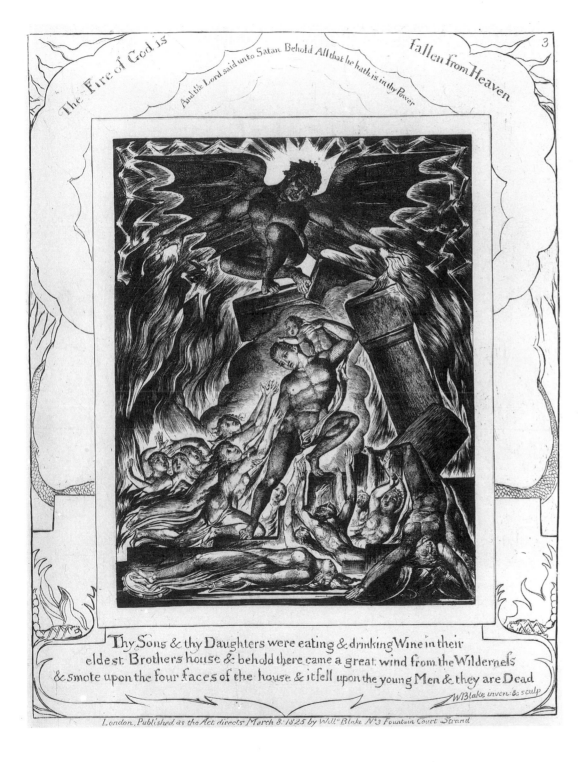

print of Newton, which shows the great scientist of the Enlightenment as an oppressor, measuring and quantifying the world with his dividers. Reynolds had asserted in his Seventh Discourse that "in the midst of the highest flights of fancy or imagination, reason ought to preside from first to last". Next to this statement in his copy of the *Discourses* Blake disparagingly wrote, "If this is True, it is a devilish Foolish Thing to be an Artist". Elsewhere in his volume he articulated his opposition to Reynolds, Locke and Burke: "They mock Inspiration and Vision. Inspiration and Vision was then, & now is, & I hope will always Remain, my Element, my Eternal Dwelling Place."

DISTURBING VISIONS

Imagination might well provide a window to the soul, but what artists found there was not always pleasant. Goya horrifyingly depicted the fiendish creatures that plagued his mind, and for his *Caprichos* produced the etching tellingly entitled *The Sleep of Reason produces Monsters*, although this particular work actually depicts the artist addressed by a group of somewhat unthreatening wild animals. An owl prompts him to pick up his pencil. The Swiss-born artist Henry Fuseli (1741–1835), in his bold depictions of nightmarish visions and men racked by mental anguish or physical pain, succeeded in imbuing his work with a psychological depth of perception that still has the power to disturb. In his drawings especially, Fuseli takes as his subject the themes of his own psychological unease, which invariably revolve around depictions of women as malevolent or cruel, and always threatening.

B lake's sketch for *Job's Sons and Daughters overwhelmed by Satan*, 1823 pencil, 8¾ × 5¹¹⁄₁₆ in (22.2 × 14.5 cm) (*far left*). The finished engraving of the same title, 1826, 7¾ × 6 in (19.7 × 15.3 cm) (*left*).

sensitive, elegaic visionary landscapes. Under the domination of his austere father-in-law John Linnell (1792–1882), an artist of far less talent but much greater success, Palmer was discouraged from pursuing this direction in his work and instead produced more conventional and less inspired pictures. However, in old age Palmer rediscovered his vision and executed the series of virtuoso etchings which portray perfect, beautiful pastoral landscapes.

IDEALIZING THE PAST

The imagination could be used for the transcendence of mundane reality, and this is partly what lies behind the popular Romantic choice of subjects drawn from the past. In common with most of their generation the Romantics were fascinated by past civilizations, and Academic convention required artists to study the achievements of the Classical world.

Romantic artists also chose to depict imaginary or mythical scenes from European history, especially the medieval period, and in the case of Germany and elsewhere this often went hand in hand with the political growth of nationalism. Celebrations of past civilizations were invariably idealized and had little to do with the reality of life in such times. The German Nazarene group, under the leadership of the artists Johann Friedrich Overbeck (1789–1869) and Franz Pforr (1788–1812), eschewed the modern world, preferring to immerse themselves in fantasies of an idealized medieval German society. "My inclination," wrote Pforr in 1810, "tends towards the Middle Ages when the dignity of man was still fully apparent."

The Nazarenes painted in a flat, stylized way that emulated medieval pictures, and they even went so far as to adopt the dress of the period they idolized. The world they depicted was entirely imaginary, as fictional as the pictures of German mythology that other artists were painting during this period, and tell us more about the desires and search for cultural identity of the early nineteenth century than about the medieval world.

Although very different in both style and technique to the work of Blake, Fuseli once pronounced him "damn good to steal from". Elsewhere he wrote a succinct description of Blake's art as an attempt "to connect the visible and invisible world, to lead the eye from the milder light of time to the radiance of eternity". These sentiments could equally well have been applied to the English visionary artist Samuel Palmer (1805–81) who was in his youth a disciple of Blake. Palmer too sought to connect the visible and invisible world, and in his early work produced

Satan smiting Job with Boils, 1823, pencil, (*above*) and (*right*), c. 1805–6 pen and ink and watercolour, the latter from a series of watercolours made of Job for the collector Thomas Butts, later re-used by Blake as designs for *Illustrations to the Book of Job* a set of 21 engravings commissioned by John Linnell.

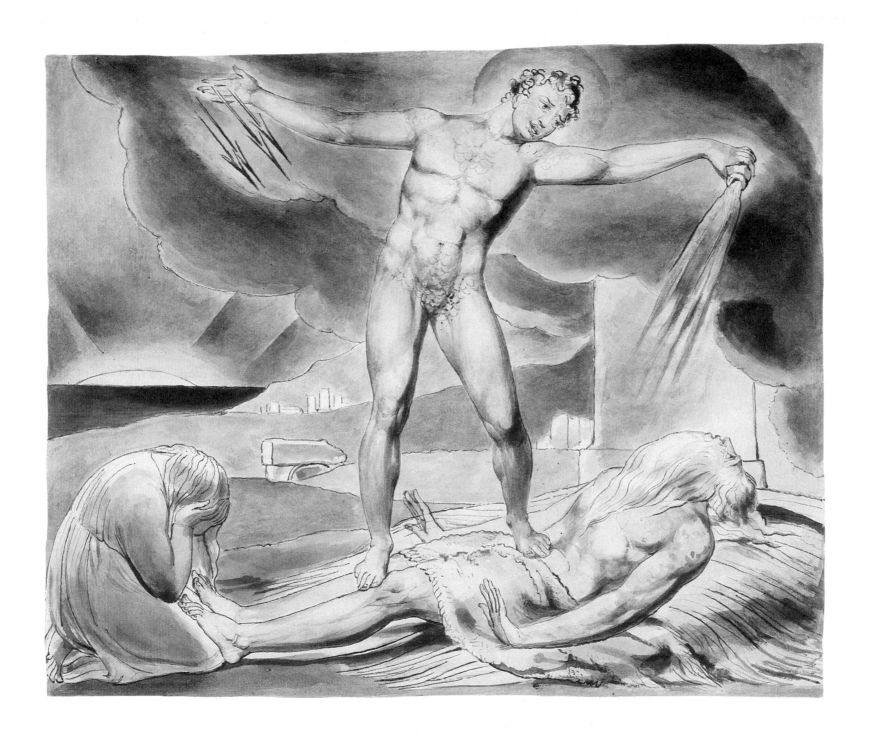

HENRY FUSELI

Three Nude Studies,
c. 1775–8
pen and ink,
7¹¹⁄₁₆ × 10¾ in
(19.5 × 27.3 cm)
Kunsthaus, Zurich

*I*n a portrait of immense directness and power, Fuseli depicts himself as a somewhat haughty, melancholic and brooding but strong character; he was noted for his cynicism and this too shows through in this perceptive image of himself. It is likely that the drawing was made before a mirror, and this may explain why Fuseli has composed the image of himself into a confined area, although this has the additional effect of heightening the intensity of the picture.

HENRY FUSELI

Kneeling Man with
raised Arms,
c. 1770–78
black crayon,
10½ × 7⅛ in
(26.8 × 18.2 cm)
Kunsthaus, Zurich

*F*useli has inscribed this sheet with a quotation in Greek from Homer's *Iliad* which refers to the constant closeness of death. The three figures he has drawn could therefore well be intended to be seen as being in the throes of death. The central figure has been carefully drawn to show the muscular construction and precise anatomy of the man. Fuseli has drawn in several diagonal construction lines linking the legs with the line of the torso in order to orientate the correct pose of the model's body.

A sheet from the sketchbook that Fuseli used during his eight-year sojourn in Rome. Following in the classical tradition of working, Fuseli has sketched in the nude figure first and then begun to draw onto the body the hanging folds of its clothing, in this case a cape or toga. Fuseli's Roman period was central to his development as an artist, and it was in Rome that he evolved the style and characteristic treatment of subject-matter that he was to retain throughout his career.

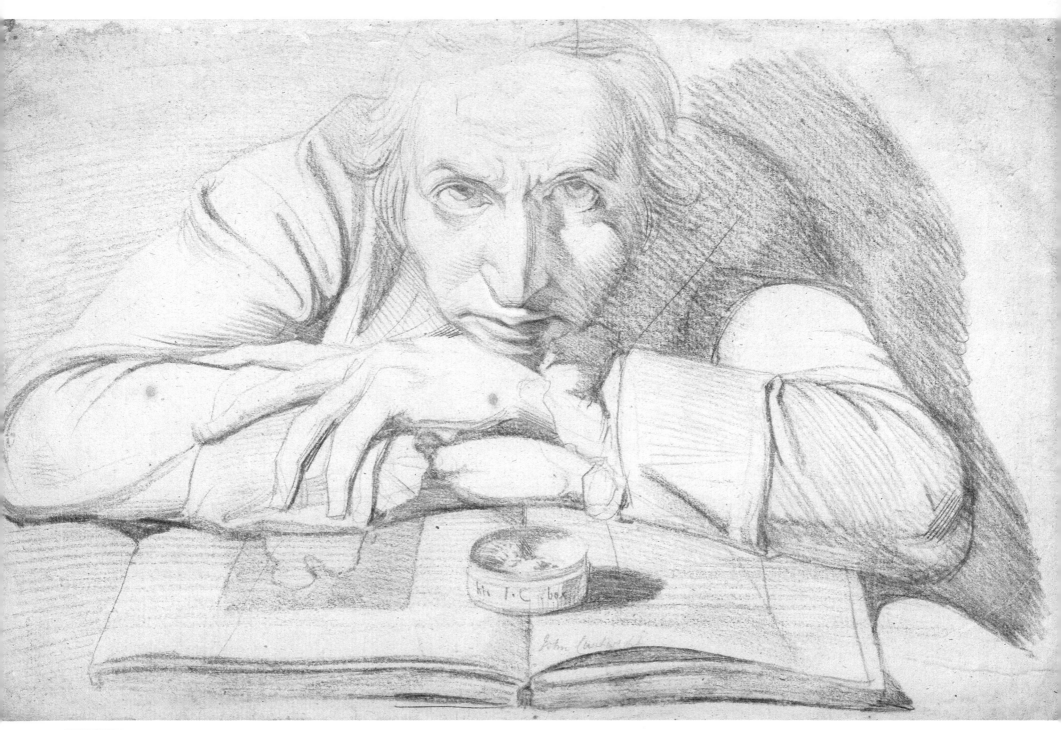

HENRY FUSELI

Self-Portrait, 1777–9
black and white chalks,
12¹¹⁄₁₆ × 19⅝ in

(32.2 × 49.8 cm)
National Portrait
Gallery, London

This is a manuscript sheet from Fuseli's *Aphorisms Chiefly Relating to the Fine Arts*; he was a great writer and lecturer on art as well as a practising artist, and was also noted for his translations of works from German into English. In addition to his draft on this sheet, Fuseli has used it for a series of sketches of courtesans, one of his favourite subjects. The artist appears to have had complex and contradictory feelings about women, for he often portrays them as sinister or threatening temptresses. In an age when it was believed that physiognomy could dictate character, Fuseli's sketches are imbued with an unusual degree of psychological perception, perfectly attuned to the Romantic belief in rigorous self-analysis.

HENRY FUSELI

Four Courtesans, c. 1815–20 pencil and pen and ink, 9¹⁄₁₆ × 7³⁄₈ in (23 × 18.8 cm) Kunsthaus, Zurich

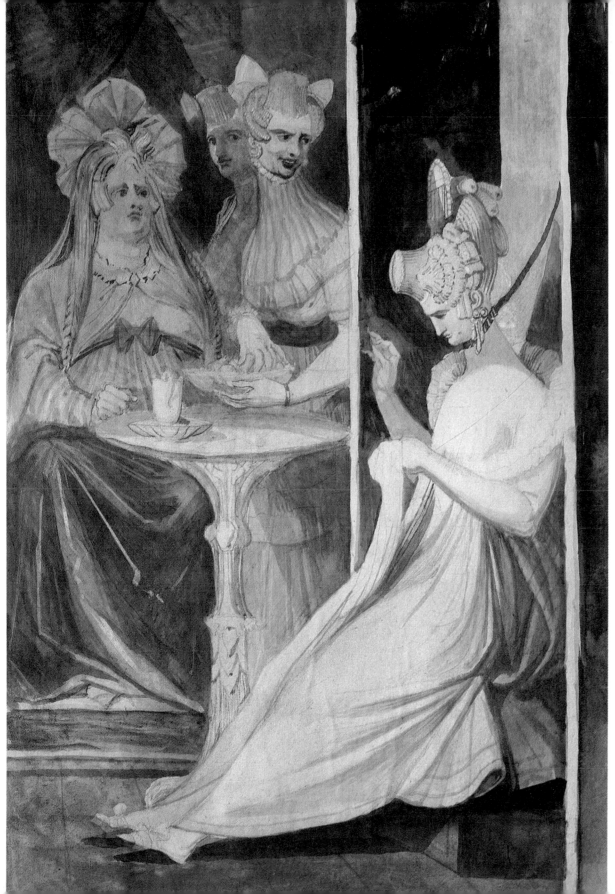

HENRY FUSELI

The Debutante,
1807
pencil and
watercolour with
some white
bodycolour,
14⅝ × 9½ in
(37.1 × 24.1 cm)
Tate Gallery, London

This drawing shows the type of finished work that might develop out of an initial sketch made separately. Fuseli has employed a vigorous pencil underdrawing technique and then applied broad strokes of watercolour, leaving many areas of the paper bare. The highlights have been added last in white bodycolour. Fuseli depicts a domestic scene, but one laden with a sense of menace. The debutante sits calmly sewing, but she is restrained by a black choker and lead which seems to be fixed to the wall. One of the standing women looks down on her with an expression of gloating satisfaction at the debutante's plight. In his depiction of women, Fuseli often relied, as here, upon the motifs of exaggeratedly long necks and elaborate hairstyles.

THE SKETCHBOOKS

The Sleep of Reason produces Monsters

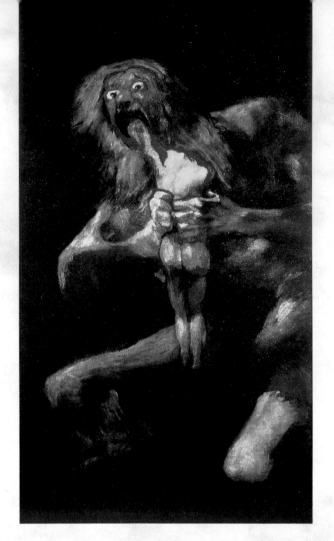

*F*rancisco Goya *Saturn devouring one of his Children* (c. 1820-3), oil, 57½ × 93½ in (146 × 238 cm) (*left*). Goya's murals that were born of old age and deafness, the so-called "Black Paintings" are among his final visions, but are ultimately perhaps the most horrific and disturbing.

*H*enry Fuseli *The Nightmare* (c. 1782), oil on canvas, 40 × 50 in (101 × 127 cm) (*right*). Fuseli's famous painting perpetuates the notion of dreams as visitations. Here, the artist shows the incubus, the bringer of the nightmare, sitting on the sleeper's chest. His wild-eyed steed stares in through the parted curtains, and the sleeper herself writhes in her unconscious torment.

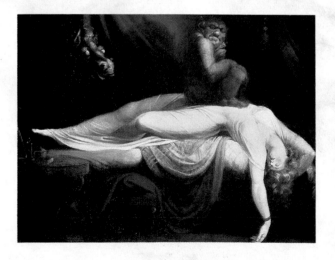

*U*nderneath Goya's aquatint *The Sleep of Reason produces Monsters* of 1799 was printed the warning that "Imagination abandoned by reason produces impossible monsters; united with her, she is the mother of the arts". Goya correctly concludes that fantasy and imagination could be a rich source of inspiration and that a contemplation of the mythical and unknown could sometimes produce great insights. Goya and many of his Romantic contemporaries encouraged their minds to be receptive to fantasy and visions, and rigorously examined the depths of their psyches, using the images that they found there in their art, however disturbing. Some Romantic artists and writers went so far as to use drugs, such as opium, in order to do this. While making the *Caprichos* series of prints, which were intended as a savage satire of Spanish society, Goya found himself tormented by demons that he felt were almost tangible. His warning of the consequences of the abandonment of reason stemmed from this experience, for he had found that the world of febrile fantasy and vision could ultimately lead to chaos or derangement as well as artistic inspiration.

The Swiss-born artist Henry Fuseli also used the products of his subconscious for some of his most original themes. Fuseli was fascinated by dreams, and it is reported that he regularly consumed raw pork chops before retiring to bed, in an attempt to induce nightmares. His sketches and drawings record some of his nocturnal visions, laden with psychological sym-

bolism that appears very advanced for the early 19th century. Fuseli often shows himself to be possessed of a tortured mind, especially in works with an underlying eroticism or sexual menace. As one reviewer remarked: "It was he who made real and visible to us the vague and insubstantial phantoms which haunt like dim dreams the oppressed imagination."

Francisco Goya *Brujas à Bolar* (*c.* 1797), pen and ink and wash, 9⁵⁄₁₆ × 5⁷⁄₈ in (23.7 × 15 cm) (*right*). "Witches about to Fly" shows the kind of satanic ritual with which Goya would have been familiar through the folklore of his native Basque contry. The 1790s saw a renewal of interest in witchcraft among Spanish thinkers.

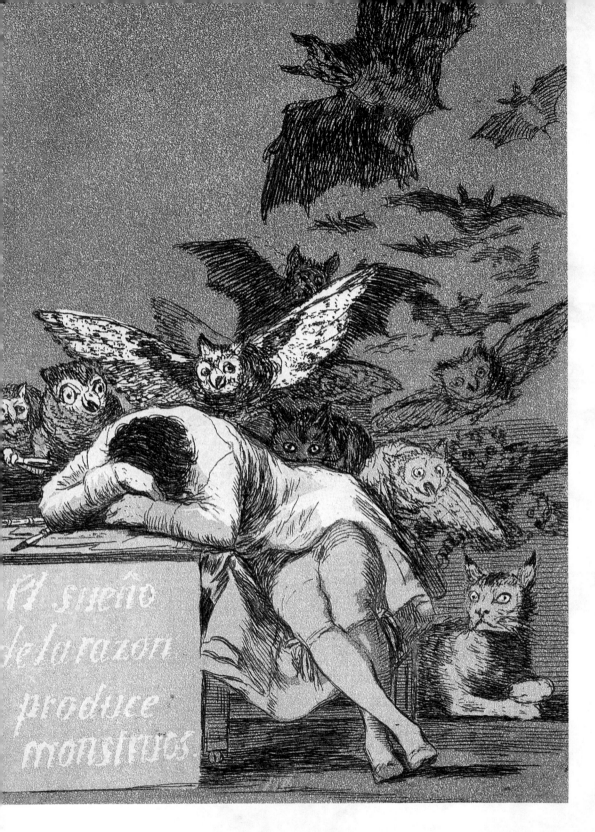

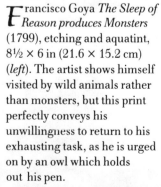

Francisco Goya *The Sleep of Reason produces Monsters* (1799), etching and aquatint, 8½ × 6 in (21.6 × 15.2 cm) (*left*). The artist shows himself visited by wild animals rather than monsters, but this print perfectly conveys his unwillingness to return to his exhausting task, as he is urged on by an owl which holds out his pen.

THE SLEEP OF REASON PRODUCES MONSTERS

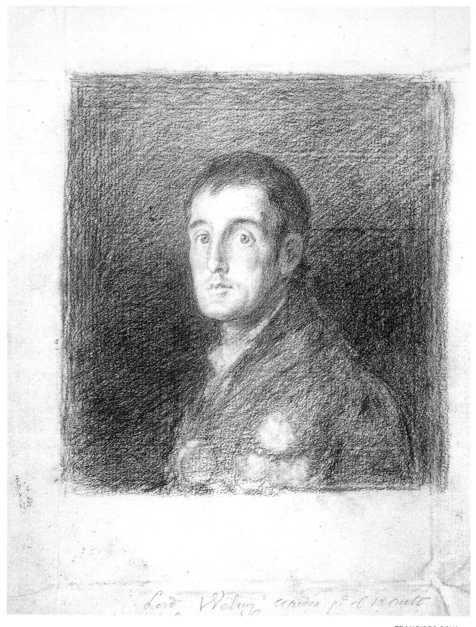

Lord Welin'g aquaria p.° el retrato

FRANCISCO GOYA

*The Duke of
Wellington*, 1812
pencil and red chalk,
9¼ × 7 in (23.4 ×
17.7 cm)
British Museum,
London

Wellington was the commander of the British forces during the Peninsular War against the Bonapartist French and Spanish forces, and he sat to Goya between August and September of 1812. Goya must have viewed him as a liberator of his country from French oppression. Wellington had a reputation for his hard and intractable character, but here Goya depicts him as an intelligent and sensitive man, his face viewed in half profile holding an expression of slight uneasiness and vulnerability. Goya was adept at revealing the character of his sitter in his portraits. As the most fashionable portraitist in Madrid he was appointed court painter to the King, but Goya had little regard for the Spanish Royalist state, and his unflattering portraits of the royal family made them appear unintelligent and boorish.

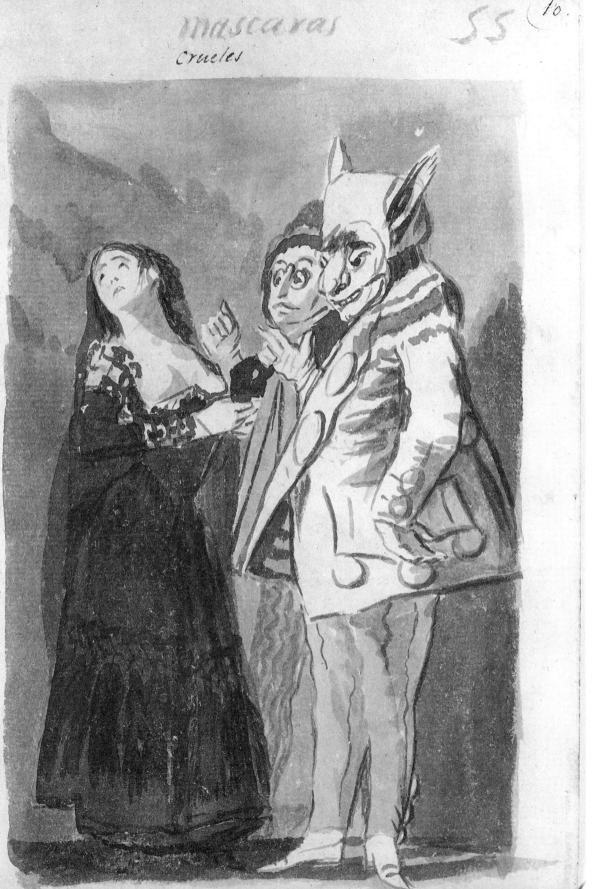

mascaras
crueles

55 (10.

FRANCISCO GOYA

*Mascares Crueles
(Cruel Masks),*
c. 1797
pen and ink and
wash on pale blue
paper, 9⁵/₁₆ × 5⁷/₈ in
(23.7 × 15 cm)
Woodner Collection,
New York

While carrying on his career as Spain's leading portrait painter, Goya was also engaged in making drawings and prints which relied upon the profound power of his imagination for their success. In *Mascares Crueles* Goya shows characters in carnival dress, but the masks worn by the male figures seem more true to their personalities than their own faces might be, and there is even a suggestion that the human face has actually been transformed into a mask. The nearest male figure leers at the woman's bared breast in a grotesque way, the ears of his mask like those of an ass. The drawing comes from the Madrid album, a series of 94 sheets which Goya has numbered on both the front and reverse. The drawings have a cohesion of subject-matter and treatment which make it likely that Goya intended to publish them as a series of prints in the manner of his *Caprichos*, to which a number of designs in the Madrid album can be closely related.

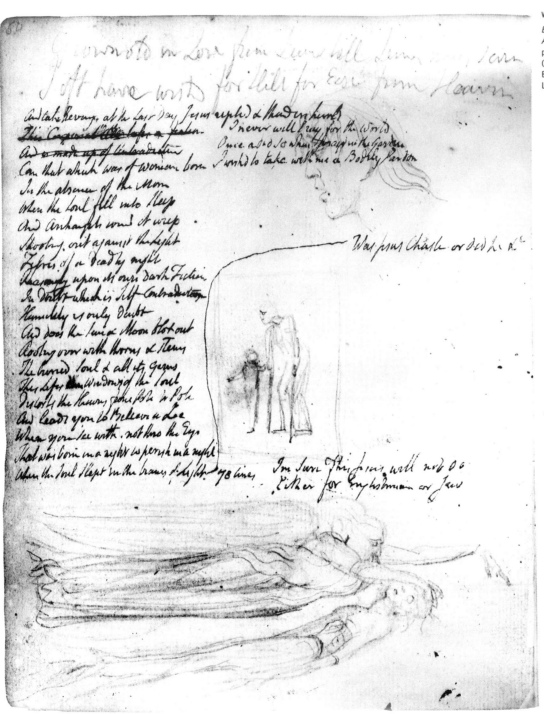

WILLIAM BLAKE

*Elohim creating
Adam*, c. 1790–5
pencil, 7⅞ × 6⅛ in
(20 × 15.5 cm)
British Library,
London

Elohim is one of the Hebrew names for God, but can also be translated as "judges". Blake shows God forging Adam from the earth, but he is already entwined by the worm, the symbol of mortality. In the 1790s Blake began to question distinctions between good and evil, which he saw as artificial and repressive towards mankind's true nature. In his illustrated text *The Marriage of Heaven and Hell* of 1793 he tried to destroy perceived divisions between good and bad. Indeed, he saw evil as a primal urge and source of great energy, an impulse nowhere stronger than in sexual desire. Blake was deeply moral and religious, but came to see God as an oppressor who had cast out Satan from Heaven to create the twin polarities of good and evil. *In Elohim Creating Adam* the oppressive theme recurs, as God enslaves Adam with mortality, fearful grief showing on Adam's face as he is dragged from the earth. It is not a joyful act of creation, and Blake's bold positioning of the figures in a tightly constrained space makes this one of his most powerful images. After 1800, Blake's inner turmoil seems to have calmed as he turned to more peaceful thoughts of religious salvation rather than oppression.

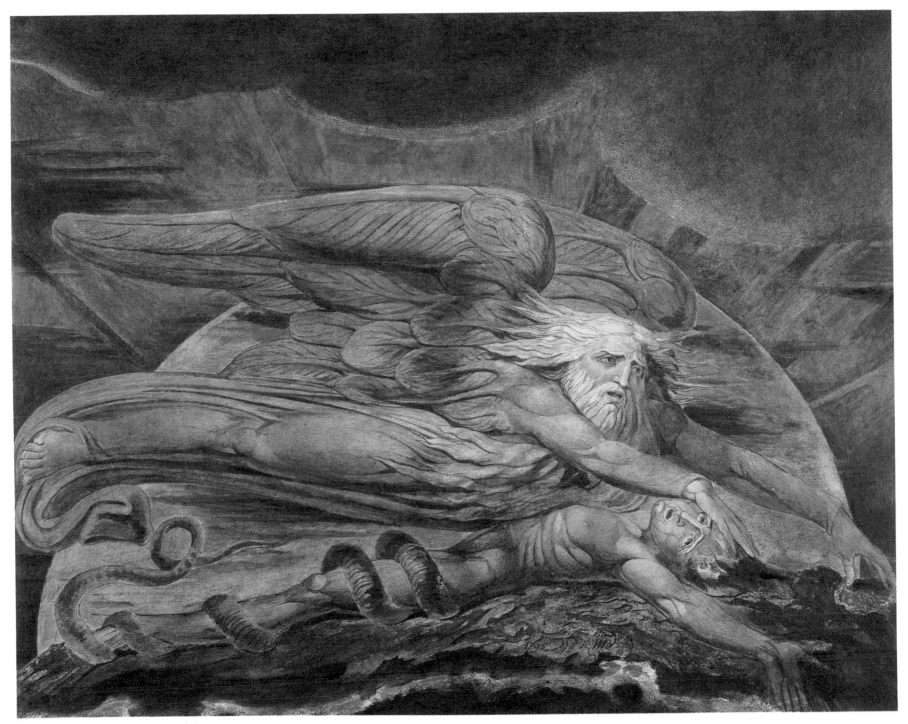

WILLIAM BLAKE
*Elohim creating
Adam, c.* 1795
colour print
finished in pen
and ink and
watercolour,
17 × 21⅛ in
(43.1 × 53.6 cm)
Tate Gallery,
London

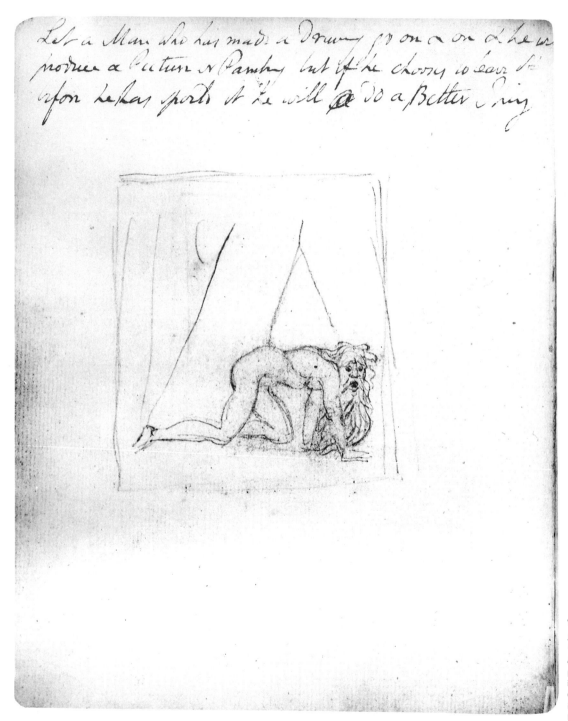

WILLIAM BLAKE
Nebuchadnezzar,
1795
colour print
finished in pen and
ink and watercolour,
17½ × 24⅜ in
(44.6 × 62 cm)
Tate Gallery, London

WILLIAM BLAKE
*Sketch for
"Nebuchadnezzar"*,
c. 1790
pencil and pen and
ink, 7⅞ × 6⅛ in
(20 × 15.5 cm)
British Library,
London

*B*lake used this design both in his book *The Marriage of Heaven and Hell* and for the large colour print in which it achieves its true grandeur and most powerful form. Blake symbolizes in the form of Nebuchadnezzar the slavery of man to his animal passions, the colour print having as a companion *Newton*, in which Blake warns of the dangers of an over-rational and measured world. The large colour prints were made by Blake by painting on a piece of millboard and then, before the paint had time to dry, pressing it on to paper. Blake would then finish the work in watercolour and pen and ink. He would pull only a small number of each print, usually not replacing the paint, so subsequent versions became fainter and fainter. There are four known prints of *Nebuchadnezzar*, all varying slightly as a result of the techniques used by Blake. Most of his other subjects have fewer colour prints.

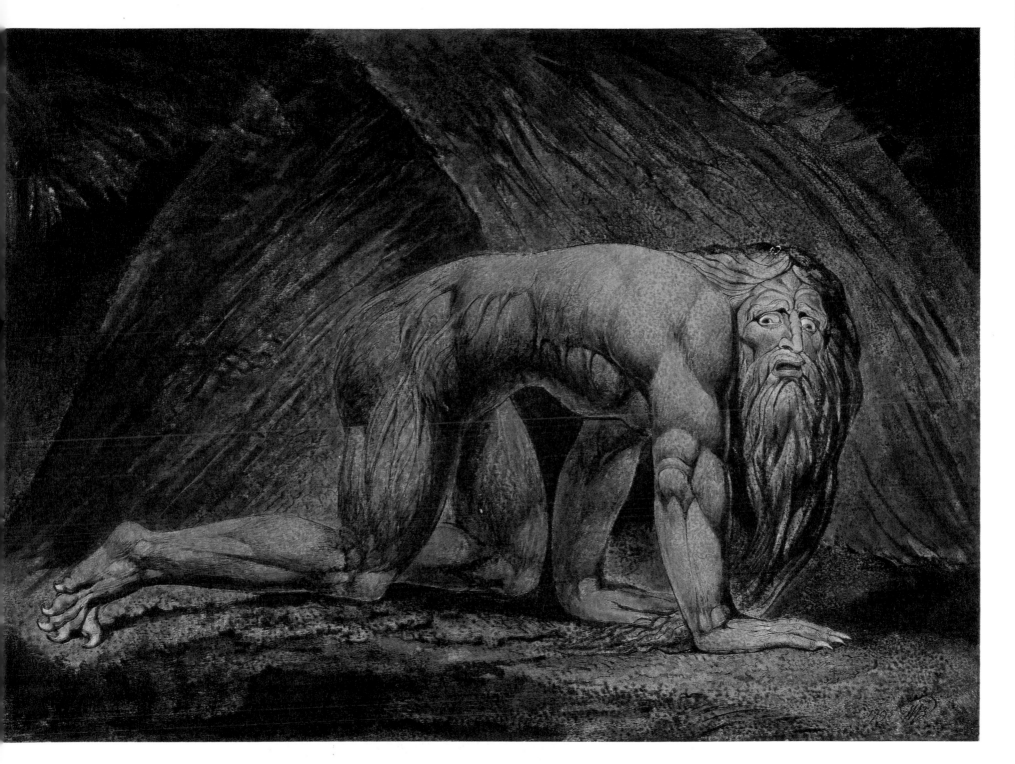

Blake's Visionary Heads

William Blake *The Man who taught Blake Painting in his Dreams* (c. 1819), pencil, 9½ × 9¹⁄₁₆ in (24 × 23 cm) (*above left*). This drawing could be viewed as a visionary self-portrait, a graphic depiction of Blake's own inspiration. The curious design on the man's forehead appears to allude to the flames of artistic inspiration. (*below left*) William Blake *John Varley* (1807), pencil, 11 × 7¾ in (27.9 × 19.7 cm).

During his lifetime Blake was famous for his visionary capacity, and perhaps some of the most remarkable products of this gift were his drawings of the so-called Visionary Heads. They record the long procession of the spirits of historical and mythical characters who visited Blake throughout October 1819. Blake was persuaded to engage in this activity by John Varley (1778–1842), a landscape artist who was fascinated by astrology. Both Varley and Blake subscribed to the belief that the position of the stars at birth influences both character and physiological appearance, and several of the Visionary Heads that Blake drew were engraved as illustrations for Varley's *Treatise on Zodiacal Physiognomy* of 1828.

Thomas Philips *William Blake* (1807), oil on canvas, 36¼ × 28⅜ in (92.1 × 72 cm) (*left*).

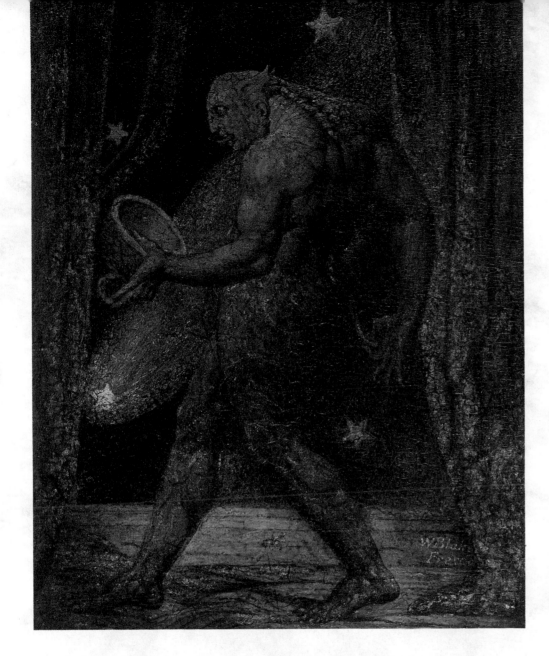

ing William Wallace, "I cannot finish him – Edward the First has stept between him and me."

The reality of the visions has been debated ever since. Blake could have been enjoying a joke at the credulous Varley's expense; he could have been suffering from mental illness, or projecting his imagination. The truth of the matter can only be speculated upon, but the Visionary Heads will remain as some of Blake's most unusual and imaginative work.

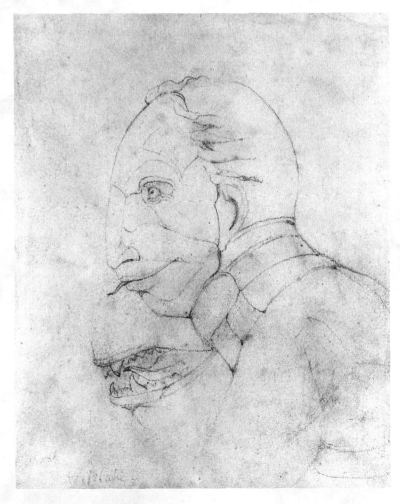

The visions took place in Varley's house in London, and Blake recorded them in sketchbooks that belonged to his admirer. Varley would suggest a character and Blake would wait for the spirit to visit him. Then he would draw what he saw. Varley himself saw nothing but believed in the reality of what Blake was seeing. The visionary figures often competed for notice, Blake complaining at one point, while sketch-

William Blake *The Ghost of a Flea* (c. 1819), tempera with gold on panel, 8⁷⁄₁₆ × 6³⁄₈ in (21.4 × 16.2 cm) (*above*). This was worked up from the sketch. William Blake *The Head of the Ghost of a Flea*, pencil, 7½ × 6 in

This notebook originally belonged to Blake's brother Robert, and includes some sketches by him in it, but after Robert's death in February 1787 William inherited the book, which he kept near him for most of his life. He used the book for a wide variety of projects, making sketches for finished works and also filling it with draft versions of his essays and poems. Today the book is priceless, for it is central to the understanding of Blake's imagery. It is here that he evolves many of the symbols that are later to be found in his finished work. On this sheet the artist shows two flying monsters, who recur throughout the notebook. Contained in their mouths are the bodies of human beings.

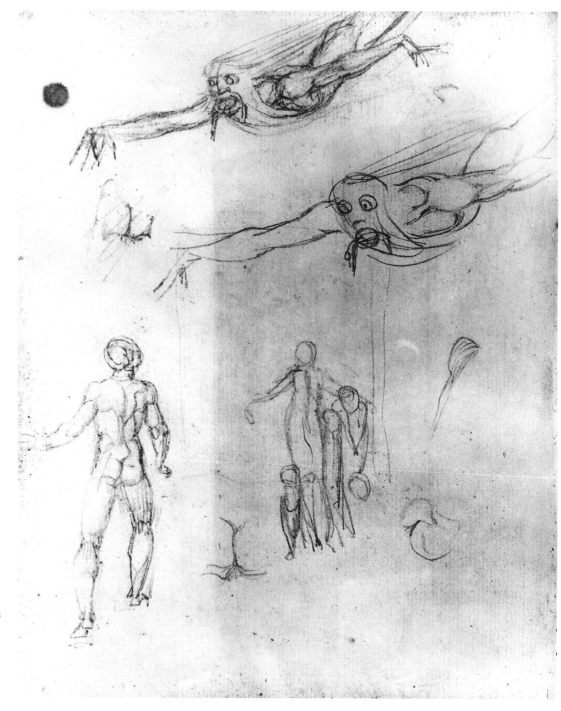

WILLIAM BLAKE
Page from Blake's Notebook,
c. 1790–1805
pencil,
8¾ × 5¾ in
(22.2 × 14.5 cm)
British Library,
London

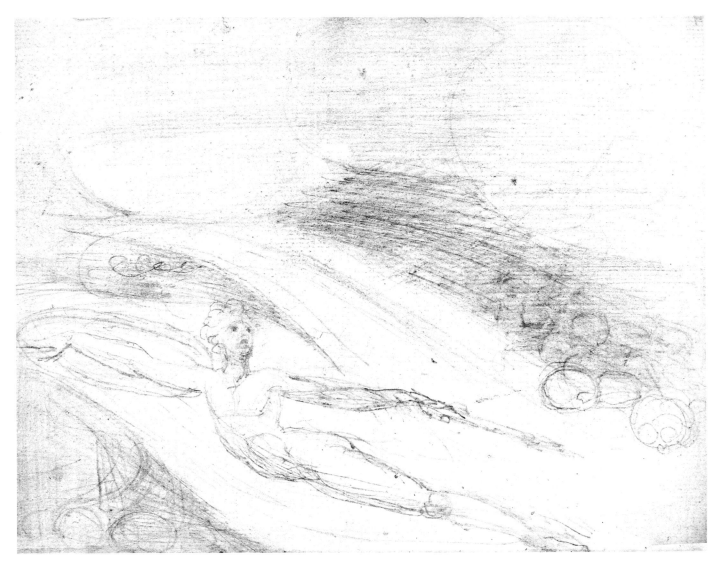

This sketch in Blake's notebook shows Satan with shield and spear in hand, and would appear to be one of the designs planned by the artist for an aborted project, an illustrated volume of the works of the poet John Milton. This sketch shows a moment from that writer's *Paradise Lost* when Satan soars upwards out of hell to forge the path that Sin and death will follow, "a broad and beaten way over the dark abyss", while telling his council: "Long is the way and hard, that out of Hell leads up to light." The circles that are sketched on either side of Satan represent his audience, and the larger circles above his head represent the gates of hell.

WILLIAM BLAKE

Satan,
c. 1790–1805
pencil,
8¾ × 5¾ in
(22.2 × 14.5 cm)
British Library,
London

JOHN BROWN

Studies of Heads,
c. 1775–80
pencil, 5$\frac{1}{16}$ × 7$\frac{11}{16}$
in (12.9 × 19.5 cm)
Cleveland Museum
of Art

*I*n this sketch Brown concentrates upon the feelings of isolation and oppression the woman is experiencing when she finds herself among a group of leering friars, their faces contorted by lust. Brown's drawing can be interpreted as a scathing indictment of the moral hypocrisy and licentiousness of the Italian *Curia* which was notorious at the time. The woman's bare-breasted apparel would not have been considered unusual during this period, but although fashionable in some circles it was also one of the symbols identifying a courtesan.

JOHN BROWN

Two Standing
Women,
c. 1775–80
pencil, pen and ink
and grey washes,
5 × 7$\frac{11}{16}$ in
(12.9 × 19.5 cm)
Cleveland Museum
of Art

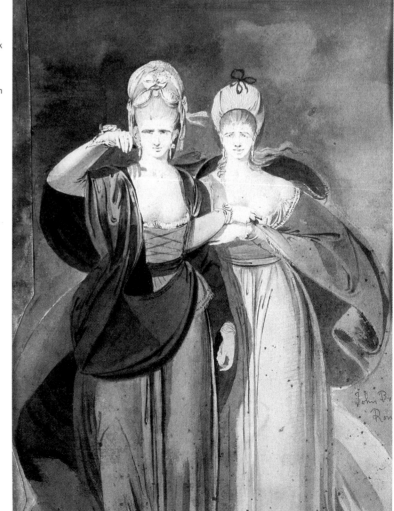

John Brown was Scottish by birth and trained at the Trustees' Academy in Edinburgh, but he spent almost 12 years in Italy. Many of his drawings are observations of scenes or people he encountered while in Italy, some having a slightly menacing or sinister quality. His sheet of drawings of heads (*above*) is one of several such series of studies and displays his interest in physiognomy and phrenology as a guide to character. His *Two Standing Women* (*right*) presents an unsettling image that is difficult to interpret. The women's facial expressions are ambivalent – a mixture of curiosity, fear and even anger.

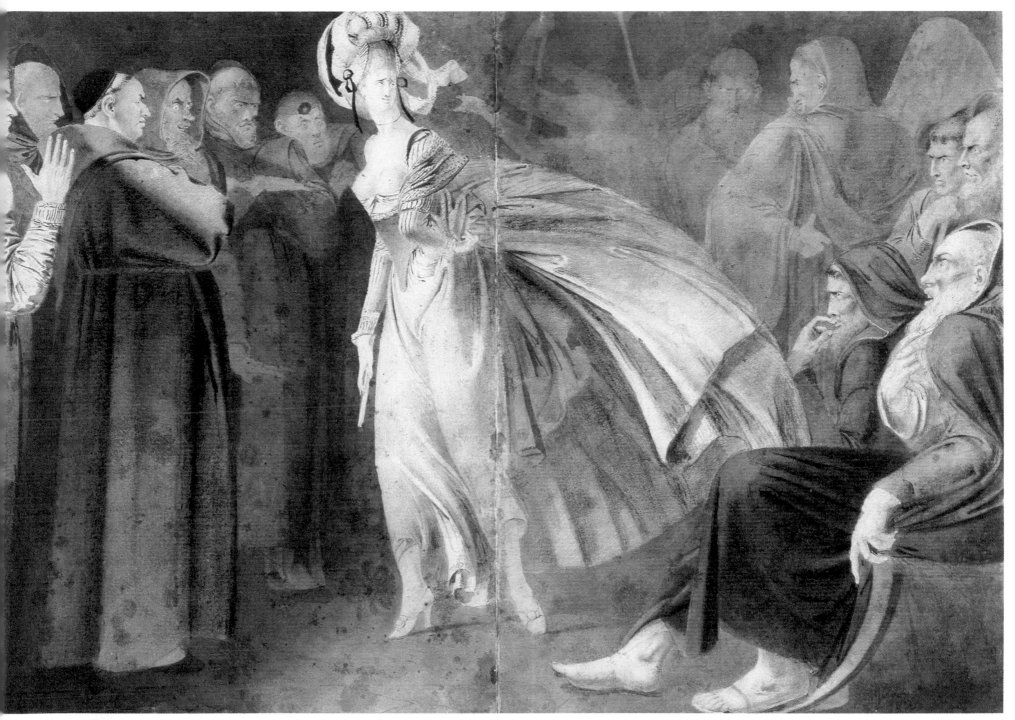

JOHN BROWN
*A Woman standing
among Friars,*
c. 1777–80
pencil, pen and ink

and grey wash,
10⅛ × 14⁹⁄₁₆ in
(25.8 × 36.9 cm)
Cleveland Museum
of Art

THE SKETCHBOOKS

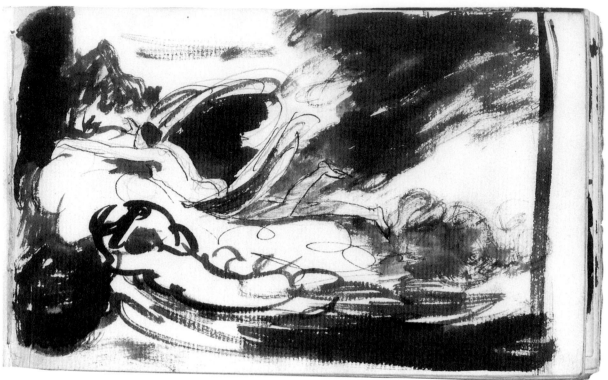

This trimmed sheet is likely to have come from the sketchbook that is now in the Art Institute of Chicago. During the 1790s Romney was engaged in making a series of studies for compositions of diabolic scenes, some connected with designs for a planned painting of Macbeth and the witches, and others, such as the present drawing, which were no doubt intended for a projected illustrated volume of Milton's works.

This sketch, by George Romney, which shows a woman swimming in rough sea, may well be inspired by ancient mythology, but it is difficult to identify the subject firmly. The sketchbook which contains this sketch includes several other reworkings of the same scene, fully bearing out Romney's son's description that "Upon some occasions so many different modes of representing the same subject presented themselves to his fancy, that he made several studies either varied in part or in whole, and executed in a slight bold and rapid manner just sufficient to convey the ideas and from these he afterwards made his selection." Sadly most of Romney's sketchbooks have since been broken up, and the process Romney's son describes has become almost impossible to imitate.

GEORGE ROMNEY
Diabolical Scene,
c. 1794
pencil,
4½ × 4⁹⁄₁₆ in
(11.4 × 11.6 cm)
Fitzwilliam Museum,
Cambridge

*I*n this drawing Romney uses the typical energetic pencil technique found in so many of his sketches, alternating light and shadow to animate the figures. *A Coven of Witches (below)* may have been a project design, but it also shows his morbid devotions that seem to have been both a manifestation of and a contribution to his growing mental unease. His drawings often focus on punishment, torment and pain; the depression seemed to stem from fears for the course of the French Revolution, which he had ardently supported, but the cause of his illness undoubtedly ran deeper. His son declared his father's mind to be "quite thrown off its pivot"; Romney died insane.

GEORGE ROMNEY
A Coven of Witches
c. 1794
pencil
5 ⅜ × 8 ⅜ in
(13.6 × 21.3 cm)
Fitzwilliam
Museum,
Cambridge

*T*his rapidly drawn sketch appears to show a figure tormented by devils, *(above)* or perhaps a witches' Sabbath, but the identification of the subject remains uncertain. Romney's devotion to the portrayal of such scenes during this period can perhaps serve as a metaphor for his deteriorating state of mind, belaboured with nervousness, apprehension and depression. Romney contributed to his own depression by foolishly designing and building a house and studio at Hampstead where he displayed his large collection of casts from the antique, from which, however, he soon had to escape, as he was suffering from loneliness.

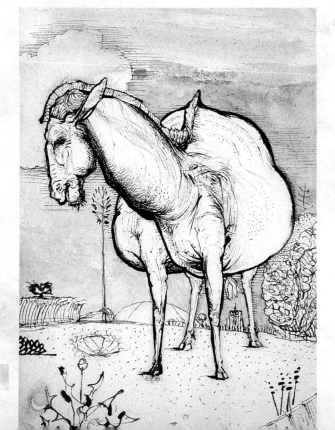

Visions and Dreams: Samuel Palmer's 1824 Sketchbook

Samuel Palmer (*above left*) *Coming from Evening Church* (1830), tempera on paper mounted on panel, 11⅞ × 7⅞ in (30.2 × 20 cm). Nature, God and worship were inextricably bound together in Palmer's pastoral vision, nowhere more clearly seen than in this work. (*below left*) *Imaginary Animal*, 1824 sketchbook, pen and ink and watercolour, 4½ × 7⁷⁄₁₆ in (11.6 × 18.9 cm). The beast appears to be part-mule, part-camel, and bears a slightly comical aspect. (*below*) *Self-Portrait* (c. 1826), black and white chalks on buff paper, 11½ × 9 in (29.1 × 22.9 cm).

Describing Blake's woodcuts for the *Pastorals of Virgil*, Palmer wrote: "They are visions of little dells, and nooks, and corners of Paradise; models of the exquisitest pitch of intense poetry ... There is in all such a mystic glimmer as penetrates and kindles the inmost soul." He could equally well be describing his own work in his 1824 sketchbook, which contains a succession of visionary images that, while based on nature, project a romanticized and dreamlike view of idealized English scenery. Palmer creates a world of imagination in his sketchbook, with sheep cropping the grass of perfectly rounded hills, rainbows, brilliant stars, and a burning sun, on one sheet actually painted with gold. Interspersed with these pastoral visions are studies of saints and angels, sometimes accompanied by more threatening figures, studies of mysterious woods and gnarled trees, and peculiar creatures such as the Imaginary Animal. As a whole the drawings have an almost hallucinatory quality. The book also contains lyrical poems and discursive passages on art and religion, written out in Palmer's flowing copperplate handwriting.

The drawings clearly show Blake's profound influence upon the younger artist, not only in visionary and imaginary potential but also technically in Palmer's reliance upon line, which he later summarized: "The great and golden rule of art, as well as life, is this: That the more distinct, sharp, and wiry the bounding line, the more perfect the work of art; and the less keen and sharp, the greater is the evidence of

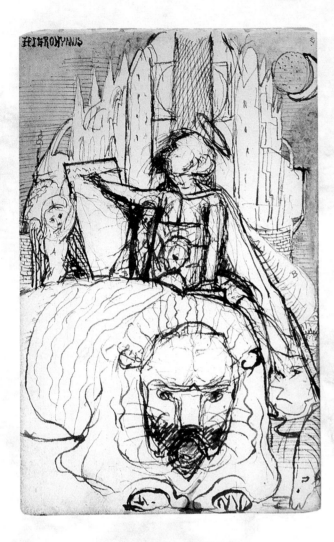

Samuel Palmer (*left*) *St Hieronymous*, 1824 sketchbook, pen and ink and watercolour, 4½ × 7⁷⁄₁₆ in (11.6 × 18.9 cm). The saint writes on a tablet in front of an elaborate cathedral, while in front of him is a lion whose menacing face has human resemblance. (*below*) *Landscape Studies*, 1824 sketchbook, pen and ink and watercolour 4½ × 7⁷⁄₁₆ in (11.6 × 18.9cm). Includes a number of studies of imaginary landscapes and foliage.

from the Shoreham years such as *Coming from Evening Church* and *Cornfield by Moonlight* (British Museum), intense but lyrical depictions of an idyllic English countryside that had sadly never existed. In middle age Palmer's vision left him and he executed more prosaic, although accomplished, work until he rediscovered his original pastoral lyricism through the superb etchings of his last years.

The 1824 sketchbook is one of just two of Palmer's sketchbooks that have survived intact out of a total of 20. Before his emigration to Canada, Palmer's son collected them together and committed an unforgivable act. "Sooner than that the multitude of slight sketches, blots, designs, etc., which my father valued so much should be scattered to the winds," he wrote, "I burnt them, and so much more before we sailed, that the fire lasted for days."

weak imitation, plagiarism, and bungling."

Palmer was first introduced to Blake by John Linnell in the autumn of 1824, some months after he had started this sketchbook, begun, as he has inscribed the cover, on "July 15th, 1824". Palmer had found another artist who thought similarly to himself, albeit undoubtedly more profoundly, and he behaved in the manner of a disciple. Palmer further developed the visionary and dreamlike quality of his work in later years. The results of the explorations in his 1824 sketchbook are clearly found in later finished works

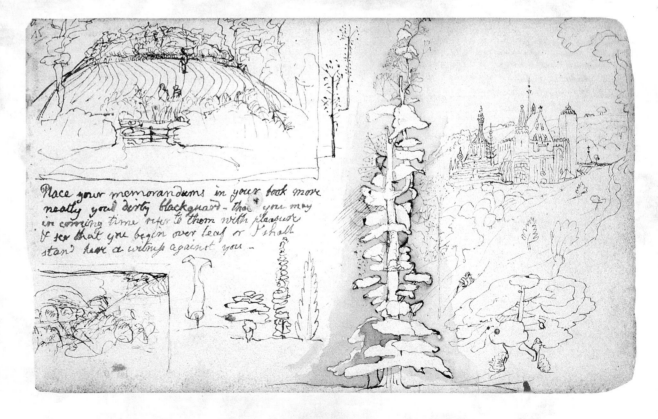

SAMUEL PALMER: VISIONS AND DREAMS

The Artists

William
BLAKE
(1757–1827); British

Blake was one of the most perceptive and original men of his generation. He produced books of his poems illustrated with his own prints, which he hand-coloured, and also worked as an engraver for commercial publishers. Blake's art is both visionary and prophetic, and relies upon a detailed knowledge of the Bible. Notable among his output are his designs for *The Book of Job*, large colour prints such as *Newton* and his woodblock illustrations to the *Pastorals* of Virgil. Blake remained poor for most of his life, and was professionally unrecognized except for a small but loyal group of fellow-artists including John Varley, Fuseli, Linnell, Palmer and Lawrence.

1767 Begins copying from the Antique while attending classes at Henry Pars' drawing school in the Strand

1769 Begins writing poems

1772 Becomes apprenticed to the engraver James Basire for a period of seven years

1773 Executes his first engraving, *Joseph of Arimathea among the Rocks of Albion*, after Michelangelo

1779 Begins to attend the Royal Academy Schools, but probably ceases his studies after a few months

1780 Exhibits for the first time at the Royal Academy, *Death of Earl Goodwin*. On a sketching trip on the Medway with Thomas Stothard is arrested as a French spy, but released. Begins working as an engraver for the publisher Joseph Johnson

1783 Blake's *Poetical Sketches* is published, financially aided by John Flaxman

1784 Blake's father dies. Contributes two works to the Royal Academy exhibition, *A Breach in a City, the Morning after a Battle* and *War unchained by an Angel, Fire, Pestilence, and Famine following*

1785 Contributes four works to the Royal Academy exhibition

1787 Death of Blake's favourite brother Robert. Becomes friends with Henry Fuseli and through him becomes acquainted with the circle of Radicals that included Mary Wollstonecraft, Tom Paine, Joseph Priestly, William Godwin, Richard Price and Thomas Holcroft

1789 Signs a declaration that he believed in the teachings of Emmanuel Swedenborg, although he was later to attack Swedenborg in *The Marriage of Heaven and Hell* the following year. Produces *Songs of Innocence* and *The Book of Thel*

1791 Illustrates Mary Wollstonecraft's *Original Stories from Real Life*

1792 Blake's mother dies. Tom Paine flees the repression of England, spurred on by Blake

1793 Produces *Visions of the Daughters of Albion* and *America*

1794 Produces *Songs of Experience, Europe* and *The Book of Urizen*

1799 Contributes tempera *The Last Supper* to the Royal Academy

1800 Moves to Felpham

1803 Blake forcibly ejects a soldier from the garden of his cottage, which leads him to be charged with sedition, but he is acquitted the following year. Returns to London in September

1804 Begins work on *Jerusalem*, although it is not to be completed until 1820

1807 Portrait painted by Thomas Phillips, which is exhibited at the Royal Academy

1808 Begins to annotate his copy of Reynolds' *Discourses*

1809 Blake's only one man exhibition during his lifetime opens at his brother's house. It is a complete failure; only one painting is sold, and this to his faithful patron Thomas Butts

1811 Visited by the poet Robert Southey

1812 Contributes four works as a member to the exhibition of Associated Painters in Water-Colour

1815 Blake copies cast of *The Laocoön* at the Royal Academy for an illustration for Rees's *Cyclopedia*

1818 Meets John Linnell, who subsequently introduces John Varley to Blake

1819 Begins work on the *Visionary Heads* series in the company of Varley and Linnell

1821 Publication of Blake's illustrations to *The Pastorals of Virgil*. Begins work on *The Book of Job*

1822 The Council of the Royal Academy decide to pay Blake, "an able Designer & Engraver laboring under great distress", the sum of £25

1824 Samuel Palmer is introduced to him through Linnell. Illustrations to Dante's *Divine Comedy*

1825 George Richmond, Edward Calvert and Francis Oliver Finch are introduced to Blake through Palmer; their work is much influenced by him

John

BROWN

(1749–87); British

Brown trained at the Trustees' Academy in Edinburgh under the successive Masters of the Academy, William Delacour and Charles Pavillon. In October 1769 he travelled to Italy in the company of his friend and fellow-artist David Erskine; he was to stay there for nearly 12 years. He split his time between Florence and Rome, the latter city being renowned at this time as a centre where artists from all over Europe came to work and study. During this period he became friendly with Fuseli. Almost all of his drawings were contained in a few sketchbooks which were broken up and distributed shortly after his untimely death.

1769 Goes to London. Travels to Italy with artist David Erskine; influenced there by Fuseli. Brown became immersed in Italian cultural life. In 1789 a friend published his *Letters upon the Poetry and Music of Italian Opera*

c. 1771 Serves as draughtsman for antiquarians Charles Townley and Sir William Young

1771–5 Becomes member of the Accademia di San Luca

1776 Begins long stay in Florence

1781 Returns to Edinburgh. Carrying out miniatures and full-size portraits. Commissioned to make portraits of a number of the members of the Scottish Society of Antiquaries

1786 Now in London. Draws portraits of the royal family. Marries Mary Esplin. Exhibits miniatures at the Royal Academy. Townley commissions him to draw his collection of marbles

1787 Illness, exacerbated by medical orders to take sea voyage to Scotland and dies just four days after arriving

John

CONSTABLE

(1776–1837); British

Constable grew up in the village of East Bergholt, Suffolk, and decided it was to be his native landscape which should form the subject and inspiration for his art – 'these scenes made me a painter', he is recorded as saying. Although modern eyes may view him as archetypally traditional, in his own day Constable's style and technique were considered quite radical and it was some time before he was accepted by the artistic establishment. It was not until 1819 that he became an Associate of the Royal Academy. His paintings had comparatively greater critical success in France than in his own country, *The Haywain* gaining particular praise despite having been dismissed in England. Delacroix was particularly influenced by Constable, as were the Barbizon School.

1793 His father takes him into his business, but Constable is already "devotedly fond of painting"

1795 Introduced to the important connoisseur, Sir George Beaumont

1796 Meets J.T. Smith who commissions sketches of Suffolk villages from him and sends him casts from the Antique to copy. Begins to study anatomy

1799 Introduced to the artist Joseph Farington, with whom he becomes friends and who commissions a copy of a painting by Wynants. Accepted as a probationer at the Royal Academy schools

1800 Farington commissions copies of works by Wilson and Ruisdael, and copies of Claude belonging to Beaumont

1802 Continues studies in London, but in summer returns to East Bergholt to work from the landscape there

1803 Contributes four pictures to the Royal Academy exhibition

1806 Tours the Lake District

1811 Exhibits *Dedham Vale* at the Royal Academy

1814 Put up for election as an Associate of the Royal Academy but fails to get any votes

1815 Exhibits *Boat Building* at the Royal Academy

1816 Constable's father dies. Marries Maria Bicknell in October

1817 Again fails to be elected as an Associate. Exhibits *Flatford Mill*

1819 Works on his first six-foot canvas *The White Horse*. Exhibits *Dedham Lock and Mill*. Rents a cottage at Hampstead for the first time. In November is finally elected as an Associate at the Royal Academy; a previous attempt the year before had failed

1820 *Stratford Mill*. Visits Archdeacon Fisher in Salisbury

1821 Exhibits *The Haywain* at the Royal Academy. Tours Berkshire with Fisher, and later visits him at Salisbury

1822 Fails to become elected as a full Academician

1824 Visits Brighton. His work is exhibited in France where it receives great admiration. Exhibits *The Lock* at the Royal Academy

1825 Learns he has been awarded a gold medal at the Paris Salon. Is visited by Delacroix. Exhibits *The Leaping Horse* at the Royal Academy. Visits Brighton

1827 Exhibits *Chain Pier, Brighton* at Royal Academy

1828 Maria dies

1829 Elected as a full Academican

1831 Exhibits *Salisbury Cathedral from the Meadows*

1832 Exhibits *The Opening of Waterloo Bridge*

Jean Baptiste Camille
COROT
(1796–1875); French

Corot devoted himself to the depiction of landscape, often painted in the open air, and in the words of one contemporary he 'does not so much paint nature as his love for her'. His paintings rely upon tonal values for the sensitive depiction of light and form rather than colour or drawing, and much of his work has a feeling of great spontaneity, found particularly in his sketches. Corot almost compulsively made drawings in his many sketchbooks while on tours through France, Switzerland and Italy, and also in the theatre, of which he was a passionate devotee.

1822 Joins studio of Victor Bertin following the death of landscape painter Achille Michallon, with whom he had studied

1825 Visits Italy. Returns to France 1826

1827 Exhibits at the Paris Salon

1830 *Chartres Cathedral*

1834 *Volterra*

1835 Exhibits *Hagar in the Desert* at the Paris Salon

1855 Shows work at the Universal Exhibition, where he makes his name

1864 Exhibits *Souvenir de Mortefontaine* at the Paris Salon

1870 *The Studio*

1872 Retouches 1830 painting of Chartres

1874 *Sens Cathedral; Woman in Blue*

John Robert
COZENS
(1752–97); British

The son of the artist Alexander Cozens, John Robert produced dramatic landscape watercolours that were both highly original and influential. According to Constable he was 'the greatest genius that ever touched landscape', his work 'all poetry'. Cozens toured Switzerland and Italy during the period 1776–9 and again in 1782–3, this time with William Beckford, the eccentric Gothicist. On these tours Cozens drew many sketchbook landscapes; these were to be the main source of compositions for his finished work when he returned home. In 1793 he became incurably insane and, following a collection among his fellow-artists, was placed under the care of Dr Thomas Monro in the latter's private mental asylum. Monro, chief physician at Bethlem Hospital for the insane, was an important artistic patron and connoisseur. He held a weekly academy in his house where he set young painters, including Turner and Girtin, to copying Cozens' drawings, which were in his possession during the artist's illness.

1767 First exhibits at the Incorporated Society of Artists and the Royal Academy

1774 *Valley with Winding Streams*, similar to the *Classical Landscape* of his father Alexander Cozens

1776 Travels to Switzerland and Italy as draughtsman to artist and antiquary Richard Payne Knight. Presents to the Royal Academy his only known oil painting, *Hannibal Crossing the Alps Shows His Army the Fertile Plains of Italy* (now lost). His attempt to become an Associate of the Royal Academy fails, he never exhibits there again. Painting: *View in the Canton of Unterwalden*

1779 Returns to Britain

1780 Drawing: *Pays de Valais*

1782 Second visit to Italy, in company of writer William Beckford (returns home the following year)

1793 Becomes incurably insane; cared for by Dr Thomas Monro

Joshua
CRISTALL
(1768–1847); British

Originally trained as a painter of porcelain, Cristall embarked upon a career as a landscape artist by studying at the Royal Academy schools, and also by attending Dr Thomas Monro's weekly informal gatherings, where young artists were set to copy from Monro's collection of drawings. Cristall was noted for his landscape watercolours and exhibited frequently at the Old Watercolour Society, becoming its president in 1820.

c. 1792 His father forces him to pursue a career in the china trade

1795 Enters Royal Academy Schools, helped by Dr Thomas Monro

1802 Visits north Wales with Cornelius Varley (meets William Havell in Ross-on-Wye)

1803 Exhibits at Royal Academy

1805 Shows eight works (including views of Wales) at the first exhibition of the Old Water-Colour Society. ("Society of Painters in Water-Colours"). From 1805 to 1847 he showed almost 500 works at the Society exhibitions, *Classical Composition*

1808 Becomes founding member of a Sketching Society ("The Society for the Study of Epic and Pastoral Design" – later "The Chalon Society"). *Fisherman on the Beach, Hastings*

1812 Cristall is part of group (including Varley and Linnell) that reforms the Society

1820 Becomes president of the Old Water-colour Society

1823 Shows 33 works in the famous Loan Exhibition mounted by the Society

Johan Christian Clausen DAHL
(1788–1857); Norwegian

Dahl grew up in Norway, but after a tour of Italy settled in Dresden in the early 1820s, and became a teacher at the Academy there. He was influenced by his friend Caspar David Friedrich. Although he has been dubbed the "Norwegian Constable", Dahl's landscapes are usually more dramatic than pastoral, but he was similarly interested in capturing the effects of the sky, making spontaneous studies of clouds and storms.

1803 Apprenticeship at an *Amts- und Dekorationsmaler* in Bergen

1811 Talents soon noticed. Attends the Akademie in Copenhagen. Academic painting methods of his tutor Lorentzen, however, do not have much impact on him; Danish painter Christoffer Wilhelm Eckersberg exerts a stronger influence

1816 Eckersberg comes from Rome to Copenhagen and motivates Dahl to make oil studies from nature

1818 Finishes his studies at the Akademie and decides – financially supported by the Danish King and Crown Prince – to widen his experiences through sojourns in Germany, Switzerland, Italy and England

1820 Marries Emilie von Block. Settles in Dresden. Taken on as Fellow of the Academy. Starts 20-year friendship with Caspar David Friedrich

1820–21 Travels to Italy where he is the guest of the Danish Crown Prince Christian Friedrich in Naples. This visit is to be important in his development as a landscape painter

1824 Called on to be the special Professor at the Dresden Akademie

1826 Returns for the first time to his homeland, Norway

1827 Member of the Copenhagen Academy

1832 Membership of the Stockholm Academy

1835 Membership of the Berlin Academy

1830 Second wife, Amalie von Bessewitz, dies. After this Dahl seeks refuge in his work. The last years of his creativity he devotes almost entirely to his homeland, Norway. He is the artistic discoverer of Norwegian nature and is a decisive influence in the founding of the National Gallery, the first Art Club and the Antiquities Association

Jacques Louis DAVID
(1748–1825); French

The leading French neo-classicist, David's works uncompromisingly subordinated colour to an almost severe purity of form and concision of drawing. Paintings such as *The Oath of the Horatii* contentiously extolled the republican political ideals of the ancient world, and it is perhaps not surprising that David played an important part in the French Revolution, becoming a Deputy and co-signing the edict that authorized Louis XVI's execution. On Robespierre's fall he was jailed, and would probably have been executed were it not for the intervention of his wife and pupils. As Napoleon took power David became a staunch supporter, and was commissioned to paint works of the Emperor as an heroic, just ruler. David fled to Switzerland after Waterloo and the restoration, ending his career in Brussels.

1766 Enrols at Académie and begins studying with historical painter Joseph-Marie Vien

1774 Wins Prix de Rome for *The Loves of Antiochus and Stratonice*

1775 Travels to Italy with Vien

1780 Paints *Date obolum Belisario*; elected to the French Academy

1783 *The Grief of Andromache*

1784 *The Oath of the Horatii*

1785 *The Oath of the Horatii* exhibited at the Paris Salon

1787 *The Death of Socrates*

1789 Becomes a Deputy in the revolutionary government

1793 *The Death of Marat*

1794 Imprisoned after the fall of Robespierre

1799 *The Rape of the Sabines*

1800 *Madame Récamier*

1807 Completes *Sacre de Joséphine*

1815 Goes into exile in Switzerland following the defeat of Napoleon (to Belgium the next year, where he remains until his death)

Eugène DELACROIX
(1798–1863); French

Delacroix was the most important painter of the French Romantic movement. He rejected the restrained French neo-classical style and opted instead for an innovatory, brilliantly coloured and freely handled use of paint. He frequently chose exotic and unconventional subjects for his work; his oil paintings *The Massacre of Chios* of 1824 and *Death of Sardanapalus* of 1829 outraged the conservative Salon. Delacroix admired developments in contemporary English painting and was much influenced by it, particularly by John Constable, whom he visited on his trip to England in 1825. In 1832 he visited Morocco and North Africa and was profoundly inspired by the exoticism he encountered there. Despite his earlier rebellious stance, by the 1830s Delacroix had been accepted by the French state and given a number of important commissions for the decoration of public buildings.

1816 Enters studio of Pierre Guérin (also teacher of Géricault)

1823 Begins his famous journal, kept until 1854

1824 Exhibits *The Massacre of Chios* at the Paris Salon

1825 Spends time in England

1826 Shows *Greece on the Ruins of Missolonghi* at the Paris Salon

1827 Exhibits *The Death of Sardanapalus* at the Paris Salon

1832 Visits Morocco and North Africa

1833 *Algerian Women*

1853 Begins paintings in Chapelle des Anges of S Sulpice, completed 1861

1855 Shows 36 works at the Universal Exhibition. Made Commander of the Legion of Honour

1857 Made member of the Institut de France

Caspar David
FRIEDRICH

(1774–1840); German

Friedrich trained at the Academy in Copenhagen but spent most of his professional life in Dresden, where he was part of the Romantic circle that included the artists Runge, Carus and Dahl. In common with these artists and influenced by the writings of Kosegarten, Friedrich understood the allegorical and symbolic potential of nature and landscape painting. He used his paintings to show the deep spirituality of nature, and frequently the melancholy gulf which lies between this perfection and the temporal life of humanity. In 1816 he was elected to the Dresden Academy but his career was curtailed by a series of illnesses which by 1835 had left him partially paralysed. In the last years of his life Friedrich was able to paint only small-scale works.

1781 Death of his mother

1797 Friedrich's brother dies while trying to save him from drowning in a frozen lake, an event that was to have a profound effect upon the artist

1790 Begins studying with the drawing master of Greifswald University, Johann Gottfried Quistorp

1794 Begins artistic studies at the Academy in Copenhagen. Taught by Abildgaard

1798 Moves to Dresden

1802 Meets Philipp Otto Runge

1805 Goethe declares him the co-winner of the Weimarer Kunstfreunde prize

1807 Visits Bohemia

1808 Exhibits *The Cross in the Mountains*, which arouses great controversy

1810 Goethe visits his studio. Exhibits *Monk by the Sea* and *Abbey in Oakwood* at the Berlin Academy where they are bought by Crown Prince Friedrich Wilhelm. Elected a member the Berlin Academy

1811 Tours the Harzgebirge

1812 Exhibits *Morning in the Reisengebirge*

1813 Dresden is occupied by the French and so moves to Elbsandsteingebirge

1814 Dresden liberated. Friedrich exhibits *Chasseur in the Woods*

1816 Elected a member of the Dresden Academy

1817 Meets Carl Gustav Carus

1818 Marries Caroline Bommer

1819 *Two Men contemplating the Moon*

1823 Begins to share his studio with Dahl

1824 Appointed Associate Professor at the Dresden Academy, and later that year Professor of Landscape painting. *Arctic Shipwreck*

1825 Begins to suffer from ill health

Henry
FUSELI

(1741–1825); Swiss

In 1761 Fuseli was ordained as a Zwinglian minister, but after his exposure of a corrupt magistrate he abandoned his vocation and began to study art. He came to London in the early 1760s and was encouraged to become a professional painter by Reynolds, among others. Fuseli went to Rome in 1770, staying for eight years, and effectively taught himself painting through the study of the Old Masters. Returning to London, he embarked on a distinguished career, becoming a Royal Academician in 1790, and later held the important posts of Professor of Painting and Keeper at the RA simultaneously. Fuseli was renowned for his dry wit and sarcasm. His paintings display great imaginative power and psychological depth.

1761 Ordained a Zwinglian minister, and preaches his only sermon that year

1763 Studies art in Berlin after being forced to leave Zurich

1764 Comes to England, becomes translator and illustrator

1766 Decides to become a painter

1768 Writes *Remarks on the Writings and Conduct of Jean-Jacques Rousseau*

1770 Begins eight-year stay in Italy

1778 Falls in love with Martha Hess, whom he uses as a subject for a number of works; her father forbids marriage

1779 *The Artist Moved by the Grandeur of Antique Fragments*

1781 *The Nightmare*

1783 *The Three Witches*

1784 *Lady Macbeth*

1788 Marries a model, while continuing affair with Mary Wollstonecraft

1790 Becomes Royal Academician

1794 *Titania, Bottom and the Fairies*

1799 Elected Professor of Painting at the Royal Academy. *Nude Woman Listening to a Girl Playing on the Spinet. Satan and Death Separated by Sin*

1800 *Silence*

1804 Becomes Keeper of the Royal Academy

1807 *Courtesans*. Drawing: *Brünnhilde Watches Gunther, Whom She Has Bound to the Ceiling*

Théodore
GÉRICAULT

(1791–1824); French

Géricault's stated ambition as an artist was 'to shine, to illuminate, to astonish the world', and he was a leading artist of the French Romantic movement. Born into a prosperous family, he had a private income, and thus had no need to earn his living through his art. Géricault exhibited only three times at the state-sponsored Salon, most notably and finally in 1819, when he submitted his monumental and politically provocative *The Raft of the Medusa*. The tepid response to this painting, in contrast to the astonishment or outrage that he had hoped for, dismayed Géricault, and he did not undertake a work of this magnitude again.

1808 Apprenticed to Carle Vernet, painter of battle scenes and animals

1810 Moves to studio of Pierre-Narcisse Guérin (also teacher of Delacroix)

1812 Wins gold medal for *Charging Chasseur* at his first Paris Salon exhibition

c. 1814 Has an affair with an aunt, causing major family crisis

1815 Joins Royalist guards

1816 Begins two-year visit to Florence and Rome

c. 1817 *The Race of the Riderless Horses*

1818 *Severed Heads*

1819 Wins medal for *The Raft of Medusa* at the Paris Salon

1820 Visits England, many studies of London street scenes and horses. *The Raft of Medusa* exhibited at Egyptian Hall, Piccadilly, to great acclaim

c. 1822 Carries out series of 10 portraits of inmates of a Paris asylum, of which only five remain (e.g. *The Madman*; *The Madwoman*; *The Cleptomaniac*)

Francisco
GOYA
(1746–1828); Spanish

By the end of the eighteenth century Goya was the most fashionable portrait painter in Madrid; his abilities were recognized in 1799, when he became First Painter to the King. Goya's relation to his position seems to have been contradictory, for his Royal Family portraits often show them as stupid, arrogant and coarse, and it is surprising if such criticism went unnoticed. Goya was dominated by his imagination, a state accentuated by an illness that left him deaf. Many of his paintings and prints depict horrific imaginary creatures or nightmarish scenes showing the cruelty and hypocrisy of the Church and Spanish society. Although working for the Bonapartist regime after the French invasion, he also criticized it in his masterpiece *The Third of May*. Forgiven and reinstated at court on the restoration of the monarchy, Goya eventually exiled himself from Spain, disgusted by the repressive excesses of Ferdinand VII.

1773 Marries the daughter of the court painter Francisco Bayeu

1775 Settles in Madrid

1776 Begins number of cartoons for the royal tapestry factory

1780 Elected to the Academy of San Fernando

1785 Becomes assistant director of painting at the Academy

1789 Made court painter to Charles IV

1794 Becomes deaf from illness of 1792

1795 Succeeds his father-in-law as director of painting at the Academy. *The Duchess of Alba*

1788 Named First Court Painter

1797 Begins work on the *Maja Nude*; with *Maja Clothed*, completed in 1800

1800 Finishes portrait: *The Family of Charles IV*

1808 *Execution of the Citizens of Madrid*

1810 Begins etching series *The Disasters of War* (65 in all), completed in 1814

1814 *The Second of May 1808*; *The Third of May 1808*

1819 Has second major illness, leading to depression which is apparent in his work

c. 1829 *Saturn Devouring One of his Children*

1824 Ferdinand VII gives consent to Goya's moving to Bordeaux

Thomas
JONES
(1742–1803); British

A landscape painter, Jones trained under Richard Wilson between 1763 and 1765, and attended the Royal Academy schools from 1769. From 1763 to 1783 he travelled through Italy, spending much of his time in Naples and Rome, and keeping a detailed journal of his tour. Jones often worked in the open air, capturing a scene directly. Upon his return to London he gave up being a professional artist, but continued to exhibit at the Royal Academy.

1763 Studies under Richard Wilson (until 1765)

1769 Attends Royal Academy Schools

1772 Oil on paper: *Penkerrig*

1776 In Italy (until 1783), many small landscape studies

1777 Cascades at Tivoli

1780 Arrives in Naples

1782 Oil on paper: *Buildings in Naples*

1784 Exhibits at the Royal Academy

1798 Last exhibition at the Royal Academy

William
LOCK
(1767–1847); British

The son of a distinguished and wealthy collector, Lock displayed an aptitude for drawing while still a child. Fuseli befriended him, and many of Lock's drawings clearly display his influence. After a trip to Italy in 1789, Lock abandoned any plans to become a professional artist, apparently because he was so overwhelmed by the achievements of the Old Masters. After his father's death he sold the family estate, Norbury Park in Surrey, and went abroad to live, principally in Rome and Paris.

c. 1778 Fuseli, a visitor to Norbury Park, the Lock family estate, recognizes his talent and helps the young Lock. Fuseli later dedicates a series of lectures on painting to Lock

1781 Begins a number of sketches whose content is clearly influenced by Fuseli

1789 Visits Italy, deeply impressed by the works of the Old Masters; abandons all hope of becoming an artist

1791 Thomas Lawrence shows his portrait of Lock at the Royal Academy

1819 Sells Norbury Park and moves to the continent, spending the rest of his life in Paris and Rome

Samuel PALMER
(1805–81); British

Much influenced by Blake, whom he met for the first time in 1824, Palmer was possessed of an idealized and spiritual vision of nature and rural life. In 1827 he settled in Shoreham, where he was to stay for several years and produced some of his most original and visionary work. He found the Bible and Milton particularly inspiring, always carrying a small edition of the latter's collected works, and their influence is clearly identifiable in much of his work from this period. He toured Italy for two years in the company of his wife Hannah. Under the pressure of his father-in-law, the artist John Linnell, Palmer abandoned his earlier style for one that was more commercial, but also pedestrian.

1818 Taught by the drawing master William Wate

1819 Exhibits first work at the Royal Academy at age of 14

1820 Meets Francis Oliver Finch

1822 Meets John Linnell

1824 Linnell introduces him to Blake which has a profound effect upon Palmer; begins the important 1824 sketchbook

1826 Buys a cottage at Shoreham, Kent, and moves there where he is visited by the other members of the "Ancients", including Edward Calvert and George Richmond. *Self Portrait* and *Harvest under a Crescent Moon*

1830 *Coming from Evening Church*, *The Magic Apple Tree* and *Cornfield by Moonlight with the Evening Star*. Helps George Richmond to elope with Julia Tatham, the sister of his friend Frederick

1831 *The Sleeping Shepherd*

1832 Writes and distributes the reactionary pamphlet *An Address to the Electors of West Kent*

1833 *The Gleaning Field*

1835 Tours Dorset, Devon and Somerset, and Wales

1837 Marries Hannah Linnell. Travels to Italy where he remains for two years

1843 Elected an associate member of the Old Water-colour Society. Tours in Wales, and visits Surrey, Kent, Sussex and Berkshire

1844 Visits Wales and Surrey

1850 Elected a member of the Etching Club

1854 Elected full member of the Old Water-colour Society

1858 Etches *The Weary Ploughman*

1864 *Children Returning from Gleaning* and *A Dream in the Appenine*

1868 *The Lonely Tower*

1870 *The Bellman*

1872 Completes *Eclogues of Virgil*

Johan Anton Alban RAMBOUX
(1790–1866); German

A noted collector of Old Master pictures and head conservator at the museum in Cologne, Ramboux studied painting under David. In 1815 he went to Munich to work as a portraitist; his work of this period is clearly influenced by Holbein and Dürer. The following year he visited Rome, and was fascinated by the classical remains he found there, noting them in his many sketchbooks. He was close to the Nazarene group of artists, and much of his work shows their influence. Ramboux was a highly successful artist, enjoying the patronage of the King of Prussia.

1803–7 Trains as a painter in Florenville (Luxembourg) with the Benedictine monk Frère Abraham d'Orval

1808–12 Student of Jacques Louis David in Paris

1812–15 Portrait painter in Trier

1815–16 Studentship at the Munich Academy under Peter Langer

1816 Travels through Switzerland to Italy and stays in Rome until 1818

1818 Visits Florence

1819 Travels in Central and Southern Italy; occupied with the art of the Quattocento

1822 Return to Trier. Design for the murals in the Haynschen house in Trier

1828 Frescoes in the Trier town house

1832–42 Second sojourn in Italy. Copies and collects Christian works of art in central Italy

1844 Becomes Konservator of the Wallrafschen Collection in Cologne

1849 Journey to Holland, Belgium and Northern France

1854 Pilgrimage to Jerusalem

George ROMNEY
(1734–1802); British

Romney trained as an artist in his native Lancashire, but after raising £100 by organizing a lottery for 20 of his paintings, he deserted his wife and children in order to pursue a career in London. He became one of the most successful society portrait painters in the capital, although his work is outshone by the brilliance of his contemporaries, Gainsborough and Reynolds. Romney, who preferred to work on historical subjects, regretted throughout his career the amount of time he devoted to portraiture.

1750 Paints portrait of brother James (earliest known of his portraits)

1756 Marries daughter of his landlady at Kendal in the Lake District while apprenticed to itinerant portrait painter Christopher Steele

1762 Abandons his family and settles in London

1764 Visits Paris

1768 Exhibits work at the Free Society

1773 Begins two-year stay in Italy, where he is strongly influenced by the neo-classical Movement and Fuseli

1781 Meets Emma Hart, later Lady Hamilton, of whom he makes a series of portraits

1798 In bad health and suffering from depression, he returns to his wife in Kendal, who nurses him until he dies insane

Johan Tobias
SERGEL
(1740–1814); Swedish

Perhaps one of the finest neo-classical sculptors of the second half of the eighteenth century, Sergel produced some of his most inspired work in Rome, where he arrived in 1767 and remained for some 11 years. During this time he studied the artistic relics of the ancient world and attended the French Academy. Sergel met Fuseli in 1770 when the latter came to Rome, and the two became close friends. Many of Sergel's drawings at this time display the influence of the Swiss artist. After his return to Stockholm Sergel received few important commissions, but he achieved the distinguished appointments of Surveyor of the Royal Works of Art in 1803 and Director of the Academy of Art in 1810.

1760 Wins Gold Medal of Swedish Academy

1767 Begins 11-year sojourn in Rome

1770 Meets Fuseli, who becomes a close friend and strong influence

1774 Completes his *Faun*

1779 Returns to Stockholm

1780 *Venus Kallipygos* (head of the sculpture is that of Gustavus III's mistress)

1785 Writes his autobiography

1790 Begins the bronze *Gustavus III*, completed in 1808

1803 Becomes Surveyor of the Royal Works of Art

1804 *Mars and Venus* in marble (following a number in plaster and terracotta)

1810 Becomes Director of the Swedish Academy of Art

Francis
TOWNE
(1739–1816); British

Towne spent much of his career as a drawing-master in Exeter, although he frequently exhibited his landscape watercolours in London, at the Royal Academy and the Royal Institution. He toured Wales and the Lake District, and also Italy and Switzerland, and executed a number of watercolours based upon his observations of these areas. Towne developed a distinct style which consisted of reducing a landscape into its constituent elements by clearly outlining them in pencil or pen and ink, and then filling them in with harmonious blocks of colour.

c. 1754 Begins to paint in oils

1759 Wins premium from the Society of Arts

1777 Makes tour of Wales. Begins working in watercolour. *Salmon Leap from Pont Aberglaslyn*

1780 Visits Italy, returning in 1781 through Switzerland

1781 *St Peter's at Sunset, from above the Arco Obscuro.* Drawing. *Source of the Arveiron: Mont Blanc in the Background*

1786 Visits the Lake District. Drawings: *Elterwater; View from Rydal Park; Grasmere from the Rydal Road*

1807 Marries French ballet dancer Jeanette Hillinsbert, some 40 years younger

1808 His wife dies

Joseph Mallard William
TURNER
(1775–1851); British

Turner was undoubtedly one of the greatest British artists of the nineteenth century. He extended the possibilities of landscape painting beyond anything that had gone before, imitating but also transcending the work of the Old Masters, including his hero Claude. Turner toured extensively throughout Britain and Europe, drawing particular inspiration from the Alps and Venice. He was a master of both oil and watercolour, carrying these media into previously unexplored areas of their potential. Turner's work, with its characteristic hazy and indistinct use of paint, 'tinted steam' as Constable described it, was recognized by some as the product of genius, but condemned by others who regarded such paintings as unfinished.

1789 Entered the Royal Academy Schools (until 1793)

1790 Exhibits first watercolour at the Academy aged 15

1793 Dr Thomas Monro invites him to come to his weekly informal Academy

1794 *Interior of Tintern Abbey*

1796 Exhibits first oil at the Academy; *Fishermen at Sea*

1799 Elected Associate of the Royal Academy

1800 *Dolbadern Castle* Mother admitted to Bethlem, dies there four years later

1802 Elected full Royal Academician. First travels on the continent

1803 Exhibits *Calais Pier, with French Poissards Preparing for Sea*

1804 *Passage of the St Gothard, Great Falls of the Reichenbach*

1805 *The Shipwreck*

1807 Made Professor of Perspective at the Academy

1809 *Valley of Chamonix*

1812 *Hannibal Crossing the Alps*

1815 *Dido Building Carthage*

1829 Exhibits *Ulysses Deriding Polyphemus*

1830 His father dies

1831 Drawing: *Rainbow over Loch Awe*

1834 *Burning of the Houses of Parliament* watercolours

c. 1836 *Valley of the Aosta*

1839 Takes house in Chelsea

c. 1840 Exhibits *Fighting Téméraire*

1842 Drawing: *Foot of St Gothard.* Painting: *Snowstorm: Steam Boat off a Harbour's Mouth*

1844 Exhibits *Rain, Steam and Speed*

1845 Appointed Deputy President of the Royal Academy

1850 Exhibits his work for the last time

John
VARLEY
(1778–1842); British

A landscape watercolourist, Varley travelled the country making sketches for his work. His brothers Cornelius, the inventor of the graphic telescope, and William were also artists. Although possessing technical mastery over the watercolour medium, Varley never reached the peaks of his profession, although he was highly regarded within the artistic community. He taught many younger artists who went on to great success. The friend of William Blake, he shared sketchbooks with the great visionary. Varley had a great enthusiasm for astrology and other occult sciences.

c, 1783 Becomes pupil of the landscape painter Joseph Charles Barrow

1798 Exhibits at the Royal Academy for the first time

c. 1800 Influenced by Thomas Girtin and his new watercolour techniques at the Sketching Society. At this time Varley well known as a teacher of pupils who include Linnell

1804 Founder member of the Watercolour Society

c. 1810 *Snowdon from Capel Curig*

1816 Publishes *Treatise on the Principles of Landscape Design* in parts (until 1821)

Peter
DE WINT
(1784–1849); British

I n his landscape watercolours, De Wint evolved a highly characteristic style which often relies upon colour being applied quite freely in broad, fluid washes, using a palette of warm greens and rich russets. He visited France, but relied for his inspiration almost exclusively upon the English landscape, particularly the area around Lincoln.

1802 Father sends him to London to be apprenticed to J.R. Smith, a mezzotint engraver

1806 With William Hilton, artist and life long friend, he leaves Smith and moves near Varley, who proves a strong influence on his technique; also a frequent visitor to Dr Monro's house

1808 Exhibits at Associated Artists in Water-Colours; becomes a member in 1810. *Westminster Palace, Hall and Abbey*

1810 Marries Hilton's sister Harriet. Is made an associate member of the Old Water-colour Society; becomes a full member in 1811

1815 Exhibits *Cornfield* at the Royal Academy; *Farmyard, Pool in Foreground*

1828 Visits France (Normandy); disappointed and prefers English landscape, especially the North

1829 Visits north Wales (possibly 1830)

1830 Drawing: *View of a Harbour*

1839 William Hilton dies. *Lowther, Landscape with Cliff and Pool*

1845 *St John's Hospital, Canterbury*

Joseph
WRIGHT OF DERBY
(1735–97); British

W right trained as an artist in London, but returned to his native Derby to work. He made his living through portraiture, but was fascinated by the spectacle of scientific experiment and industrial processes, which were to form the most original subjects for his paintings. Often Wright explores the beauty of effects of light and shade, and his candlelit subjects, employing deep chiaroscuro, are among his best-known works. In 1773 he departed for Italy, returning home two years later, and he subsequently executed a series of paintings of Italian scenes, including a number of night views of Vesuvius in eruption.

1751 Apprenticed to the painter Thomas Hudson in London

1755 Earliest dated portrait painted – *Anne Bateman*

1756 Studies with Hudson again, with John Hamilton Mortimer as a fellow pupil

1757 Starts portrait painting business in Derby

1765 Exhibits at the Society of Artists for the first time, showing *The Gladiator*

1766 Exhibits *The Orrery* at the Society of Artists

1768 Exhibits *The Air Pump* at the Society of Artists. Begins working in Liverpool

1773 Marries Hannah Swift. Departs for Italy

1774 Arrives in Rome in February. Visits Naples in October

1775 Returns from Rome by way of Florence, Venice, Parma and Lyons, arriving back in Derby in September. Establishes himself in Bath in an attempt to become a fashionable portraitist

1776 Exhibits his first painting of Vesuvius at the Society of Artists

1777 Returns to work in Derby

1778 Exhibits for the first time at the Royal Academy, contributing six paintings

1781 Exhibits *Brooke Boothby* at the Royal Academy

1785 Has one man exhibition at Robin's Rooms in Covent Garden

1794 Tours the Lake District

SKETCHBOOK LOCATIONS

Many sketchbooks from the Romantic period have survived intact in their original bound state, but a large number of others have been dismembered and their sheets scattered through many collections. Below is a list of public institutions or private collections to which the public have access, where sketchbook material can be found for all the artists illustrated in this book. This material is sometimes on display, but frequently because of its extreme fragility it is kept in store. It is sometimes possible for members of the public to arrange to see such material, although each institution's restrictions vary. An asterisk denotes that examples from an institution's holdings are illustrated in this book.

BLAKE:
Sketchbook sheets are held by the Tate Gallery, London * and the Fitzwilliam Museum, Cambridge. * Blake's notebook is held by the British Library, London *

BROWN:
Sketchbook sheets are held by the Cleveland Museum of Art * and the Yale Center for British Art.

COROT:
Bound sketchbooks and sketchbook sheets are held by the Musée du Louvre, Paris. *

CONSTABLE:
Bound sketchbooks are held by the British Museum * and Victoria and Albert Museum, London, and the Musée du Louvre, Paris. Sketchbook sheets are also held by the Victoria and Albert Museum, London * and British Museum, London. *

J.R. COZENS:
Bound sketchbooks are held by the Whitworth Gallery, Manchester.*

CRISTALL:
A sketchbook sheet is held by the Tate Gallery, London. *

DAHL:
Sketchbook sheets are held by the Nationalgalerie, Oslo. *

DAVID:
Bound sketchbooks are held by the Musée de Versailles. * Sketchbook sheets are held by the Musée du Louvre, Paris, * the Art Institute of Chicago, * and the Fogg Art Museum, Harvard. *

DELACROIX:
Bound sketchbooks and separated sketchbooks sheets are held by the Musée du Louvre, Paris. *

FRIEDRICH:
Bound sketchbooks are held by the Kupferstichkabinett und Sammlung der Zeichnungen, Berlin, the Kupferstich-Kabinett, Dresden and the Nationalgalerie, Oslo. Sketchbook sheets are held by these institutions, the Staatsgalerie, Stuttgart, * and the Ashmolean Museum, Oxford. *

FUSELI:
Sketchbook sheets are held by the Kunsthaus, Zurich. *

GÉRICAULT:
Sketchbook sheets are held by the Musée du Louvre, Paris. *

GOYA:
Sketchbook sheets are held by the Prado, Madrid, and the Woodner Collection, New York. *

JONES:
Bound sketchbooks are held by the British Museum, London, * and the National Museum of Wales, Cardiff.

LOCK:
A bound sketchbook is held by the Victoria and Albert Museum, London. *

PALMER:
Bound sketchbooks are held by the British Museum, London, * and sketchbook sheets by the Victoria and Albert Museum, London. *

RAMBOUX:
Bound sketchbooks are held by the Wallraf-Richartz-Museum, Cologne, * and the Hessisches Landesmuseum, Darmstadt.

ROMNEY:
Bound sketchbooks are held by the Victoria and Albert Museum, London and the Fitzwilliam Museum, Cambridge. *

SERGEL:
Bound sketchbooks are held by the Nationalmuseum, Stockholm. *

TOWNE:
Sketchbook sheets are held by the Wordsworth Trust, Grasmere, * and the British Museum, London.

TURNER:
Bound sketchbooks and sketchbook sheets are held by the Tate Gallery, London. *

J. VARLEY:
Bound sketchbooks are held by the Victoria and Albert Museum, London. *

DE WINT:
Bound sketchbooks are held by the Victoria and Albert Museum, London. *

WRIGHT:
Bound sketchbooks are held by the British Museum, London, * and the Metropolitan Museum of Art, New York.

INDEX

Numbers in italic indicate illustrations

SUGGESTED READING

John Barrell *The Dark Side of the Landscape*, Cambridge University Press, Cambridge, 1980

John Berger *Ways of Seeing*, Penguin, London, 1972

Ann Bermingham *Landscape and Ideology*, University of California Press, Los Angeles and London, 1986

Anita Brookner *Jacques Louis David*, Chatto & Windus, London, 1980

Martin Butlin *The Paintings and Drawings of William Blake*, Yale University Press, New Haven and London, 1981

Kenneth Clark *The Romantic Rebellion: Romantic versus Classic Art*, John Murray, London, 1973

Lorenz Eitner *Neoclassicism and Romanticism 1750–1850*, Prentice-Hall International, London, 1971

David Erdman *The Notebooks of William Blake*, Readex Books, London, 1977

Ian Fleming-Williams *Constable and his Drawings*, Philip Wilson, London, 1990

John Gage *J.M.W. Turner: 'A Wonderful Range of Mind'*, Yale University Press, New Haven and London, 1987

Philippe Grunchec *Géricault's Horses*, Sotheby's Publications, London, 1982

Hugh Honour *Neo-Classicism*, Penguin, London, 1968

Hugh Honour *Romanticism*, Penguin, London, 1979

Karl Kroeber and William Walling (Eds.) *Images of Romanticism: Verbal and Visual Affinities*, Yale University Press, New Haven and London, 1978

Susan Lambert *Drawing Technique and Purpose*, Trefoil, London, 1984

Raymond Lister *British Romantic Art*, Bell, London, 1973

Raymond Lister *Samuel Palmer: his Life and Art*, Cambridge University Press, Cambridge, 1987

Claude Marks *From the Sketchbooks of the Great Artists*, Hart-Davis, MacGibbon, London, 1972

Robert Rosenblum *Modern Painting and the Northern Romantic Tradition: Friedrich to Rothko*, Thames & Hudson, London, 1975

Michael Rosenthal *Constable*, Thames & Hudson, London, 1987

Hammond Smith *Peter De Wint*, F. Lewis, London, 1982

Joshua Taylor (Ed.) *Nineteenth-century Theories of Art*, University of California Press, Los Angeles and London, 1987

William Vaughan *German Romantic Painting*, Yale University Press, New Haven and London, 1980

William Vaughan *Romantic Art*, Thames & Hudson, London, 1988

Robert Wark (Ed.) *Sir Joshua Reynolds Discourses on Art*, Yale University Press, New Haven and London, 1975

August Wiedman *Romantic Art Theories*, Gresham Books, Henley, 1986

Andrew Wilton *Turner in his Time*, Thames & Hudson, London, 1987

ACKNOWLEDGMENTS

Quarto would like to thank the following for providing photographs, and for permission to reproduce copyright material. While every effort has been made to trace and acknowledge all copyright holders, we would like to apologize should any omissions have been made.

Key: a=above; b=below; l=left; r=right; c=centre

Abbreviations; BM = Reproduced by Courtesy of the Trustees of the British Museum; GP = Giraudon, Paris; L/RMN = Louvre/(c) Service Photographique de la Réunion des Musées Nationaux; TG = The Tate Gallery, London; V&A = Reproduced by Courtesy of the Board and Trustees of the Victoria & Albert Museum.

Page 6 BM; p.17 The National Portrait Gallery, London; p.18–19 The National Portrait Gallery, London; p.21 Yale Center for British Art, Paul Mellon Collection; p.22 National Museum of Wales, Cardiff; p.24 ET Archive; p.26 L/RMN; p.28 ET Archive; p.30 L/RMN; p.32 Bridgeman Art Library, London; p.33 L/RMN; p.35 Private Collection; p.36 Staatliche Museen Preussischer Kulturbesitz (Nationgalerie); p.38 TG p.39–40 TG; p.40 National Gallery of Canada, Ontario/The Bridgeman Art Library, London; p.43 TG; p.44–45 TG; p.46 Roy Miles Fine Paintings, London/The Bridgeman Art Library, London; p.50 Reproduced by permission of the Trustees of the Science Museum; p.51 V&A; p.53 TG; p.54 (c) The Art Institute of Chicago, Helen Regenstein Collection, 1961. All Rights Reserved; p.55 V&A; p.56 BM; p.57 Städtische Kunsthalle, Mannheim; p.58 L/RMN p.60 L/RMN; p.61 Wallraf-Richartz Museum, Cologne; p.62 a L/RMN b Versailles/RMN; p.63 Versailles/RMN; p.64–65 Versailles/Edimedia, Paris; p.66 a TG b BM; p.67 L/RMN; p.68 TG; p.69 Nasjonalgaleriet, Oslo; p.70–71 Nationalmuseum, Stockholm; p.72 a TG b The Royal Academy of Arts, London; p.73 The Royal Academy of Arts, London; p.74–75 Wallraf-Richartz Museum, Cologne; p.76 L/RMN; p.77 l The Harvard University Art Museums, Bequest of Grenville L. Winthrop r L/RMN; p.78 Fitzwilliam Museum, Cambridge; p.79 l TG r National Portrait Gallery, London; p.80–81 L/RMN; p.82–83 L/RMN; p.84 L/RMN; p.85 TG; p.86–87 TG; p.88 Musée Condé, Chantilly/GP; p.89 V&A; p.90–91 TG; p.92 Nasjonalgaleriet, Oslo; p.93 TG; p.94 a TG bl The Courtauld Institute of Art br V&A; p.95 V&A; p.96 Staatsgalerie Graphischen Sammlung, Stuttgart; p.97 BM; p.98 BM; p.99 The Whitworth Art Gallery, University of Manchester; p.100–101 BM; p.102 a BM b TG; p.103 TG; p.104 TG; p.105 a TG b Southampton Art Gallery; p.106–107 V&A; p.108–109 V&A; p.110–111 TG; p.112–113 TG; p.114 Musée Condé, Chantilly/GP; p.115 L/RMN; p.116 L/RMN; p.117 Musée Condé, Chantilly/GP; p.118–119 Musée Condé, Chantilly/GP; p.120 L/RMN; p.121 Neue Pinakothek, Munich/Artothek; p.122 BM; p.123 Ashmolean Museum, Oxford; p.124 TG; p.125 Wallraf-Richartz Museum, Cologne; p.126 V&A; p.127 Private Collection, by Courtesy of The Leger Galleries; p.128 TG; p.129 a TG b BM; p.132–133 TG; p.134 l BM r V&A; p.135 TG; p.136 L/RMN; p.137 V&A; p.138–139 V&A; p.140–141 (c) The Wordsworth Trust; p.142–143 L/RMN; p.144 TG; p.145 The Whitworth Art Gallery, University of Manchester; p.146–147 TG; p.148 V&A; p.149 TG; p.150–151 TG; p.153 V&A; p.154 Fitzwilliam Museum, Cambridge; p.155 TG; p.156 Fitzwilliam Museum, Cambridge; p.157 Harvard University Art Museums, Bequest of Grenville L. Winthrop/photo Rick Stafford; p.158 Kunsthaus, Zurich; p.159 The National Portrait Gallery; p.160 Kunsthaus, Zurich; p.161 TG; p.162 a Prado, Madrid/GP b (c) The Detroit Institute of Arts, Gift of Mr. & Mrs. Bert L. Smokler and Mr. & Mrs. Lawrence A. Fleischman; p.163 l BM r The Ian Woodner Family Collection, New York; p.164 BM; p.165 The Ian Woodner Family Collection, New York; p.166 The British Library; p.167 TG; p.168 The British Library; p.169 TG; p.170 a TG bl & br The National Portrait Gallery; p.171 TG; p.172–173 The British Library; p.174–175 The Cleveland Museum of Art, Dudley P. Allen Fund; p.176 a V&A b Fitzwilliam Museum, Cambridge; p.177 Fitzwilliam Museum, Cambridge; p.178 a TG bl BM c Ashmolean Museum, Oxford; p.179 BM.